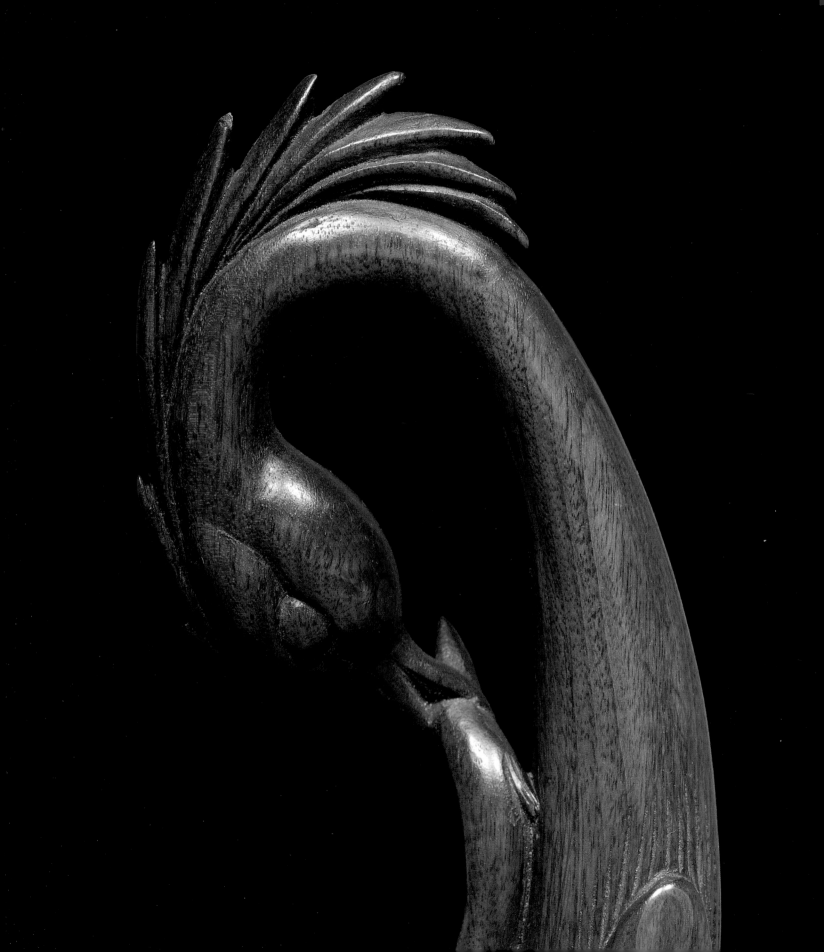

Willard Stone

GILCREASE MUSEUM | TULSA, OKLAHOMA

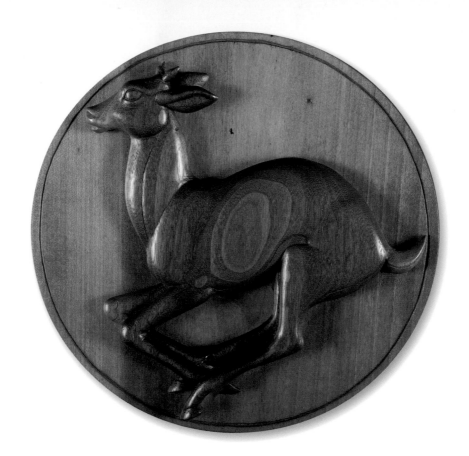

GILCREASE
M U S E U M

1400 NORTH GILCREASE MUSEUM ROAD

TULSA, OKLAHOMA 74127-2100

Gilcrease Museum is a University of Tulsa/City of Tulsa partnership.

International Standard Book Number 978-0-9725657-4-5

Printed in Korea.

SERIES CURATOR: Randy Ramer

ASSOCIATE CURATORS: Carole Klein, Kimberly Roblin

SERIES EDITOR AND DESIGNER: Carol Haralson

PHOTOGRAPHER: Rob Cross

PAGE ONE: DETAIL, STYLIZED BUFFALO HEAD, CHERRY, 1945, 12 X .5 X 8.25. GM 1127.53

ABOVE: THE YOUNG BUCK. WILD CHERRY, 9.75 X 1.5. GM 1127.3

FACING: CRAZY BUFFALO, 1943–1948. PHILIPPINE MAHOGANY, 17 X 3.25 X 12.25. GM 1127.18

CONTENTS, TOP LEFT: DETAIL, THE BAIT THIEF. WILD CHERRY, 4.5 X 2 X 9.25. GM 1127.10

CONTENTS, BOTTOM LEFT: DETAIL, TENSE JACKRABBIT, 1943–1948. WALNUT, 4.5 X 4 X 15.5. GM 1127.20

CONTENTS, RIGHT: DETAIL, PRAIRIE SONG. WALNUT, 19.75 X 2.75 X 2. GM 1127.79

Dimensions throughout are in inches, height preceding width.

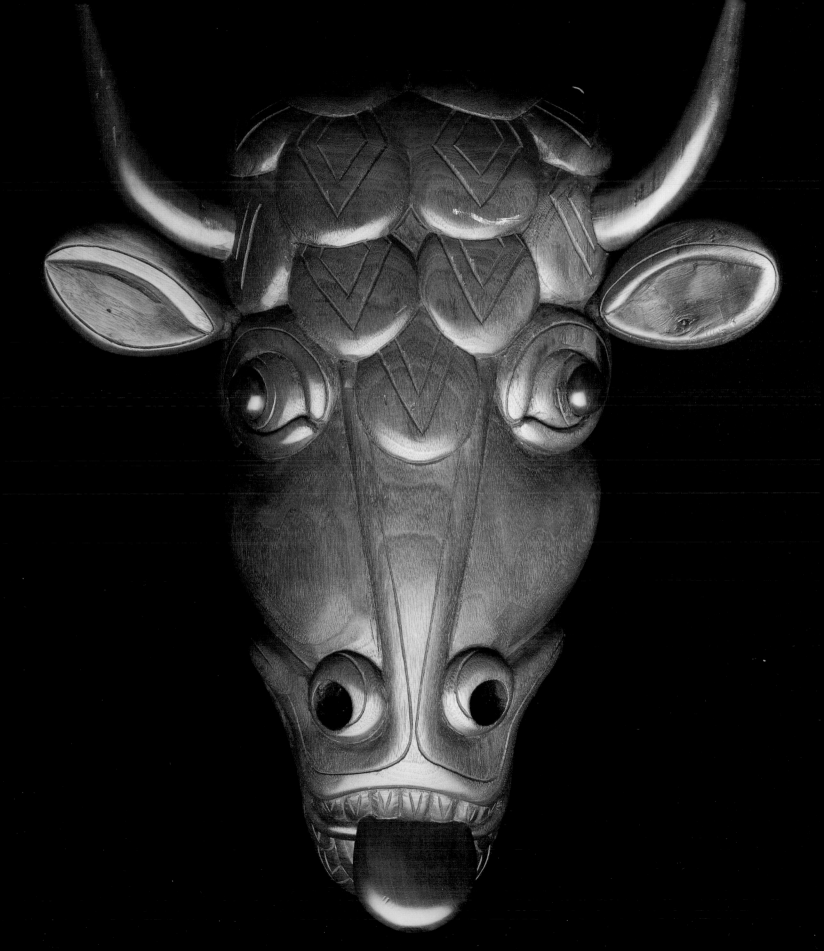

Preface

Duane King, Executive Director, Gilcrease Museum

Willard Stone and Thomas Gilcrease had a common bond based on shared heritage and love of art which brought them together, helping to create the legacy of Gilcrease Museum. Their stories, however, are more distinct than similar. Despite the geographical proximity of their homes, they lived, in many respects, worlds apart. Their lives were shaped by forces over which they had little control. Yet their accomplishments and their legacies were very much of their own making. They were unlikely players in the creation of perhaps the finest collections of Western and Native American art in existence.

Both began humbly, born to families of mixed Native American and Euro-American lineage whose livelihoods were dependent upon working the land. Thomas Gilcrease was born in Nachitoches County, Louisiana, in 1890. As a youngster, he moved with his family to the Muskogee Nation, where his mother's Creek ancestry secured the family a 160-acre allotment in preparation for Oklahoma statehood. The Gilcrease family allotment was near Glenpool, which would later be discovered to sit atop one of the richest oilfields in North America.

Willard Stone's mother, Lyda Headrick, was living in Parker County, Texas, when her family decided to join other Cherokee families from the area relocating to Indian Territory. They hoped to receive allotments in the Cherokee Nation. Travel was difficult, with lengthy delays resulting from wagon breakdowns and illnesses. The group was determined to reach Tahlequah before the rolls closed, ending eligibility for Cherokee citizenship. At one point, a rider was selected, mounted on the best horse available, and entrusted to carry the names of all individuals in the wagon train to Tahlequah on the chance that their applications would be accepted in absentia. The rider never made it and neither did the wagon train. Discouraged and without resources to continue, the group disbanded, and many of the participants settled along the route.

The Headrick family made it as far as the Creek Nation and settled near Oktaha, fourteen miles from Muskogee, Oklahoma. It was here that Lyda met and married George Stone; Willard was born in Oktaha on leap year day, February 29, 1916. His father died the following year and his mother supported the family as a sharecropper. His mother encouraged his artistic interests but his early promise as an artist was

WOODWORKING TOOLS,

WILLARD STONE STUDIO

shattered by the accidental blast of a dynamite cap when Willard was thirteen. His gifted right hand was mangled, and most of his thumb and first two fingers were lost. Unable to hold a pencil or a brush, Willard withdrew from school and society to ponder an uncertain future from the perspective of a seemingly unsurmountable tragedy.

The artistic genius in Willard Stone could not be quelled by the minor setback of a partially-missing hand. He learned to grip a pocketknife with the stubs of his fingers and found creative expression in his own imagination. By age fifteen, he was carving birds and animals from blocks of wood, occasionally selling them for spending money. Grant Foreman, the famed Oklahoma historian, took notice of Willard's talents and encouraged him to further his education at Bacone College. Willard accepted Foreman's advice and assistance. Through Foreman's influence, jobs and opportunities became available, and Willard remained at Bacone for almost four years from 1936 until 1940. Two of the faculty members under whom he studied, Acee Blue Eagle, in 1937, and Woody Crumbo, in 1939, were influential in helping to shape his development as an artist.

The person that Willard would later credit as his greatest influence, however, was Thomas Gilcrease. In late 1945, Gilcrease offered Willard Stone a job as artist-in-residence for the Gilcrease Foundation. The appointment would be for three years, 1946–48, with a stipend of $200 per month and a year-end bonus of $600. For Willard, it was a chance to concentrate on his art without having to support his growing family through odd jobs. The agreement was sealed with a handshake as "contract." All the art Willard created during the agreed-upon duration would belong to Gilcrease, and Willard could care for his family on a steady income totaling $3,000 per year.

Willard would later reflect that "Tom Gilcrease gave me the chance to find out what I could do with wood and clay and to develop a style of my own. I would not have been recognized had it not been for him, because he gave me the courage to try. His criticism helped me to correct erroneous approaches to my subjects. He had a good eye for art and if I was working on a carving he would not say too much, but when he did voice an opinion he would comment only on the good points. His omission of the bad ones told me what he wanted to convey."[1]

Willard completed more than forty sculptures during the three years, including *Lady of Spring* and *Birth of Atomic Energy,* which he felt were the most important works in the group. Today the Gilcrease collection contains fifty-seven sculptures and twenty-eight drawings by Willard Stone, virtually all from the 1940s. In admiring his work, it is easy to understand why many have concluded that Willard Stone did for wood what Michelangelo did for marble.

In the early 1960s, Thomas Gilcrease picked up a seasoned block of walnut from one of his archaeological sites in Illinois. He brought it back to Oklahoma and gave it to Stone. Willard thanked him for the gift but did not have an immediate answer

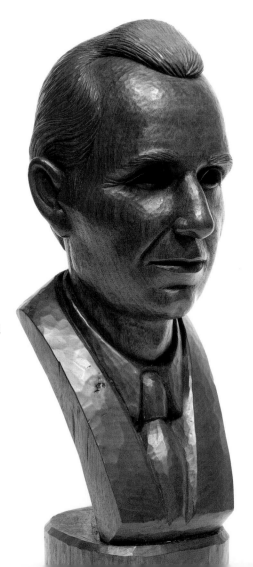

THE OLD MAN, 1963.

WALNUT, 15.125 X 6 X 6.5

GM 1127.63

1 Milsten, David Randolph. *Thomas Gilcrease.* San Antonio, Texas: The Naylor Company, 1969: 258. See also pages 253–265.

Unless otherwise attributed, direct quotes from Willard Stone throughout the book are from correspondence and other documents preserved in the Sarah Erwin Library and Archives at Gilcrease Museum.

FOR FURTHER READING:

Erwin, Sarah. "All in Good Time: A Gilcrease Chronology." *Gilcrease Journal,* vol. 7, no. 1 (Spring/ Summer 1999): 17–37.

Hamilton, Margaret W. and Sophie I. Stone. *Willard Stone: Sculptor/ Philosopher.* Edmond, Oklahoma: Persimmon Publications, 1993.

Maddox, Cindi. "A Visit with Willard Stone." *Gilcrease Magazine of American History and Art,* vol. 7, no. 3 (July 1985): 21–31.

to the question of what he would do with it. "I guess I will have to dream a little," Willard replied. In 1962 news of the death of Thomas Gilcrease came as a terrible blow to Willard Stone. The block of walnut that had remained untouched for so long now had a purpose. As Stone had done so many times before, he turned the vision in his mind's eye into a three-dimensional work of art in wood. *The Old Man,* a walnut bust of Thomas Gilcrease, was completed in 1963. It was presented by the artist to Gilcrease Museum on February 17, 1966, a lasting tribute the person Willard Stone always said had given him "a chance to show what I can do."

In late 1982, I had a chance to visit Willard Stone at his home and studio in Locust Grove. He was working on a small carving that day and had several others underway in his workshop. We talked about his sculpture *The Exodus* that had become a symbol for the Cherokee Nation and about his work for Thomas Gilcrease. It was obvious that he took great pride in those associations. On March 6, 1985, a massive heart attack claimed the life of Willard Stone. He left behind his wife, Sophie, ten children, and a legion of friends and admirers.

It is only fitting that in 2009, the Gilcrease Museum presents the exhibition *Willard Stone: Storyteller in Wood* to share with all the genius and mastery that has become the artist's legacy.

Willard Stone highlights a distinguished exhibition season made possible by support from Bank of Oklahoma, H.A. and Mary K. Chapman Charitable Trust, Joe and Kathy Craft Foundation, George Kaiser Family Foundation, Pete and Nancy Meinig, Nadel and Gussman, L.L.C., Samson, The William K. Warren Foundation, The Williams Companies, Inc., and Anne and Henry Zarrow Foundation. We are grateful for their generous assistance.

In addition, The University of Tulsa and Gilcrease Museum owe a special debt of gratitude to the individuals and organizations whose commitments form the foundation upon which we are building a stronger, more vibrant museum. As of October 31, 2008, these important Gilcrease Council members were led by a Founders Council comprised of The Mervin Bovaird Foundation, H.A. and Mary K. Chapman Charitable Trust, Mr. and Mrs. Walter H. Helmerich, III, George Kaiser Family Foundation, The Anne and Henry Zarrow Foundation, and The Maxine and Jack Zarrow Family Foundation. Members of the Patrons Council included J.A. Chapman and Leta M. Chapman Charitable Trust, Burt B. Holmes, Andrea and Wayne Rumley, and the Charles and Peggy Stephenson Family Foundation. Leaders Council members were Tom and Joanie Atkinson and Susan B. and Robert W. Jackson, and Friends Council members were Joan F. Flint, Jean M. and Randy A. Foutch, Sandra K. and Kent J. Harrell, Piper and Deacon Turner, and Patricia Wheeler. Our profound thanks to each of these valued partners and patrons.

A Gift to Use

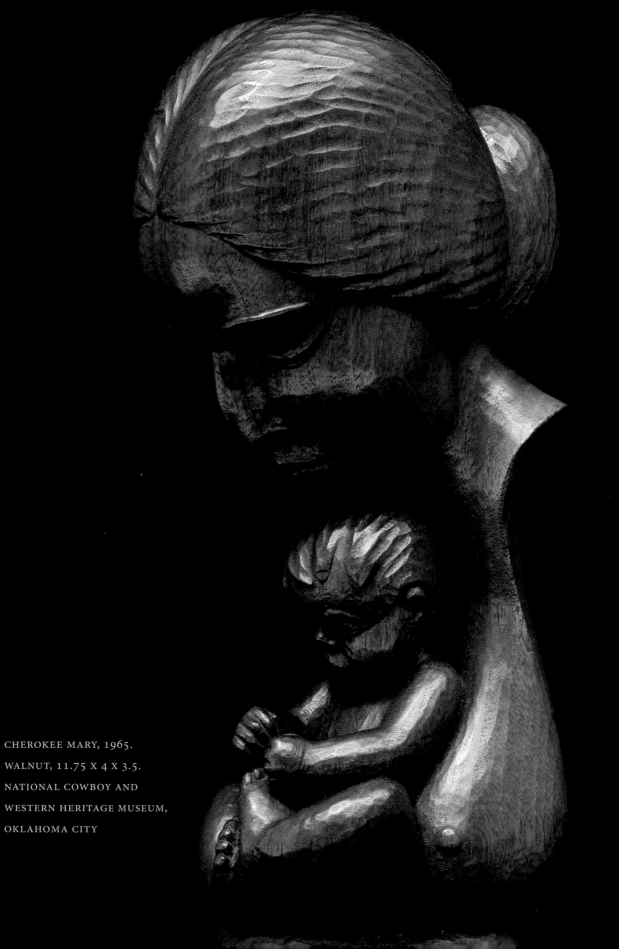

CHEROKEE MARY, 1965.
WALNUT, 11.75 X 4 X 3.5.
NATIONAL COWBOY AND
WESTERN HERITAGE MUSEUM,
OKLAHOMA CITY

"For some reason the Great Spirit gave me a gift to use and he kept me using it."

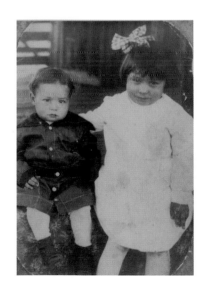

WILLARD STONE AND HIS
SISTER, CA. 1917.

Willard Stone produced over a thousand works as a professional artist. His themes embrace a broad spectrum of human experience—war and destruction, loss and shame, innocence, hope, and love. He excelled in revealing the profundity of everyday life. The lines and forms of Stone's artworks are as unique as his medium; as a sculptor of wood, he is yet to be equaled. In a life shaped by both tragedy and joy, Stone became a keen interpreter of the human condition, and his art maintains a universal appeal.

In the 1870s Willard Stone's paternal grandfather, William P. Stone, moved his family from Georgia to Searcy County, Arkansas, where Willard's father, George Maloy Stone, was born in 1878. By 1900, the family had relocated to lands near Muskogee in the Creek Nation in present-day Oklahoma. Willard's mother, Lyda Blanche Headrick, was born in Parker County, Texas, in 1885. Her parents, James and Caroline Headrick, moved their family north to settle in the Cherokee Nation in the late 1800s. George and Lyda Stone met in Indian Territory and were married in 1902 in Muskogee.

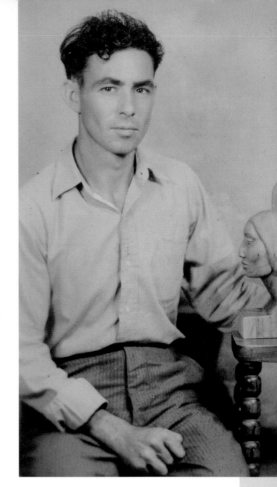

Over the next several years, George and Lyda Stone and their family worked on a number of farms in the region. Willard was born to the couple on February 29, 1916, near Oktaha, Oklahoma, the youngest of seven children. His father died of pneumonia less than a year later, at thirty-eight. Willard's mother became the family's sole breadwinner and worked at whatever jobs she could to support her children. She mostly worked in the fields picking cotton. As they grew, the children joined her. Days were filled with hard work for the family. Throughout his youth times were hard, but Willard had never known any other way.

Stone's interests were not unusual for a boy growing up in rural Oklahoma. He enjoyed hunting, fishing, and roaming freely in the countryside. The natural world, however, appealed to him more than to most. It was a place of wonder—a place of artistic inspiration though he did not yet know it. At home, Willard loved to draw, and he practiced intently on rainy days when not working in the fields. The discovery of art at an early age urged in him a deeper awareness of the things that made up his everyday existence. In his drawing, he favored crayons and coveted every scrap of paper that could be found, filling the precious pieces with images of the birds and animals so much a part of rural life. He was becoming not only an observer but also an interpreter. The fields and creeks of Muskogee County allowed him to develop an affinity for the natural world that would serve his artistic interests for the rest of his life.

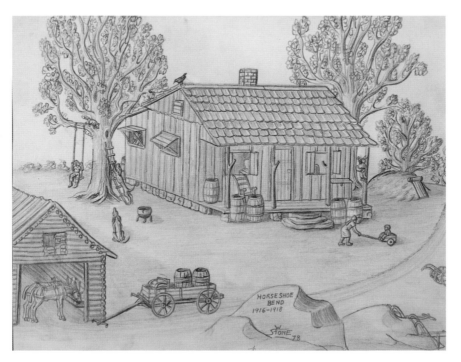

WILLARD STONE AS A YOUNG MAN. COURTESY OF THE STONE FAMILY.

LEFT: DRAWING BY STONE OF HIS CHILDHOOD HOME AT HORSESHOE BEND, 1916–1918.

FACING, TOP: A COTTON FIELD NEAR MUSKOGEE, 1929. GM 4327.1203. BOTTOM: ARKANSAS RIVER BOTTOM SIX MILES EAST OF MUSKOGEE. GM 4327.992

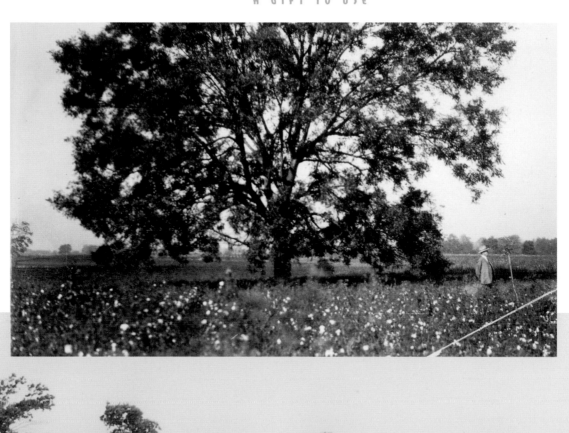

FULLENWIDER
MUSKOGEE OKLA.

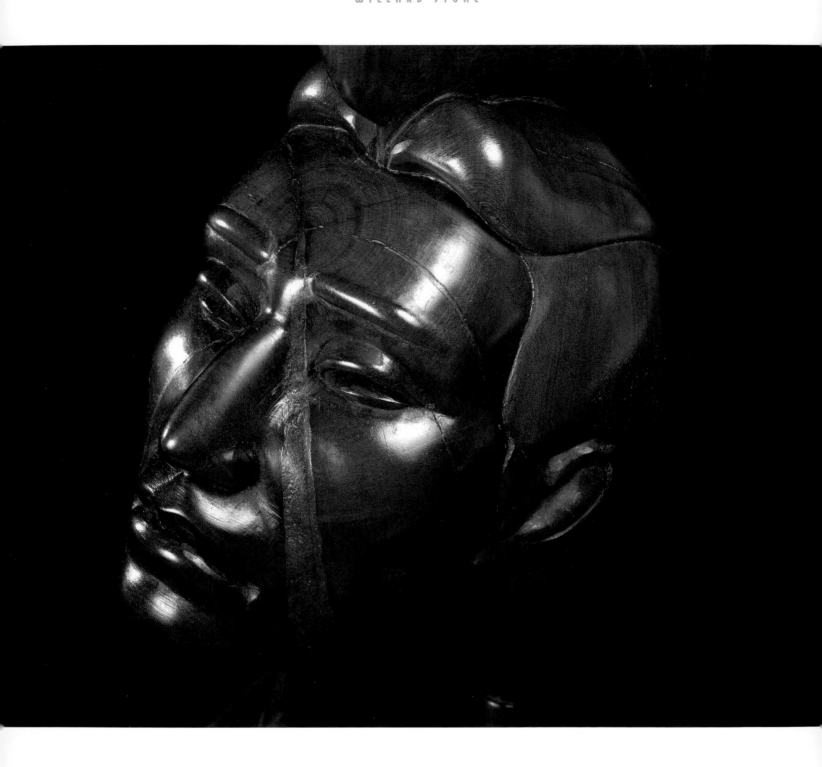

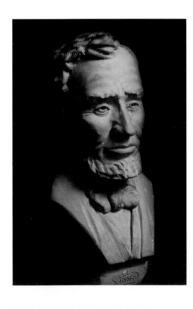

Over time, Willard began to dream of becoming a famous painter. He marveled at the works of Michelangelo and Leonardo Da Vinci he saw in books at school. The two masters would become lifelong influences. Willard's mother supported his interest as best she could and saved enough money to buy him some sketchbooks. As he grew, his need for artistic expression continued to grow as well. He needed to create something and dreamed of having the tools of a real painter—paints and brushes. He wanted to share with others the quiet beauty and hidden grandeur he could see and feel in the world around him.

Willard Stone's world changed forever in the summer of 1929. One day on the way home from school, the curious thirteen-year-old stopped to pick up an unusual object that had caught his eye. While Oktaha was largely a farming community, coal mining was also a common enterprise in the region. The object he picked up turned out to be a blasting cap intended for use in detonating dynamite in the mines. Just how the device had found its way to the boy's path is not known. It is certain, though, that he had no idea of the danger he had taken into his hands. As he paused to look it over, the cap went off. The force of the explosion tore through his hand, chest, and face, leaving him momentarily stunned. Then, bleeding and gasping in pain, Willard clutched his wounds tightly and ran for home.

The boy's life was fundamentally altered. Although he eventually healed, he lost segments of two fingers and the thumb of his right hand. As he recuperated, the full significance of the event began to settle in. Just as he knew that an ability to draw was crucial to being a painter, he also knew that his capacity to develop that skill had been utterly taken away. While he healed physically, his awareness of what had been lost only continued to deepen. His dreams were suddenly gone. His mother tried to console him, Stone later recalled. To the boy at her side, she said, "Willard, our lives are often filled with tragedies. They can destroy us or we can learn to live in spite of them, even drawing strength from the things they teach."

Despite her efforts, her son became increasingly withdrawn. He dropped out of school, preferring to be alone. He began spending his days aimlessly wandering the woods and along the creeks that had once given him inspiration. The days in the countryside helped to heal him but the pain in his hand and in his heart remained. The accident had left him without a sense of purpose. Hunting and fishing became his sole interests. Weeks and months passed but the emotional effects of the accident lingered. The changing seasons offered a quiet backdrop, however, to changes that were gradually occurring within him.

While he could later not recall exactly when, it was during this time that the young man began to use his hands again creatively. He took an interest in modeling small animals from clay gathered in the rain-soaked ditches along the roadside near his home. Working the clay not only helped to rehabilitate his injured hand but also quickly became the creative outlet he so desperately needed. At his roadside studio, the young artist placed his newly sculpted works atop the family mailbox and

waited patiently for the critique of his one-man audience—the postman. In time, his audience grew. Friends encouraged him to enter his work in the Muskogee State Fair. There, his sculptures captured the attention of acclaimed Oklahoma historian Grant Foreman. "You show brilliant potential talent," said Foreman. "You must get some art education."

With Foreman's help and encouragement, Willard Stone was enrolled at Bacone College in 1935. At Bacone, Willard found it difficult to study anything but art. He studied under Acee Blue Eagle and Woody Crumbo, among the most noted American Indian painters of their time. "As far as sculpture is concerned, I'm self taught," Stone once said. He credited the two, however, with teaching him the fundamentals of draftsmanship. More importantly, they encouraged him to believe in himself. Later in life, he attributed much of his success to their influence. It was at Bacone that Stone made his first serious attempts at wood sculpture. It was there also that his interests turned toward Native American–inspired subjects.

Throughout his adult life, Stone referred to himself as an ordinary "boil pot American." His father was German and Scots-Irish while his mother was a non-government–enrolled member of the Cherokee Nation. At Bacone, Willard began to learn more about his Native American heritage. From the examples of Blue Eagle and Crumbo, he discovered that cultural imagery from the past could be used to inform the present. More significantly, his confidence in his work continued to grow. In 1938, Stone won second prize in his first national contest—the Procter and Gamble competition for best advanced sculpture in soap. "I can still see that letter," Stone later said about receiving notice of the award. He remembered praying to himself that he would at least finish in the first fifty of the several hundred entered "because it would be a rare honor."

As Stone's days at Bacone were coming to a close, his interests turned toward a beautiful young Choctaw woman named Sophie Coger. The two had met at the Log Cabin, a "honky-tonk" near Muskogee. "Marvin, my brother, and his wife Maggie came to stay with us when I was in high school," Sophie later recalled. "When we went honky-tonkin' Maggie introduced me to all the kids . . . that's how I met Willard. We had a good time. No drinking was allowed . . . just good clean fun." As their relationship developed, Stone became increasingly ready to move on with his life. He left Bacone only a few weeks away from receiving his high school diploma. He and Sophie married within the month, on December 28, 1940.

Before the end of the following year, the first of Willard and Sophie Stone's eleven children, Sophie Irene, was born. Times continued to be hard as the two parents struggled to make a living in the waning years of the Great Depression. After America's entry into World War I the family moved to Muskogee, where Willard worked on construction projects for the United States Army. The couple's second

BELOW: AS A TEENAGER, STONE WON SECOND PRIZE FOR HIS SOAP SCULPTURE. BOTTOM: AN AWARD TO STONE FROM HIS EMPLOYER, DOUGLAS AIRCRAFT COMPANY.

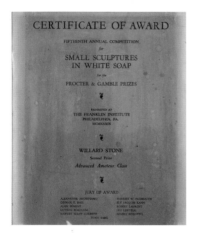

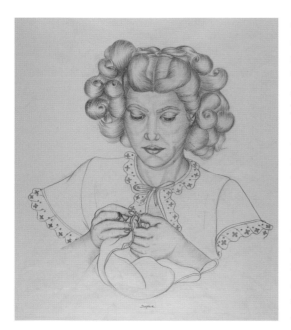

SOPHIE, 1946.

COLOR PENCIL ON PAPER,

24 X 19. GM 1327.337

child, Grant Willard, died in infancy, but the third, Nettie Carolyn, came soon thereafter. Stone next took work in Pryor, Oklahoma, at the Industrial Powder Plant making ammunition to be used in the conflict abroad. By the war's end, the family had added a fourth child, Jason Monroe. Less than a year later, the Stones moved to Locust Grove.

Throughout the early 1940s, Stone's impulse to create, his need to pursue his art, continued to grow. In her 1992 essay, "Willard Stone: Sculptor, Philosopher," Margaret W. Hamilton sheds light on the times:

According to Willard, those early forties years of struggling to properly care for a burgeoning family were a time without art or carving. But according to his family, it seemed that no matter what the job, Willard always had a small piece or block of wood in his hands and, whenever he had a spare minute, out came the old pocket knife . . . His hands were never still. They usually moved in response to some creative, imaginative urge within him . . . The obsession to sculpt had never left him. It only hibernated for a short period. And the hibernation quickly gave way to full blown activity once he met Thomas Gilcrease.

Oklahoma oilman Thomas Gilcrease was in the prime of his professional career. He had amassed millions in his business pursuits since the 1920s. Perhaps more significantly, he was at the apex of more non-professional interests. While building a fortune over the past two decades, he had also studied and traveled the world. He had visited great museums. He had developed an understanding of history and its relevance to contemporary times. And he had developed a taste for collecting, most notably fine art and historical documents—all to be displayed in his yet-to-be-constructed Tulsa museum. Among his collecting pursuits was art with Native American themes, specifically works made by Native American artists.

Of the fifty-two Willard Stone artworks that would later become part of the Gilcrease collection, one of Thomas Gicrease's favorites was purchased from the artist in 1943. Willard had sent three initial wooden sculptures to gauge the oilman's interest. Stone described them in a letter from Oktaha to Gilcrease's San Antonio, Texas, headquarters in January. "I have completed three other pieces which I am sending for your approval." One of the sculptures he described as being "any full blood Indian of today . . . His mind is in the past. Tomorrow holds no joy for him. I call this carving 'Today's Full Blood' . . . "

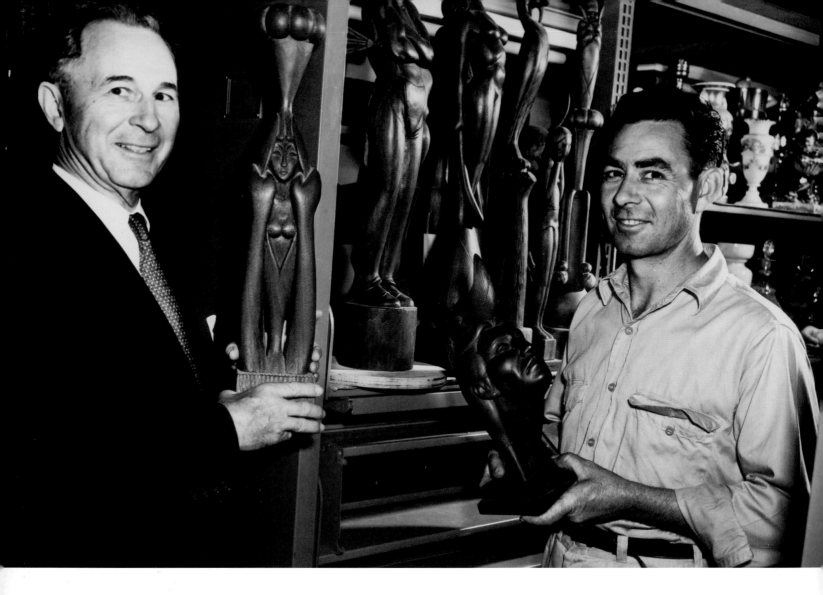

A few weeks later came Gilcrease's reply.

Dear Mr. Stone,
Thank you for your letter I think that the little standing figure would interest me In connection with this figure I would like to voice a little constructive criticism. You seem to sacrifice form for stylization by which I mean that an excessive amount of design is present at the expense of detail Your choice of wood texture is good but be careful of round grain patterns on flat surfaces, as on the back and on the seat they flatten those plains [sic] unnecessarily. Remington solved those problems to perfection. I can send you some photographs of my bronzes if you wish for study purposes . . . "
Very cordially yours,
TG

THOMAS GILCREASE (HOLDING
BIRTH OF ATOMIC ENERGY)
WITH WILLARD STONE
(HOLDING THE APPEAL), AT
THE GILCREASE MUSEUM.

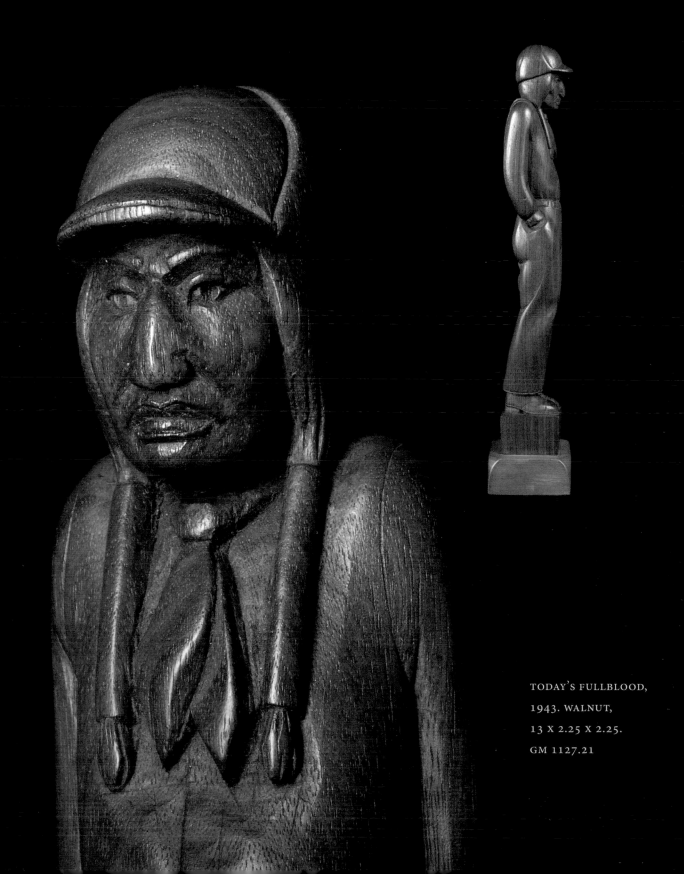

TODAY'S FULLBLOOD,
1943. WALNUT,
13 X 2.25 X 2.25.
GM 1127.21

This exchange demonstrates the relationship between artist and patron that would prevail through the coming years. In 1946, Thomas Gilcrease and Willard Stone entered into an agreement—a contract that would allow Stone the financial freedom to pursue something unique. The agreement called for a three-year stipend. All works produced during that time would become part of the Gilcrease Foundation collection. Though formally considered an "artist in residence," Stone would remain at his Locust Grove home to produce his works. While his life in the countryside of eastern Oklahoma would continue as a primary source of inspiration, his relationship with Thomas Gilcrease was fundamental to his expanding knowledge of artistic expression. The two maintained a mutual respect and understanding as artist and patron as Gilcrease urged Willard to greater and more challenging levels. Years later Stone commented on the time: "Tom Gilcrease gave me the chance to find out what I could do with wood and clay and to develop a style of my own. I would not have been recognized had it not been for him . . . he gave me the courage to try. His criticism helped me to correct erroneous approaches to my subjects If my work or finished carving did not tell a story, he knew I had a dull knife . . . "

Of the masterpieces created during his tenure with the Gilcrease Foundation, *Lady of Spring* is among the most highly regarded. He wrote to Thomas Gilcrease in April 1946 of his efforts:

> Dear Tom,
> When I showed you the Atomic carving you told me that anything that made people think was good art. So the one I have just finished was carved with that thought in mind.
> To explain it, I will have to give you my understanding of the beginning of things.
> God must have created the world as an experimental garden spot. In this garden he then sewed all the seeds, two of a kind (male and female) of all the different plants and animals including man and woman. When he had done this he then gave them the right to grow and multiply according to the way they cultivated themselves. And they in turn were to always look to him as their source of energy. This carving I have finished is dedicated to all the flowers of nature, who in the springtime, blossom out to show their appreciation to God for the right given them to live. The carving itself is of the nude figure of a woman bursting forth from the bud of life. I hope you get my point and haven't tired of reading all this . . .
> Sincerely and thanks,
> Willard Stone

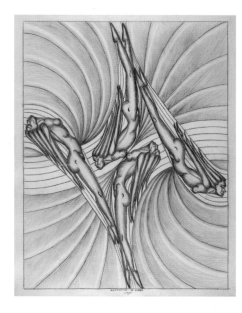

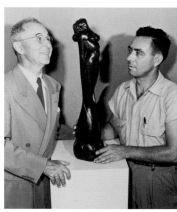

TOP: ABSTRACTION IN LIMBO, 1947. COLOR PENCIL ON PAPER, 29 X 22.75. GM 1327.345

BOTTOM: THOMAS GILCREASE WITH WILLARD STONE AND LADY OF SPRING.

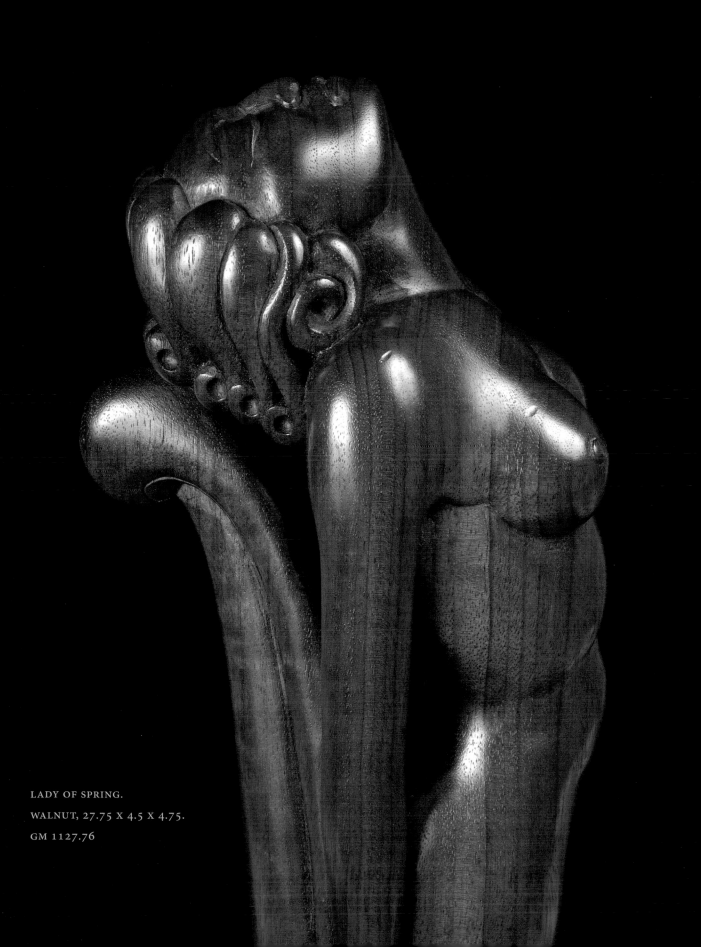

LADY OF SPRING.

WALNUT, 27.75 X 4.5 X 4.75.

GM 1127.76

A few weeks later, Thomas Gilcrease responded:

> Dear Willard:
>
> The story of your last carving is rather interesting and I will be happy to see the carving itself, which I am sure will be pleasing. I like the idea very much of having your own story and conception of your carvings, as this will add interest to them. We will describe each one and display same along with the carving. Hope to see you on my next visit to Tulsa.
>
> With kindest regards, I remain
>
> Sincerely,
>
> TG

The three years spent with the Gilcrease Foundation were among the most productive of Willard Stone's long career. While he had matured as an artist beyond his own imaginings, his pursuit of financial security seemed never-ending. In 1947, Danny Will Stone was born. That year, Willard and Sophie purchased thirty acres just off the narrow highway east of Locust Grove. Times continued to be lean, but the family had at last found a homestead. Though not far from town, the acreage provided a place to grow—a place to take root.

During the first few years after his tenure with the Gilcrease Foundation ended, Stone found employment with at the Weiman Ornamental Iron Works in Tulsa, designing and forging gates, fences, and other decorative implements. In 1950 he began work at Douglas Aircraft as a die finisher. For the next decade, Stone commuted to Tulsa from the farm in Locust Grove. During that time, he continued his artistic pursuits, often sculpting in the back seat of the car on the trip to and from work. At home, however, four more children were added to the Stone family. The fifth child, Laura Evelyn, was born in 1951. In the following year came Lyda Blanche, named for Willard's mother, who had died a few years before. In 1954 Linda Joyce was born, followed by Dwight Clyde in early 1956. To Willard, the farm had become more than home. It had become a source of inspiration. In a letter, he wrote: "We have 30 acres here on which we have a variety of chickens, ducks, geese, pigeons, cows, pigs, and one horse, along with cats, dogs, and 'possums. Moneywise, they are a losing proposition, but it's a lot like kicking a can down the street, there is no money in it but it's a lot of fun. Also, the kids like them for pets and I gather ideas from them."

In 1960, Willard Stone abruptly gave up the security of full time employment to pursue the work of a full time artist. Reflecting on the previous decade, he said, "For awhile my carving became strictly a part time thing . . . I decided that I had to either do it full time or quit . . . so I took the plunge." For the first time in his life, he believed strongly enough in his art to trust that it could support his young and growing family. In his Locust Grove studio he had at last found comfort in

TOP: WILLARD STONE.

BOTTOM: BLACK AND WHITE AND BROWN (SELF-PORTRAIT), 1947. COLOR PENCIL ON PAPER, 30 X 22. GM 1327.354

his own ability. Stone had mastered the techniques and styles that would become his trademark. He was poised to pursue not only financial security but also new heights as an artist. Significantly, he had also developed a set of priorities for his work. "Boiling it all down, the real pleasure an artist gets out of his work is to create something that other people like," Stone said. "The money that the object might bring is a necessary thing that disappears overnight but what people say about it and the impression it leaves no man can take away."

Over the next decade, Stone's notoriety as an artist continued to expand. As the demand for his work increased, the demand for his appearance in public increased as well. In 1961, he traveled to Santa Fe to for a one-man show at the New Mexico Museum of Art. The following year, he was contacted by Rudolf Wunderlich, president of the Kennedy Galleries in New York. Wunderlich had been a longtime friend of Thomas Gilcrease and was aware of the broader appeal that Stone's work

THE AGGRAVATOR, 1947.

PENCIL ON PAPER, 22 X 30.

GM 1327.342

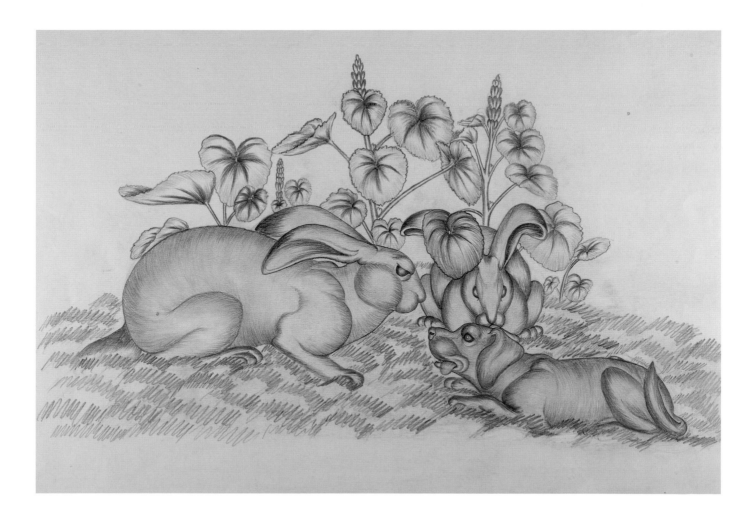

would find outside the Southwest. Dean Krakel, one-time director of the Gilcrease Institute, wrote "Of the myriad nice things that Mr. Gilcrease did in his lifetime, one of them was to introduce Willard Stone to Rudolf Wunderlich Casual as it was, it was part of a plan that dated back almost twenty years. Thomas Gilcrease, more than anyone, knew that at last, Mr. Stone, the Cherokee wood sculptor, was ready for the biggest and the best exhibition of his life."

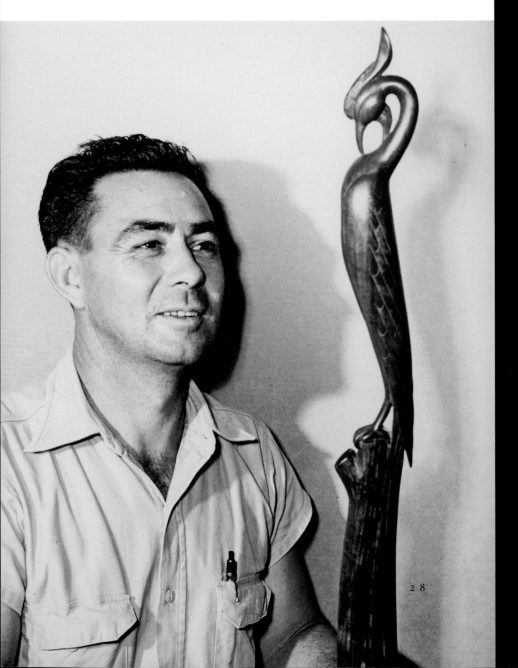

28

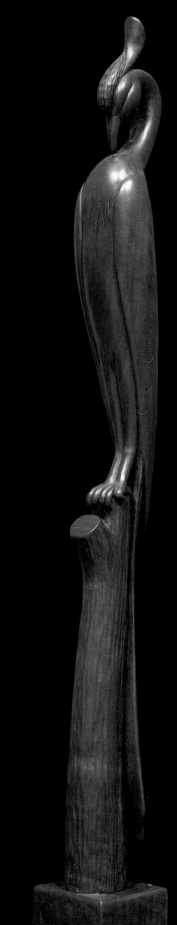

BIRD, 1947.

WALNUT,

30.125 X 3 X

GM 1127.75

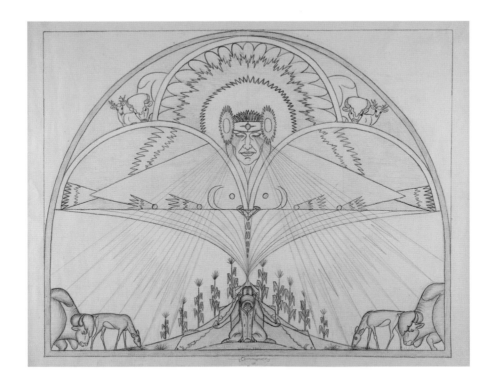

COMMUNION OF
THANKS. COLOR
PENCIL ON PAPER,
30 X 24.
GM 1327.353

BELOW AND DETAILS
ON FOLLOWING PAGE:
GUARDIAN OF THE
BUFFALO.
WOOD, 30 X 50 X 2.5.
COLLECTION OF PAT
AND PATTI LESTER

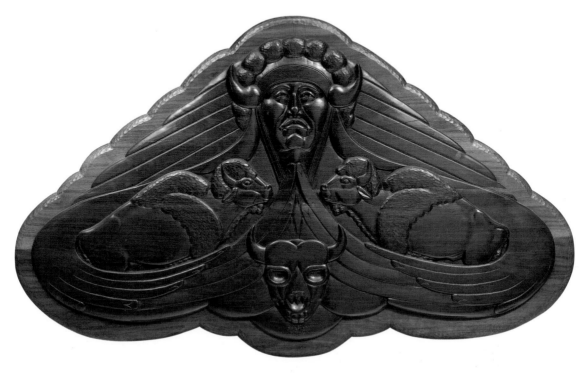

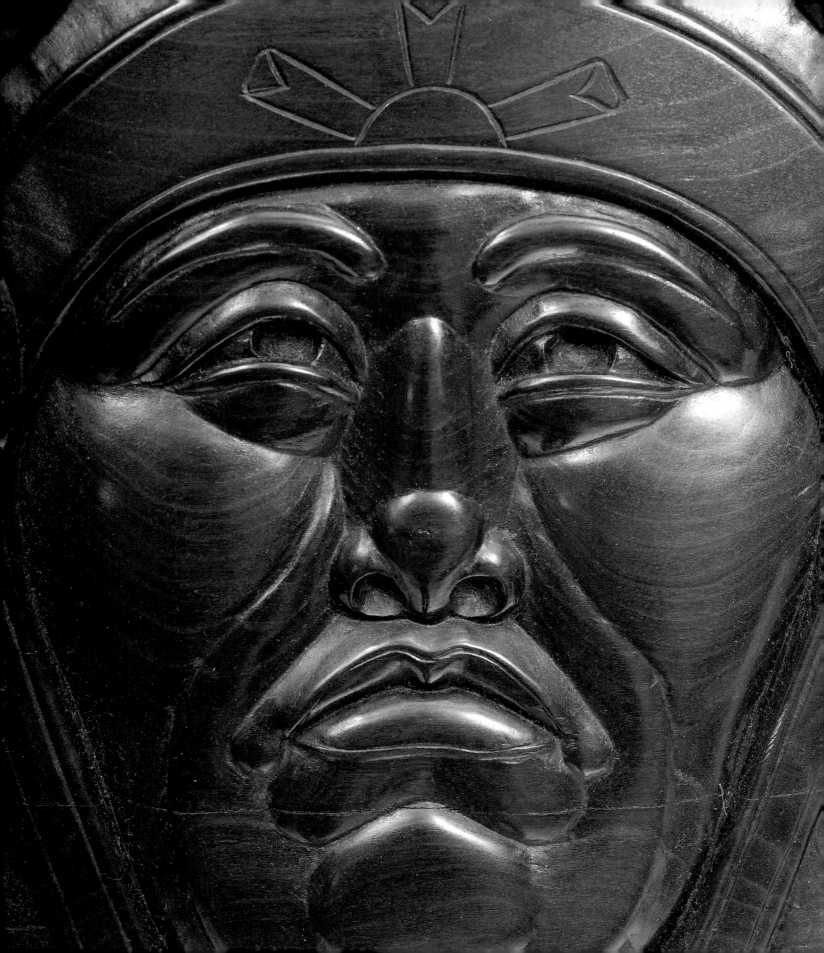

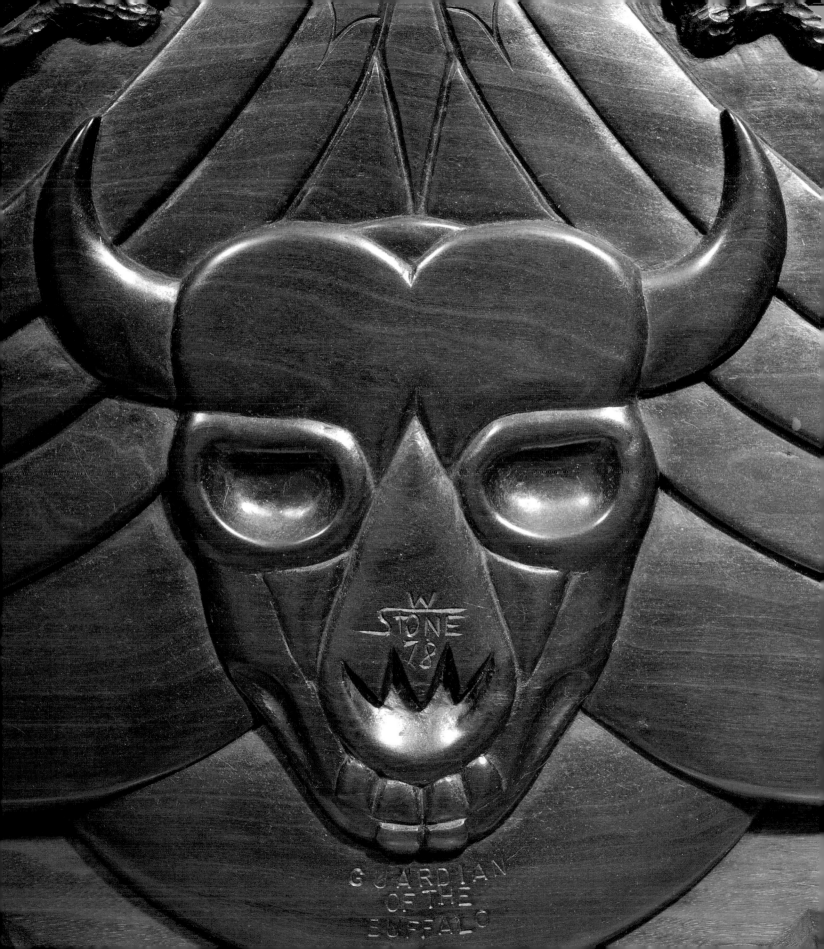

GUARDIAN
OF THE
BUFFALO

FACING: FALL SEASON, 1948.
INK AND COLOR PENCIL ON
PAPER, 30 X 22. GM 1327.346

The New York exhibition was indeed a high point of Willard Stone's career. Sadly, his good friend and longtime patron would be absent—Thomas Gilcrease had died only months before at his home northwest of Tulsa. "I think Tom would have been proud of me," Stone later said. "I would have been proud of his being there. I can just see him walking in the door and asking, 'Is there an Indian here named Willard Stone? If so, tell him there is a Creek here to look at his whittling . . .'" Thomas Gilcrease's impact on Stone's work had been profound. Even years after his residency at the Gilcrease Foundation had ended, the artist continued to seek out his former patron. "Every time I'd finish a piece, I'd take it over and show it to him and get his criticism. His encouragement helped me over an awful lot of rough places."

The New York exhibition ended after one month in mid December, 1962. Stone eagerly returned to Oklahoma and continued his artistic efforts, never really taking seriously the acclaim and attention he had received. The artist had always maintained a modest demeanor and abhorred the limelight. He had taken great efforts to instill in his children the notion that they were no better or worse than anyone else. He considered himself a simple man. Both personally and artistically, he never tried to separate himself from the creek bottoms and cotton fields that had been such a fundamental part of his early life. The complexity of his nature, however, was evident in his art. Poised to become one of the nation's most important sculptors, Stone remained genuine. His quiet humility was ever present. The profound images of his sculptures reveal a man moved by a unique passion and spirit. His work would ultimately reveal the complexity found in so-called simple things.

WEASEL. WOOD,
1.25 X 1.5 X 6.5. WILLARD
STONE MUSEUM, LOCUST
GROVE, OKLAHOMA

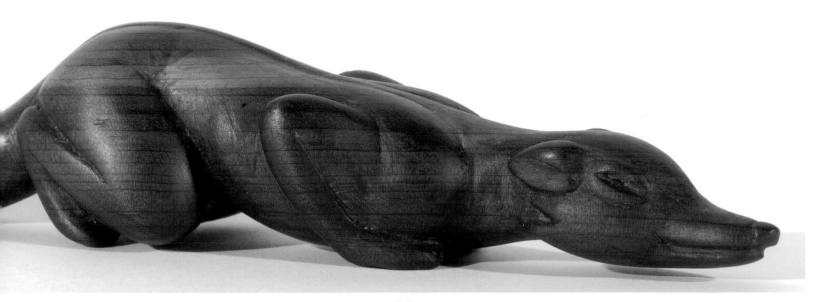

Follow the Grain

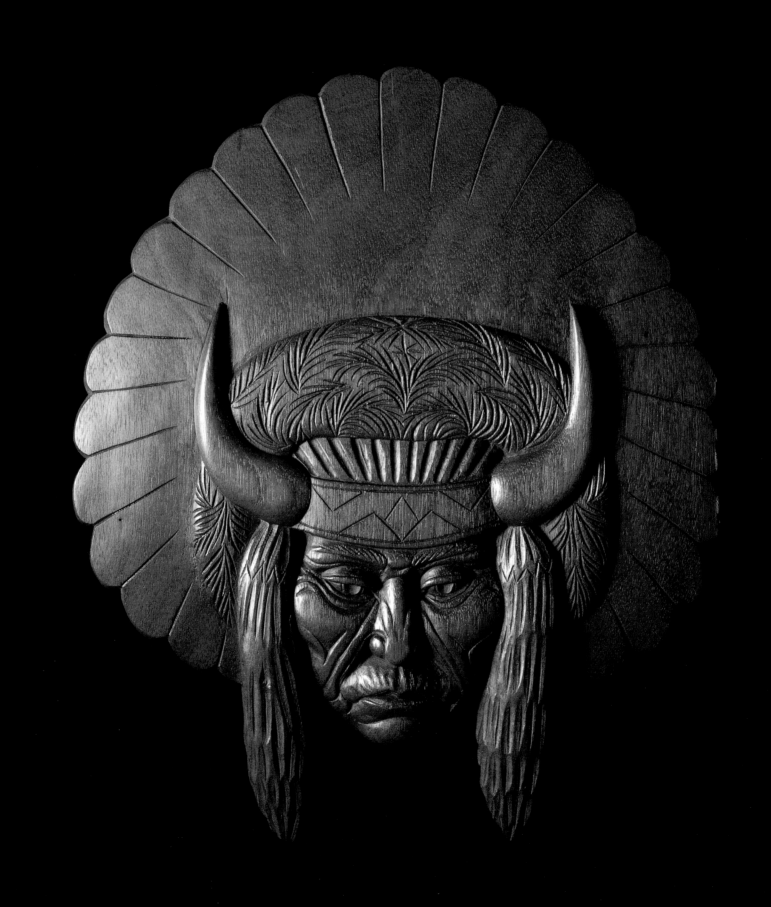

"Life is much like sculpting in wood—you have to follow the grain."

A sculptor looks for essential forms in life. The material he uses to express his interpretation of these forms is highly personal. The medium must reveal physical characteristics that respond to his touch, incite his mind's eye, and provide him the means to an artistic voice. It was wood that fired the imagination of carver Willard Stone. He loved the warmth of it, the color of it, even the way it smelled: "I love the smell of wood. When I walk through the timber, I enjoy just smelling the different woods of the trees. My sense of smell for wood is highly developed, probably like an animal."

THE OLD ONE,
MAHOGANY, 1947,
13.5 X 1 X 11.
GM 1127.52

Sassafras, cherry, walnut, oak, mahogany, red cedar, bois d'arc, and more—all were shaped by the sculptor's hands into memorable works of art, the wood both enhancing and enhanced by Stone's clever design skill. He respected the qualities of each—their hardness or softness and how they responded to the carving tools. He especially liked sweet-smelling sassafras with its rich grain and ease of carving. "I like sassafras because it has a prominent wood grain Sassafras is a marvelous wood. It's like oak, only it's hard all the way through—no soft spots in it…"

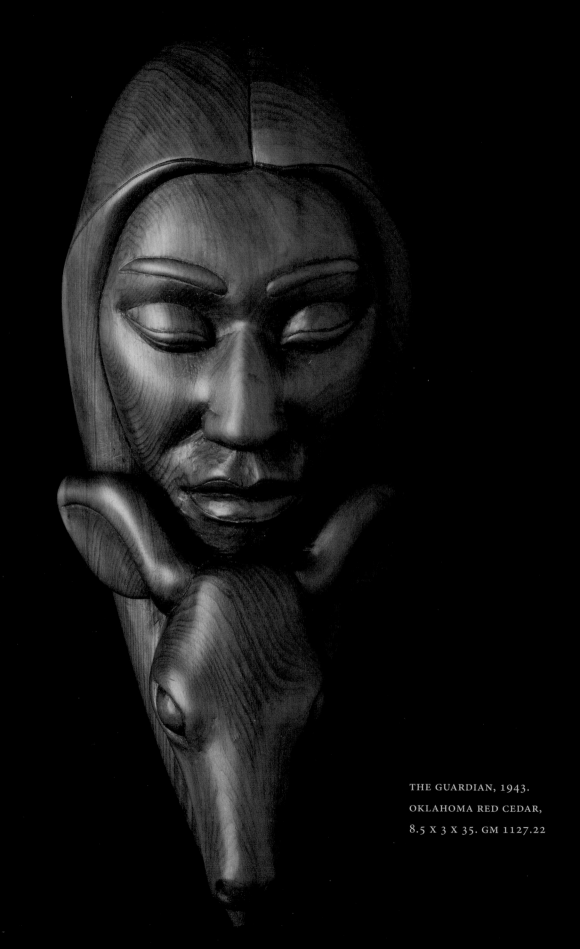

THE GUARDIAN, 1943.
OKLAHOMA RED CEDAR,
8.5 X 3 X 35. GM 1127.22

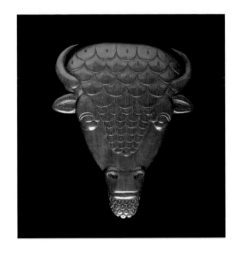

STYLIZED BUFFALO HEAD,

CHERRY, 1945, 12 X .5 X 8.25.

GM 1127.53

EAGLE DANCER. OAK AND

WALNUT, 7.75 X .75 X 28.25.

GM 1127.7

Stone became transformed by his relationship with wood and the desire to shape it. He brought new life to dead wood and felt that in his carvings "wood comes alive again—life goes on." He searched for wood with anticipation, allowing the material to speak to him. "I can actually see a figure in the wood then I begin chipping away . . . "

Sometimes he would have an idea first and then search for the right color and grain of a wood to best express it. Occasionally he combined several woods within a work. The grain of wood was one of the most important elements of Stone's artistic technique. He ingeniously incorporated it into his designs, believing that the grain was integral to the overall success of the work. One only has to look at some of Stone's masterpieces to see how the wood grain follows natural form. "I have to match the wood to an idea, and the idea has to follow the grain If you go with the grain, it's a good strong piece of work. If you go against the tree, against the grain, it's weak."

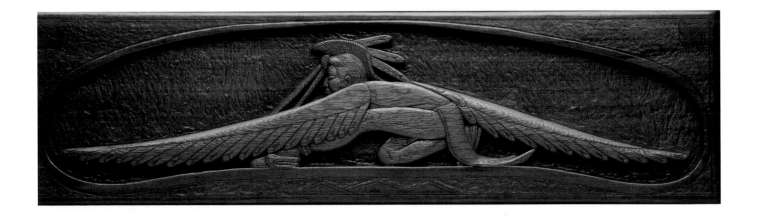

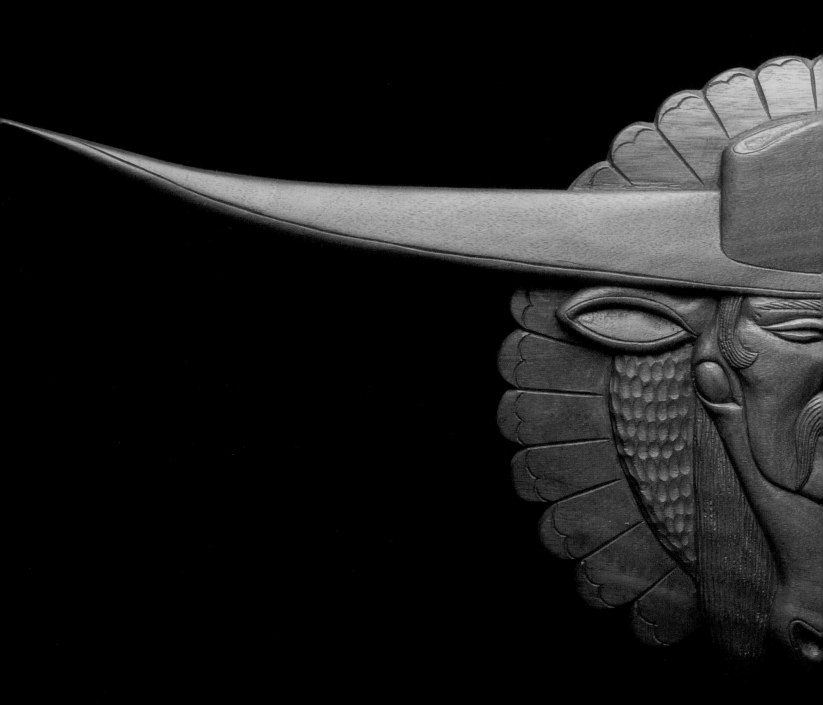

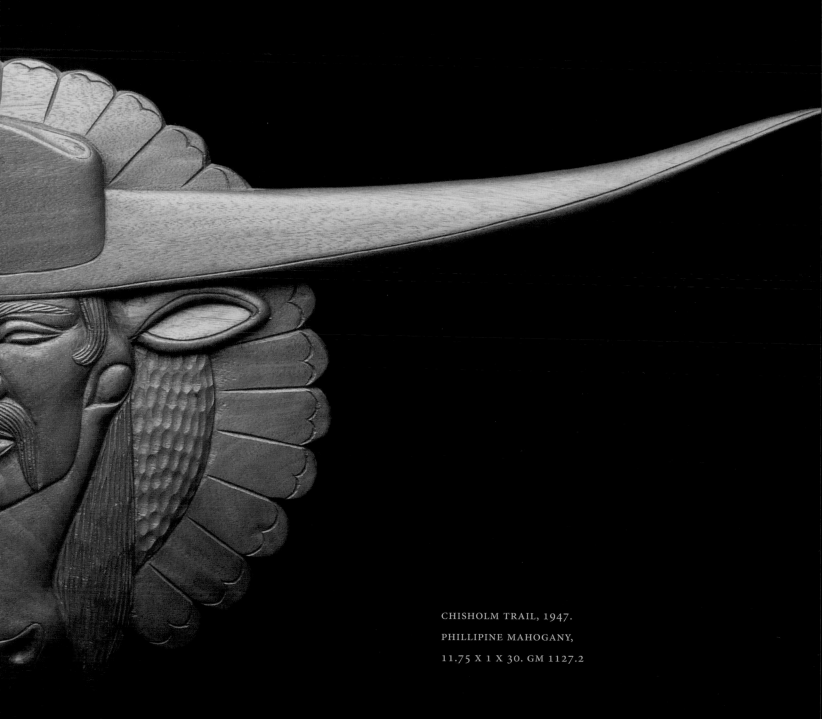

CHISHOLM TRAIL, 1947.
PHILLIPINE MAHOGANY,
11.75 X 1 X 30. GM 1127.2

The land Stone called home near Locust Grove was a treasury of timber. Freshly cut wood has to cure, so Stone used a loft in his barn for this purpose. Walnut and cherry, for example, cured in ten to twelve years, whereas sassafras usually took about three to four years to cure. He always had an eye out for wood from any source, and was happy to find wood that was already seasoned. "It is hard to find wood of any size that is seasoned Tuesday of this week I went to Fayetteville, Ark. and found some good seasoned cherry wood . . . " He would sometimes recycle salvaged wood, such as a piece from a 150-year-old log cabin in Michigan. Some of his early works were carved from walnut logs from the original stockade at Fort Gibson. Thomas Gilcrease would also often bring him wood from his world travels.

An artist's inspiration, imagination, and skill at manipulating a particular material come together in successfully designed works. Stone's wood carving technique, born of a need to express himself, provided the artist a means to communicate his ideas. The inspiration that came to him from observing the natural world of his Oklahoma home would occupy him for a lifetime. An insightful philosopher, he carved works related to politics, world events, and the power of the federal government, referring to himself as a "folklorist in wood." Amid serious subjects, he also found humor in everyday life and drew inspiration from the animals and people he observed. His ideas were influenced by values born of deep religious conviction.

WILLARD IN HIS STUDIO. COURTESY OF THE WILLARD STONE MUSEUM.

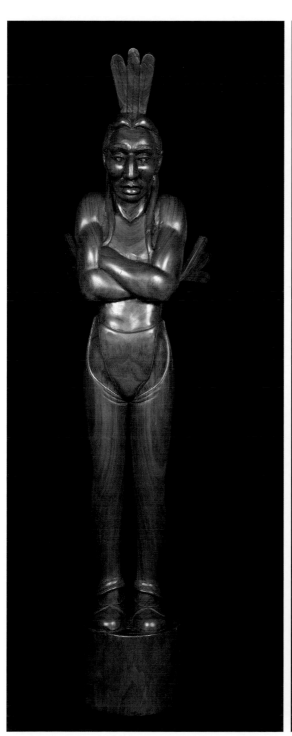
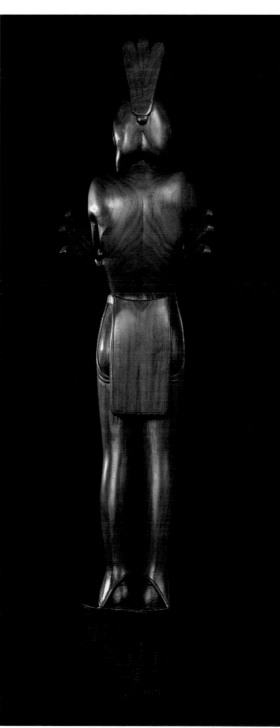

THE OBSERVER.
WALNUT,
31.5 X 6.25 X 5.
GM 1127.73

Stone's approach to the process of carving was organized. "I think more than I whittle," he said. He would start with small conceptual drawings. When the idea was refined he proceeded to a full-size working drawing that he would then transfer onto wood. Revealing a sculptor's emphasis on volume and mass, the drawings are characterized by strong composition. Through an ingenious sense of design, he resolved spatial relationships in advance, freeing his hands to simply reach into the wood, wield the blade, and bring forth his vision.

Stone's injured right hand required him to make some adaptations to his carving tools. Aside from his trusty pocket knife from boyhood, he used simple woodworking tools, including ½-inch, ¾-inch and 1½-inch chisels, and modified them to suit his needs. He would grind and shape the blades of standard carpenter's chisels, rounding off the corners and creating a low bevel so he could push easily through the wood and obtain smooth transitions when cutting contours. He adapted his pocket knives to accommodate the crippled stub fingers of his right hand.

The carving process began with a blocking-down stage in which large chunks of wood were removed with chisels and mallet. After that the artist excised successively smaller pieces, working down to the tiniest details. He used his knives for intricate elements and some gouges, for example V gouges, to incise lines. It is said that when the chips got so small that he could not see them with his bifocals, the cutting was finished. Sanding would then proceed, as he worked from coarser to finer grades of sandpaper, sometimes even using steel wool.

FACING: THE WOOD CARVER, 1946. CHERRY, 15.25 X 2.5 X 2.5. GM 1127.64

THE CHASE, 1947. MAHOGANY, 10.5 X X 31.25. GM 1127.26

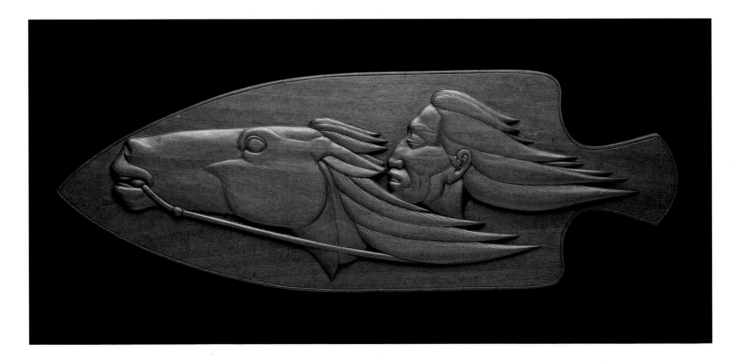

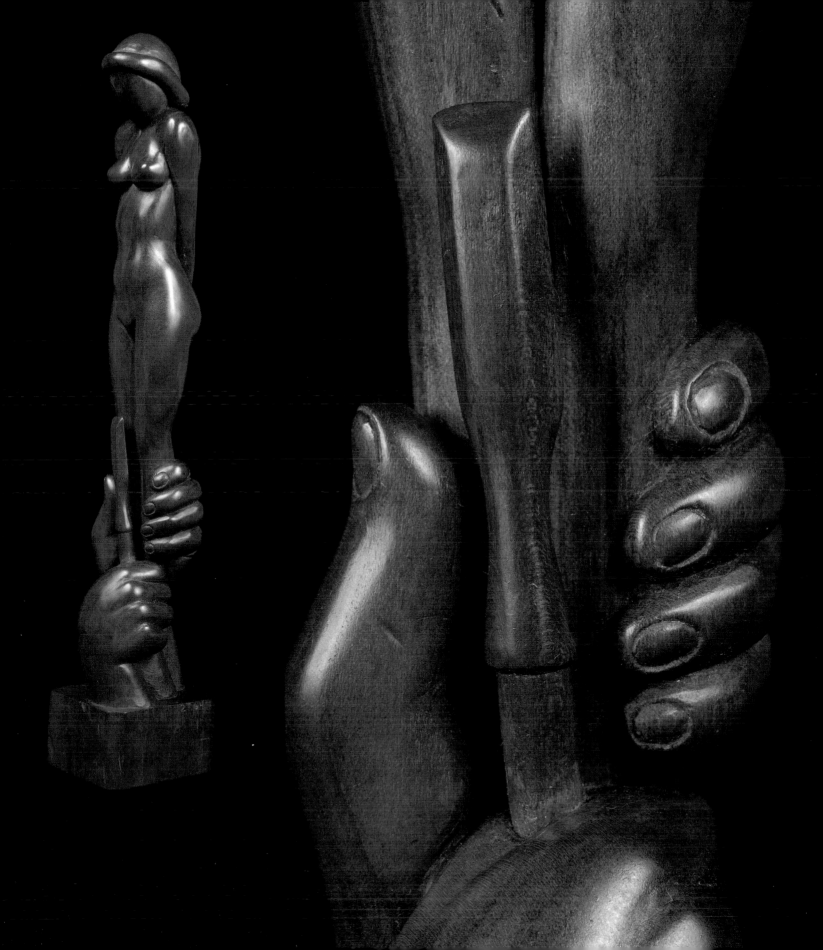

Stone's subjects are diverse and his compositions varied. He carved three-dimensional sculpture in the round as well as bas-relief wall pieces. The reliefs are sometimes rectangular in form, sometimes oval, and sometimes are cut out, their contours following the shape of the composition. Every sculpture is unique. He did not like to repeat compositions. Two approaches to *Running Buffalo* include a cutout wall relief and a three-dimensional carving. If Stone repeated subject matter, he took a fresh approach to its composition and design. An example is *Bait Thief* (overleaf)—he carved the subject in two versions, one a bas-relief on an oval shape, the other a sculpture in the round. Also, though he did commissioned works, Stone preferred to carve what came to him by way of inspiration. Innovative compositions indicate that he was constantly exploring new ways to present his subjects. *The River* (pages 50-51) shows two animals carved from two different woods, the fish in old cherry and the turtle in oak, one atop the other.

FACING: RUNNING BUFFALO, 1947. WOOD, 6 X 2.5 X 7. GM 1127.16

RUNNING BUFFALO. PHILIPPINE MAHOGANY, 12 X .75 X 16.75. GM 1127.6

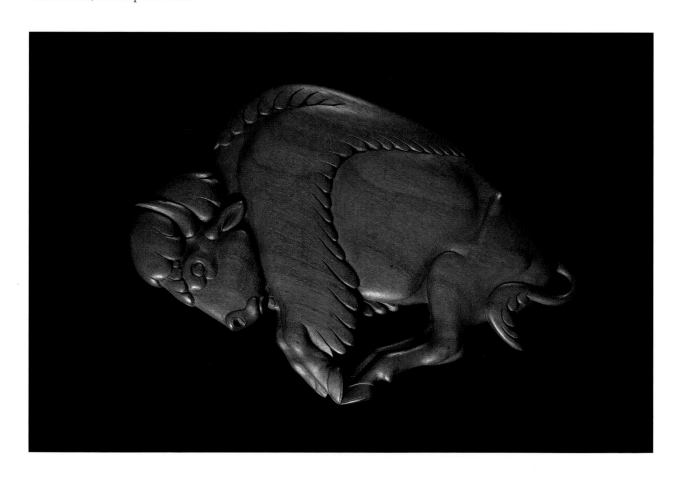

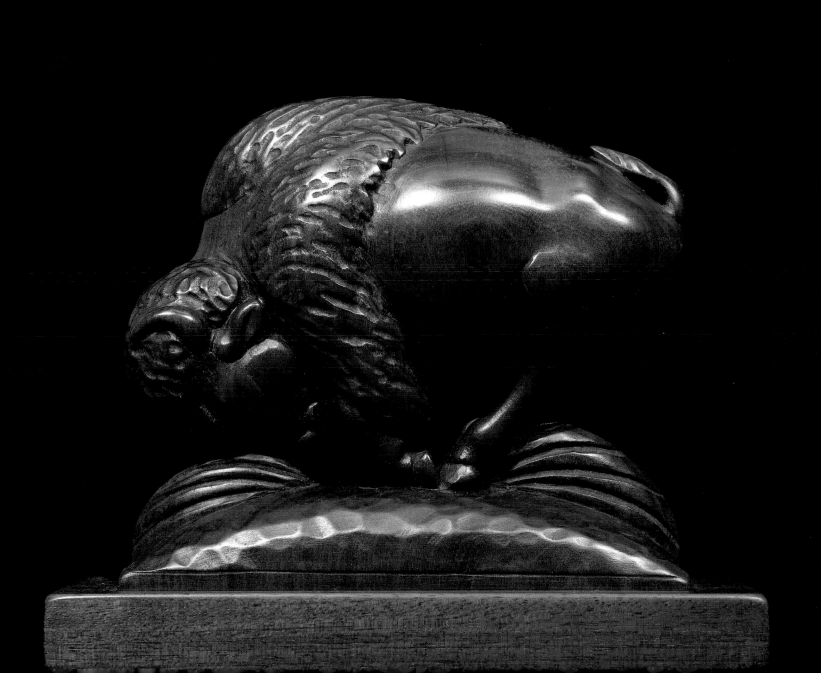

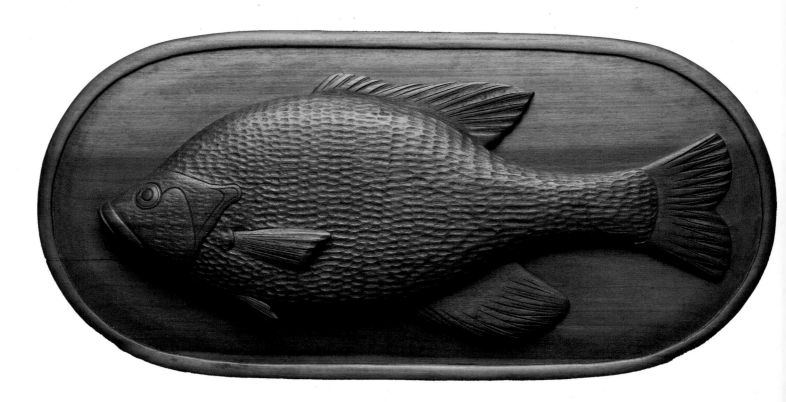

THE BAIT THIEF, 1947.
WALNUT AND WILD CHERRY,
8.5 X 2 X 17.75. GM 1127.5

THE BAIT THIEF.
WILD CHERRY, 4.5 X 9.25 X 2
GM 1127.10

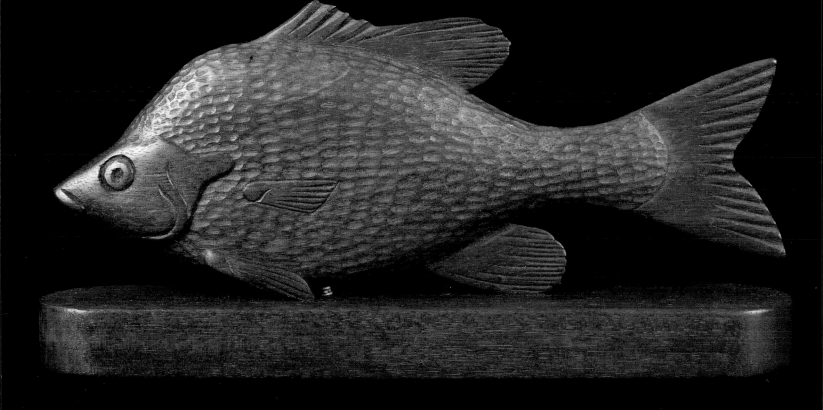

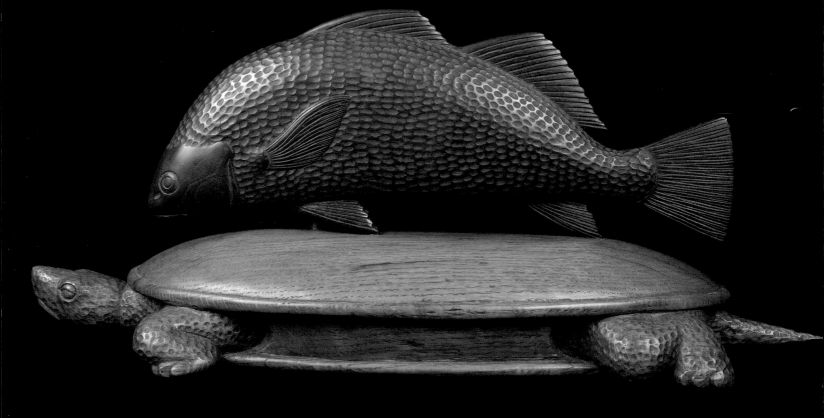

THE RIVER.
AGED CHERRY AND OAK,
9.5 X 7.75 X 21.25.
GM 1127.77

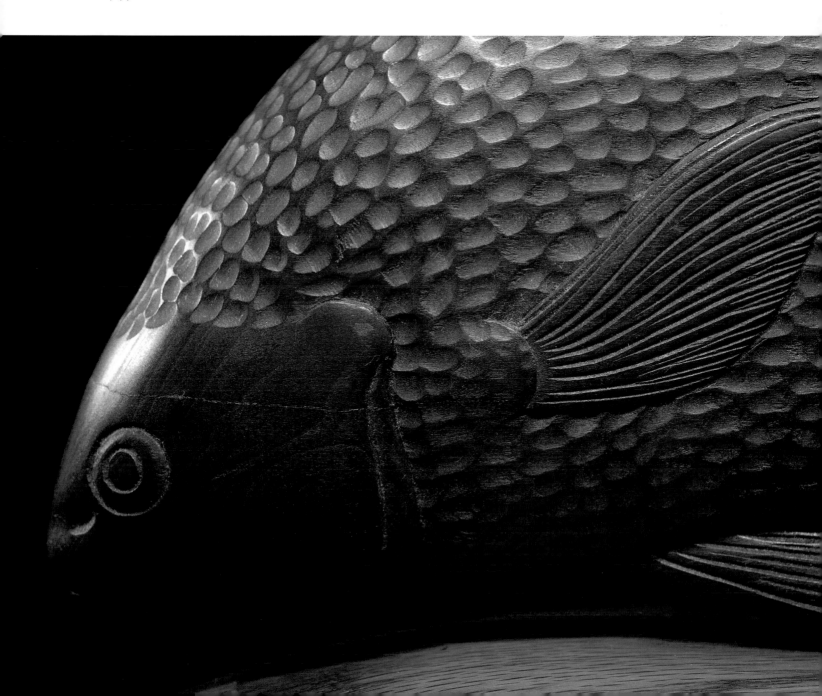

In *Rain Crow Illusion,* Stone represents two birds in a single carving—one side the rain crow, the other side the phoenix, with a clever transition of forms evolving one into the other. This is the only time Stone ever used this type of complex composition. *Siesta* is a work made of two pieces, the baby separate and removable from the hand that holds him. Many of Stone's sculptures are elongated. He said that finding height in wood is easy, but width is another matter. Whatever the reason, this elongation of the graceful forms evokes an uplifting attitude, both physically and spiritually, as do the spires of Gothic architecture.

SIESTA, 1976.

WOOD, 2.75 X 4.25 X 8.

GM 1127.84

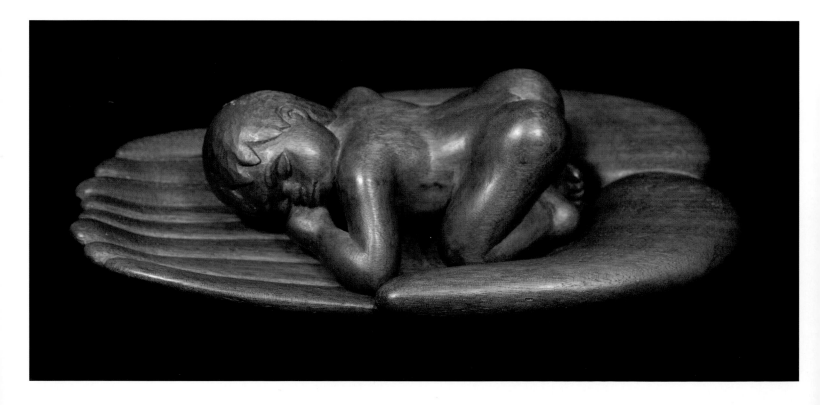

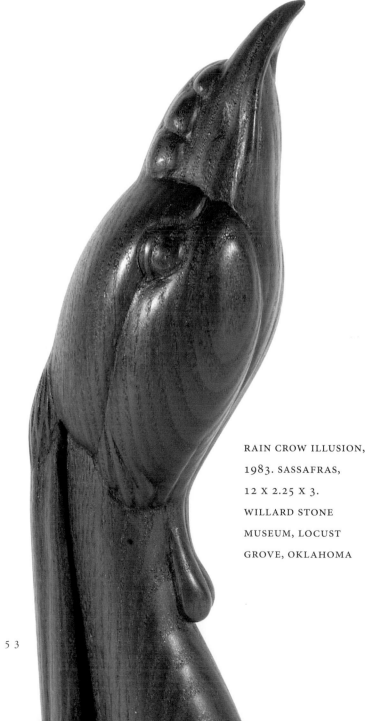

RAIN CROW ILLUSION,
1983. SASSAFRAS,
12 X 2.25 X 3.
WILLARD STONE
MUSEUM, LOCUST
GROVE, OKLAHOMA

A sense of time is a repeated motif in Stone's work. The element of linear perspective appears in his three-dimensional *War Widows* (page 112) as a poignant symbol of time. Stone represented the great number of grieving widows at the end of World War II. But the chain of connected figures from large to small, or small to large, also suggests time's continuum, driving home the devastating effects of multiple wars throughout history. *Tomorrow* also employs the metaphor of time, as the figure leans forward into a perceived future. This figure exudes an air of Art Deco, as do other Stone works that exhibit flowing and curvilinear design, especially those which treated modern subjects. It makes sense that he would have absorbed some influence from the style since he lived during a time when he would have seen Art Deco design in items mass produced between the 1920s and 1940s, and would have been exposed to Art Deco architecture in Tulsa as well. Stone did not copy Art Deco images, but perhaps was inspired by their abstraction and simplification of form.

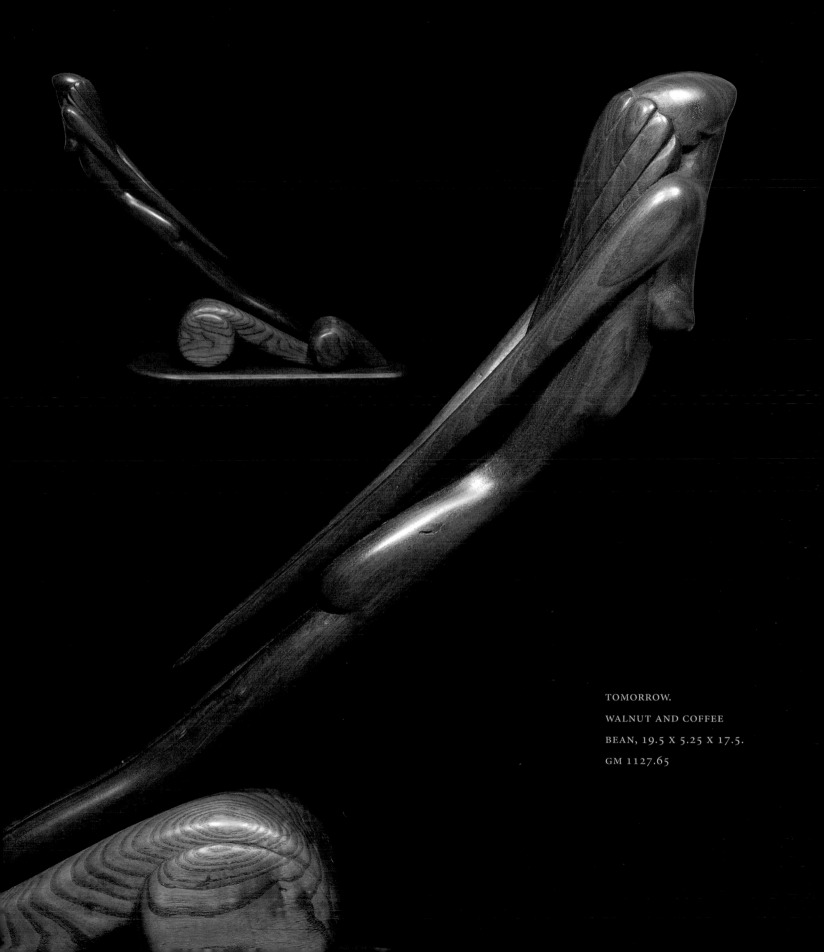

TOMORROW.
WALNUT AND COFFEE
BEAN, 19.5 X 5.25 X 17.5.
GM 1127.65

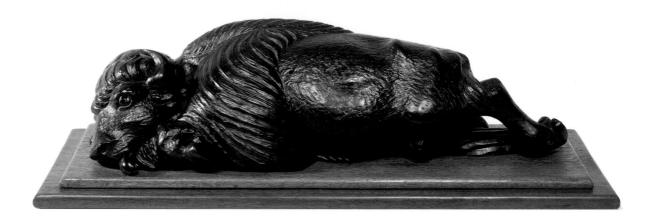

Stone's work reveals a belief in the sacredness of nature, which he portrayed always as a vital force, usually in the fullness of its natural healthy state. Only a few works represent death, as in *Dying Buffalo* and *Spoils of War,* while a few warn of destruction, as his modern themed works about atomic energy.

Stone was largely self-taught. He did, however, spend the years 1936 through 1940 at Bacone College studying with art instructors Acee Blue Eagle and Woody Crumbo. There he learned the basics of draftsmanship, composition, and perspective, but, most importantly, was encouraged to find his own artistic voice and a medium to suit his vision. Both his drawings and his comments in letters to Gilcrease reveal his thinking about the artistic process. Referring to his design for *Buffalo Bulls,* which exhibits a masterful use of grain in describing the form and anatomy of the animals, Stone wrote: "Found two very good pieces of mahogany in Tulsa. From it I have carved you one piece It is of two rather massive simplified buffalo horning each other. The whole thing is designed to put across the massive strength of the animals. The grain of the wood came out very well in this piece."

DYING BUFFALO, 1947.
EBONY, 7.5 X 9 X 25.75.
GM 1127.62

LETTER CONTAINING A
DRAWING OF BUFFALO BULLS.
GM 3827.7824.1

FACING AND DETAIL,
FOLLOWING PAGES:
BUFFALO BULLS, 1946.
MAHOGANY, 8.125 X 4 X 23.75.
GM 1127.23

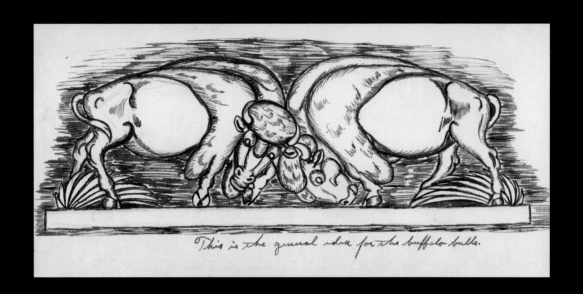

This is the general idea for the buffalo bulls.

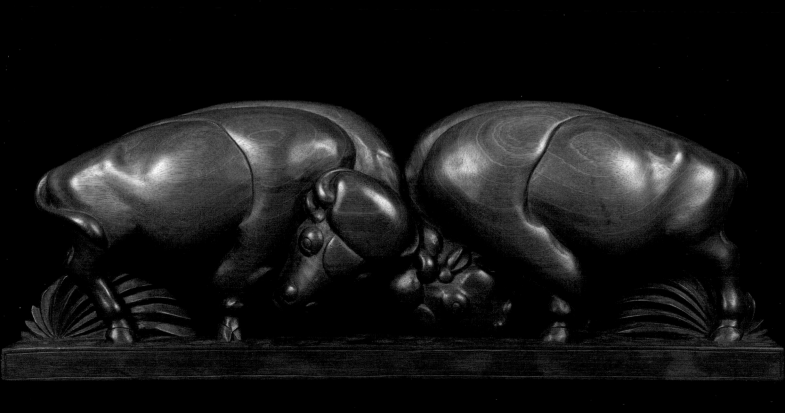

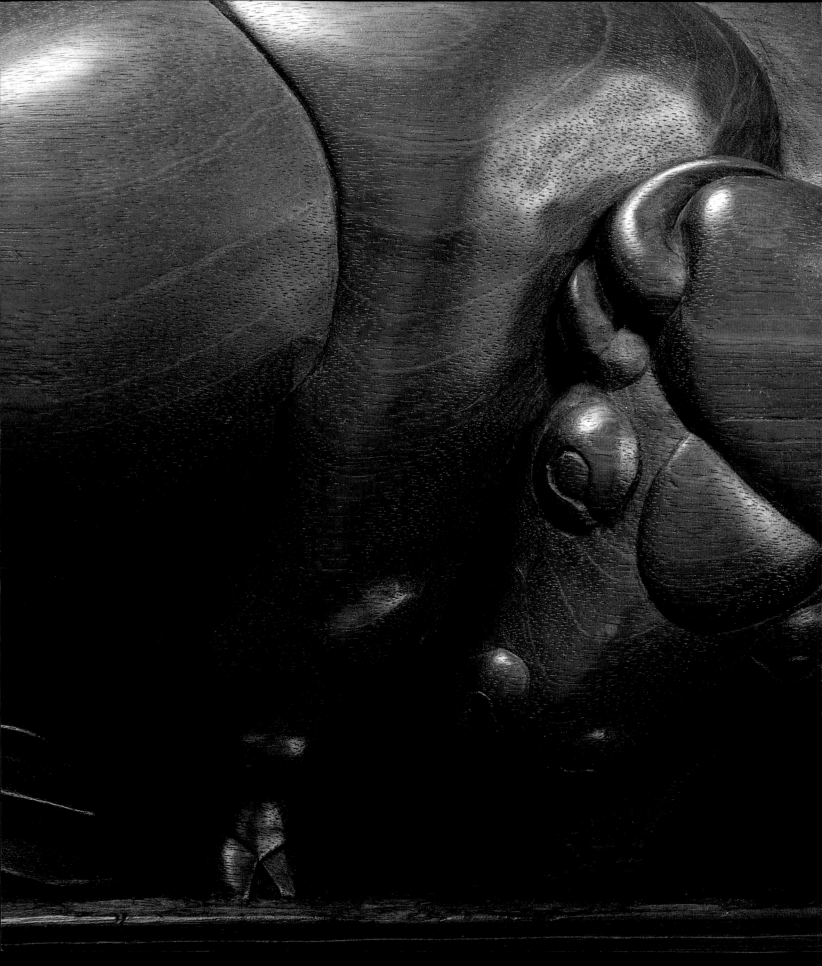

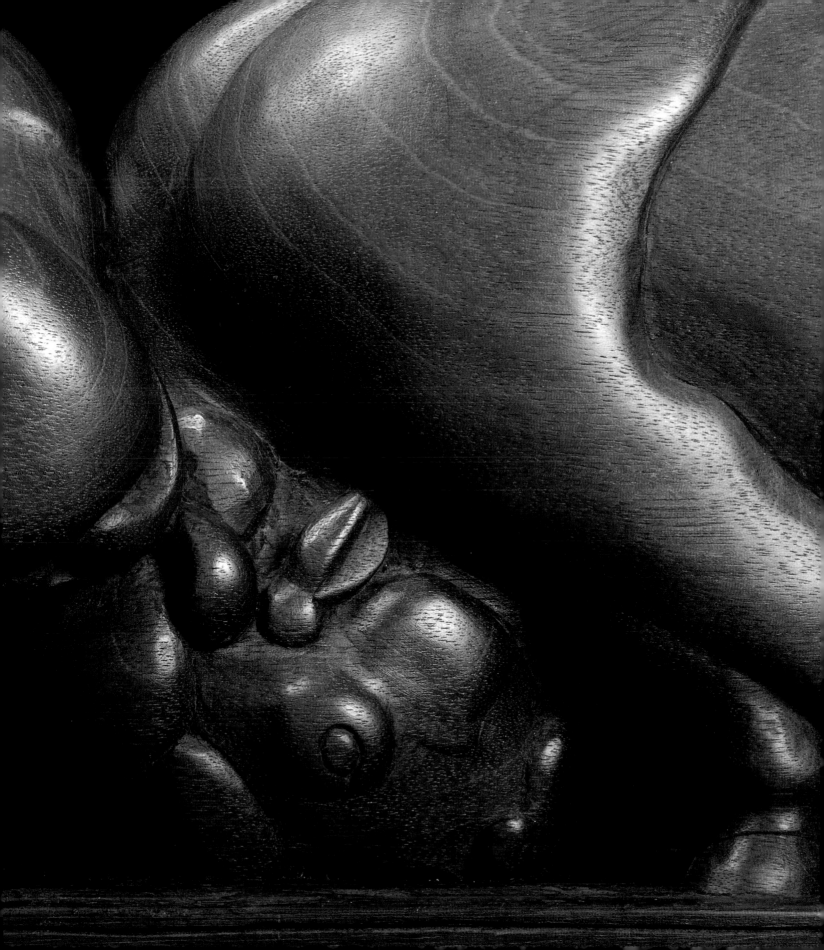

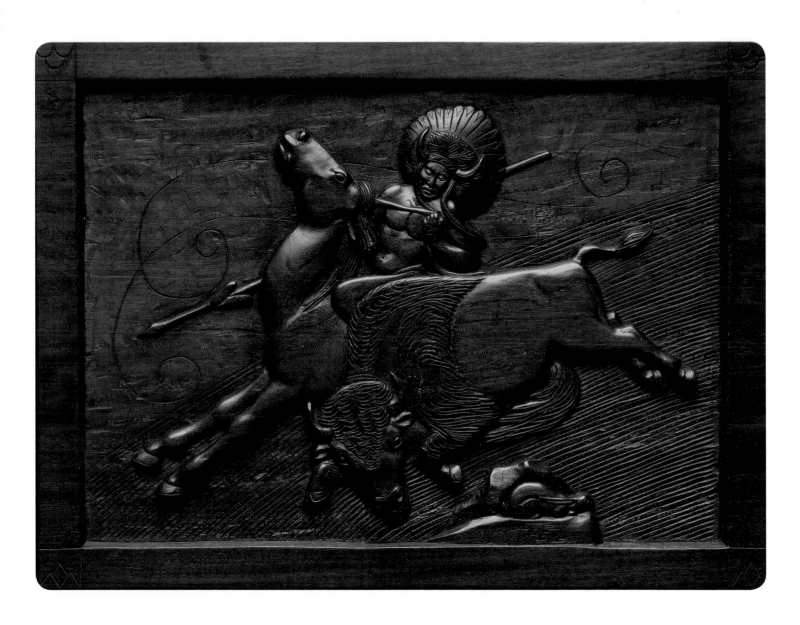

BUFFALO HUNT, 1945.

WALNUT, 14 X 1 X 19.

GM 1127.11

MUSTANGS IN DEAD HEAT, 1981.

SASSAFRAS ON WALNUT,

18.5 X 57 X 2.

WILLARD STONE MUSEUM, LOCUST

GROVE, OKLAHOMA

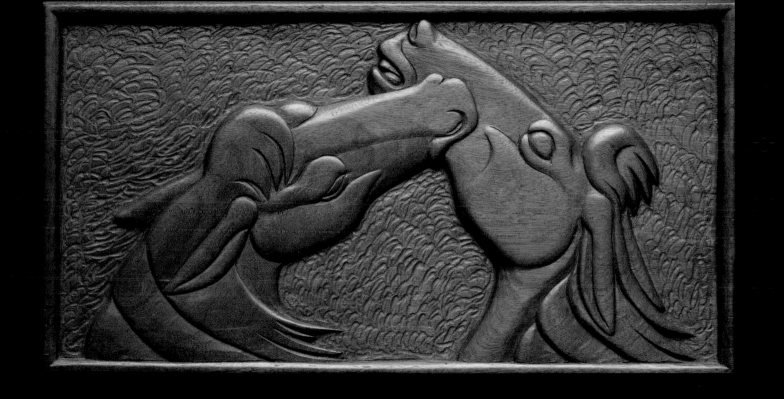

HORSES FIGHTING, 1943–1948.

PHILIPPINE MAHOGANY,

11.25 X 1 X 21.25.

OVERLEAF:

THE ROBBERS, 1946.

WALNUT, 18 X 1 X 17.25.

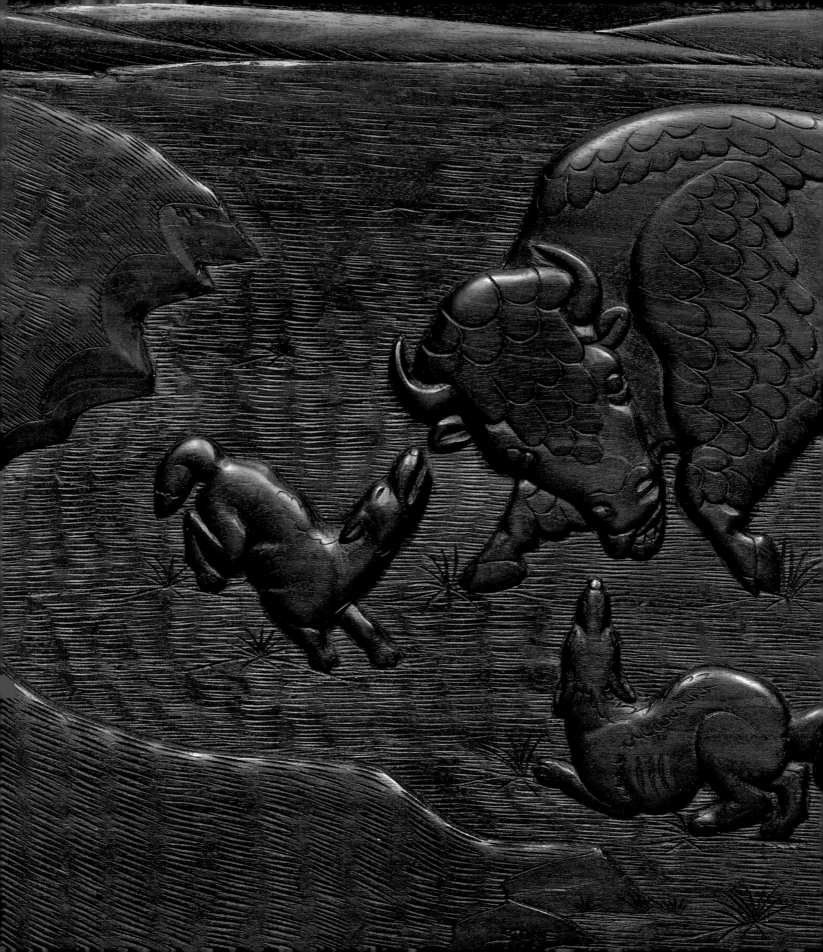

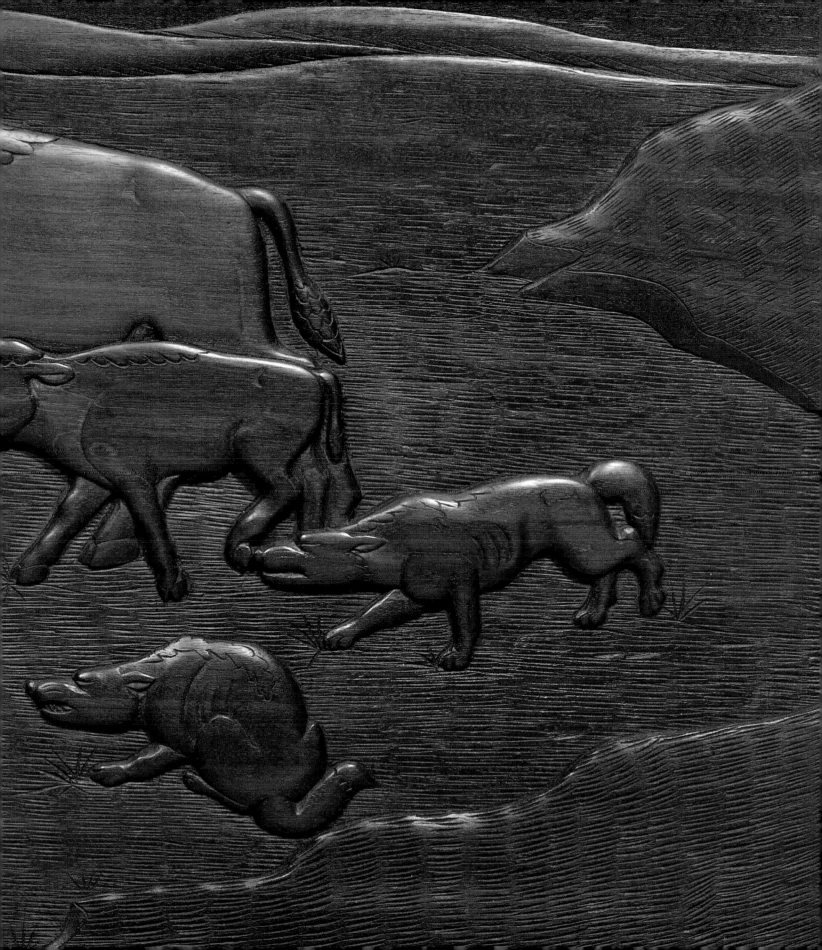

WILLARD STONE

MODERNISTIC
INDIAN GIRL,
1946. OAK,
9 X 1.75 X 2.5.
GM 1127.24

YOUNG CHIEF, 1946. OAK,
13.75 X .75 X 14.5. GM 1127.51

Overall, Stone's work is serene, with a spiritual quality reflected in flowing forms and smooth surfaces. His works are realistic but simplified and stylized. A definitive quality of his work is that it is storytelling. He not only catches the nature of his subject but tells a story in the process. Early works are rougher cut, with faceted surfaces that reveal knife and chisel marks. As time evolved the artist's technique, the works became more refined, more graceful, and the surfaces smoother.

> I try to get a piece as smooth and as simple as I can, expressing an idea with a limited amount of detail. I feel that a piece should say something, get a point of view across, or I am not interested in doing it at all. That's why I draw my ideas first on paper. First comes the thought, maybe politics, religion, current events, world affairs, or whatever . . . I turn it over in my mind until I tell a story in a piece of wood.

In the final finishing of his works Stone revealed the deep richness of his material. After the sanding was done, he rubbed the carvings with linseed oil, polishing the wood with his hands, caressing every curve with the love of an artist for his medium. In this final treatment of surface, he leaves evidence of the respect he held for wood and for the craft of carving. Writing to Thomas Gilcrease in 1945, Stone said, "I never could talk. And if my work won't speak for itself, then I guess I will always be silent."

Fortunately, Willard Stone found his voice in the trees of a land precious to him, lived out his love affair with wood, and left carvings that speak volumes.

WATERMELON THIEF,
1946. CHERRY,
4.25 X 3.25 X 24.25.
GM 1127.57

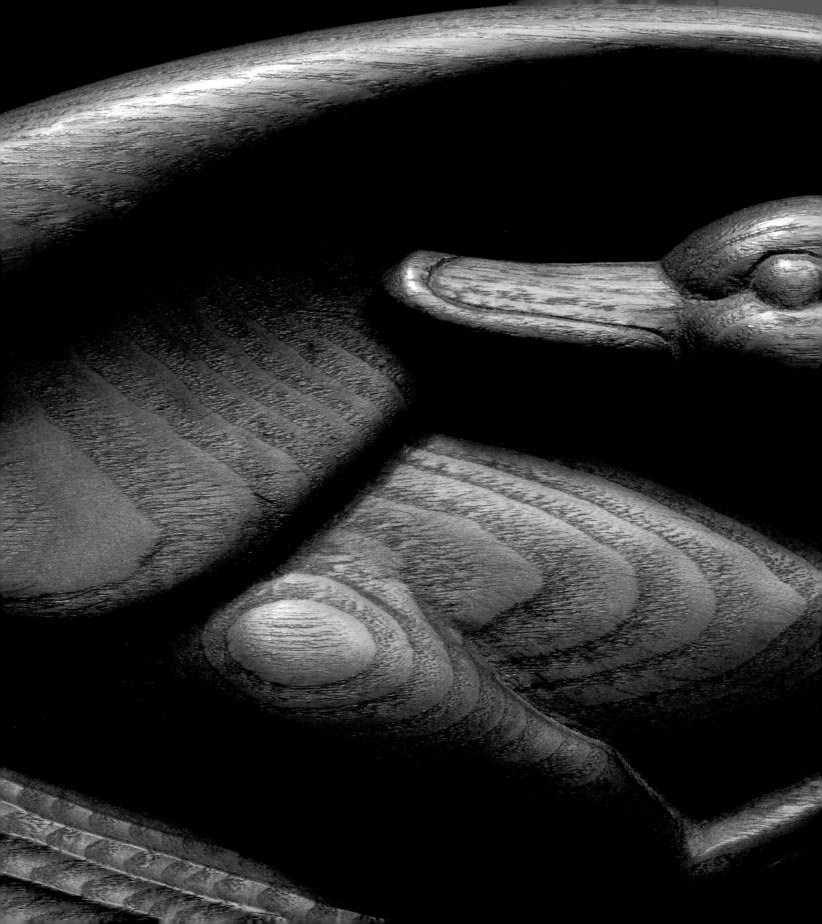

Nature: A Carver's Muse

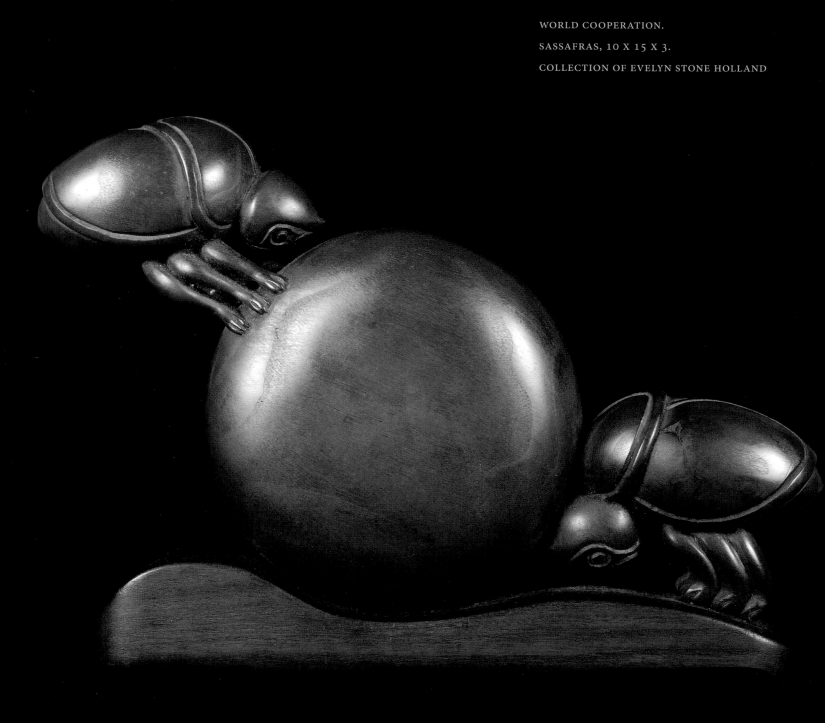

WORLD COOPERATION.

SASSAFRAS, 10 X 15 X 3.

COLLECTION OF EVELYN STONE HOLLAND

"Nature balances itself—everything plays a part."

The word *nature,* derived from the Latin word "natura," means "the course of things, or natural character." In another context it refers to the larger world of living things. Artist Willard Stone would bring these meanings together in a lifetime of woodcarving. The natural world was his primary source of inspiration; through his profound curiosity, he developed an intimate knowledge of the intrinsic character of plants, animals and people.

With affection and reverence, he would come to understand the "course of things" and artfully acquire what artist Robert Henri calls a sense of "the persistent life force back of things which makes the eye see and the hand move…"

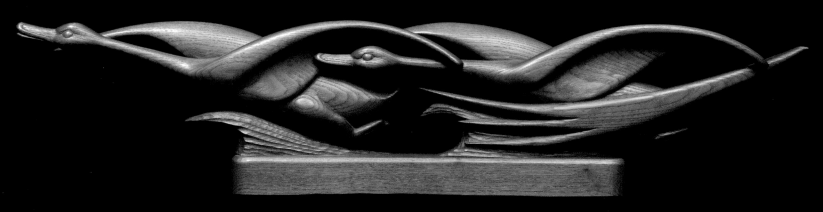

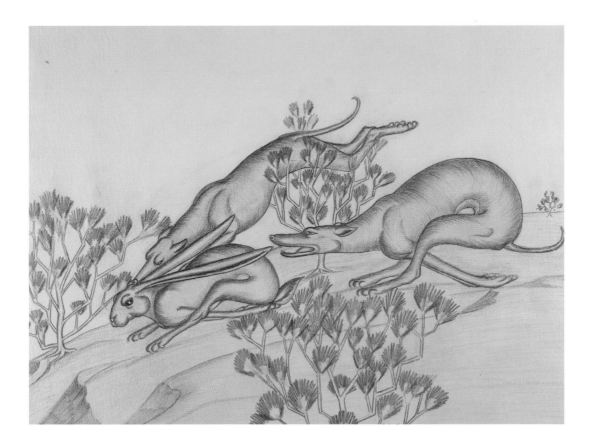

THE STRETCH.

PENCIL ON PAPER, 20 X 26.

GM 1327.340

FACING:

FOLLOW THE WIND, 1964.

SASSAFRAS, 7.25 X 3 X 35.

NATIONAL COWBOY AND

WESTERN HERITAGE MUSEUM,

OKLAHOMA CITY

As a boy living with his family in the rural northeastern Oklahoma town of Oktaha, Willard spent much time hunting, fishing, and observing the activities of birds, rabbits, snakes, squirrels, fish, and many other creatures that would become the subjects of his carvings. After an accident at age thirteen in which he lost segments of two fingers and the thumb of his right hand, he discovered that even though he could no longer draw or paint, he could mold little animal figures out of wet clay scooped from ditches near his home. His desire to shape nature's myriad forms eventually led him to discover that wood's warmth was more exciting to his sculptor's sense than clay. He could extract the excess from a block of wood and bring to life the ideas he saw within it. So, inspired by nature, Stone carved animals and people, representing fertility, reproduction, motherhood, and the seasons. He carved his philosophy of life into his work, creating stories in wood that glowed with the universal truth of folklore and resonated with his own personality.

In 1945–46, Willard bought land near Locust Grove and built a home in the midst of trees that for years to come would provide much of the wood he carved, particularly walnut, cherry, sassafras, and cedar. Through country living he experienced nature every day, drawing from its abundance and remaining close to

the earth and to living creatures. He read nature's signs regarding the seasons, once commenting that spring was just around the corner according to the sap of the walnut tree. He would talk to the animals, and one even joined him in his studio. A peacock named George wandered in and out at will.

George comes in here regularly and each time he takes a complete look around before he gets very far into the room to see if anything new has been added or if anything is out of place. Sometimes I put a mirror down for him to look at. But he is so smart and curious that he goes around behind it after a while and then comes back to the front trying to figure out why he can't see himself from both sides. When he gets tired, he just plops down on the floor and goes to sleep—he even snores. When I'm carving he watches the chips fall for a while and then comes right up on the work bench for a better look.

FACING: TREE DOG. TORCH-BURNED CHERRY AND UNBURNED CHERRY, 13.75 X 5.125 X 3.75. GM 1127.71

TURTLE. WOOD, 2 X 3.5 X 3. WILLARD STONE MUSEUM, LOCUST GROVE, OKLAHOMA

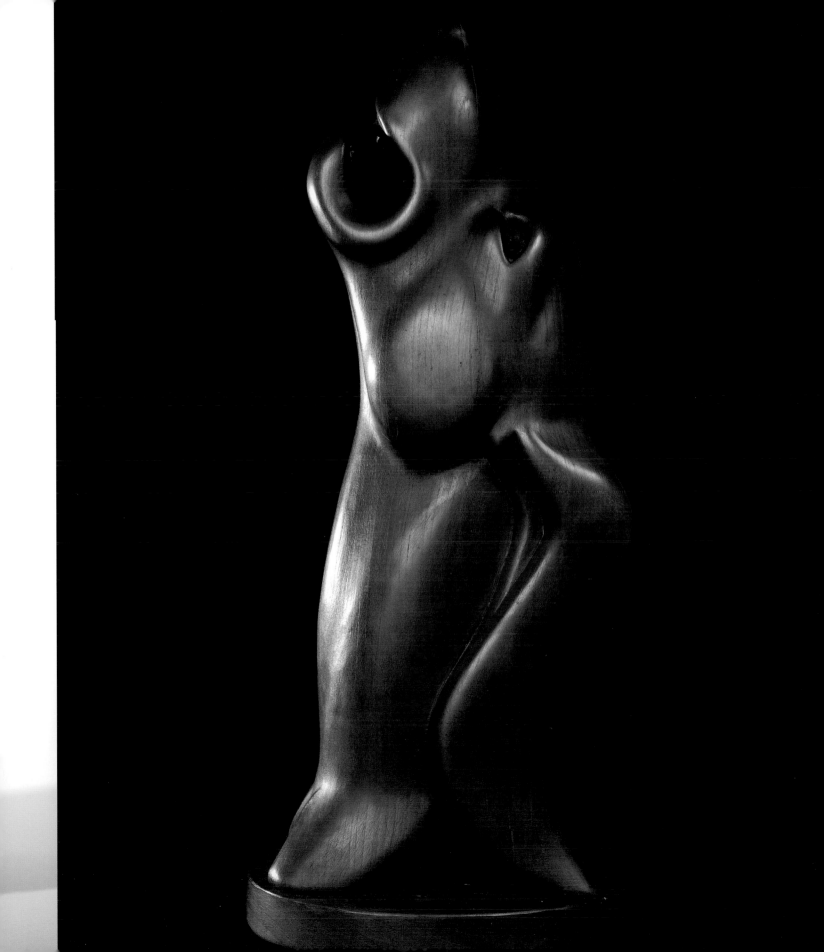

Activities for the Stone family centered around planting, cultivating crops, and caring for a menagerie of animals, including goats, chickens, a horse named Sugar, and orphaned baby opossums that his daughter brought home to raise. Willard always told his children that they were to take care of the "Good Earth." He was a devoted family man; his creative ideas grew out of watching his family as well as the seasons of the "Good Earth" and its inhabitants.

Quietly and attentively Stone connected with the pulse of life beneath appearances. He expressed some of his thoughts about the character of different animals in correspondence with Thomas Gilcrease. Intrigued by a movement peculiar to the garfish, he writes: "Sometimes the Garfish will maneuver like this in the water. He does this so fast that it looks almost like a continuous curved line…"

He notes on his sketch for *Pregnant Jackrabbit:* "She is the kind who, near oat cutting time, are too heavy with young to run fast. So she will run to a safe distance then sit straight up and watch for your approach."

PREGNANT JACKRABBIT.
OKLAHOMA CEDAR,
21 X 2 X 2. GM 1127.69

LETTER CONTAINING
A DRAWING OF PREGNANT
JACKRABBIT. GM 3827.7831

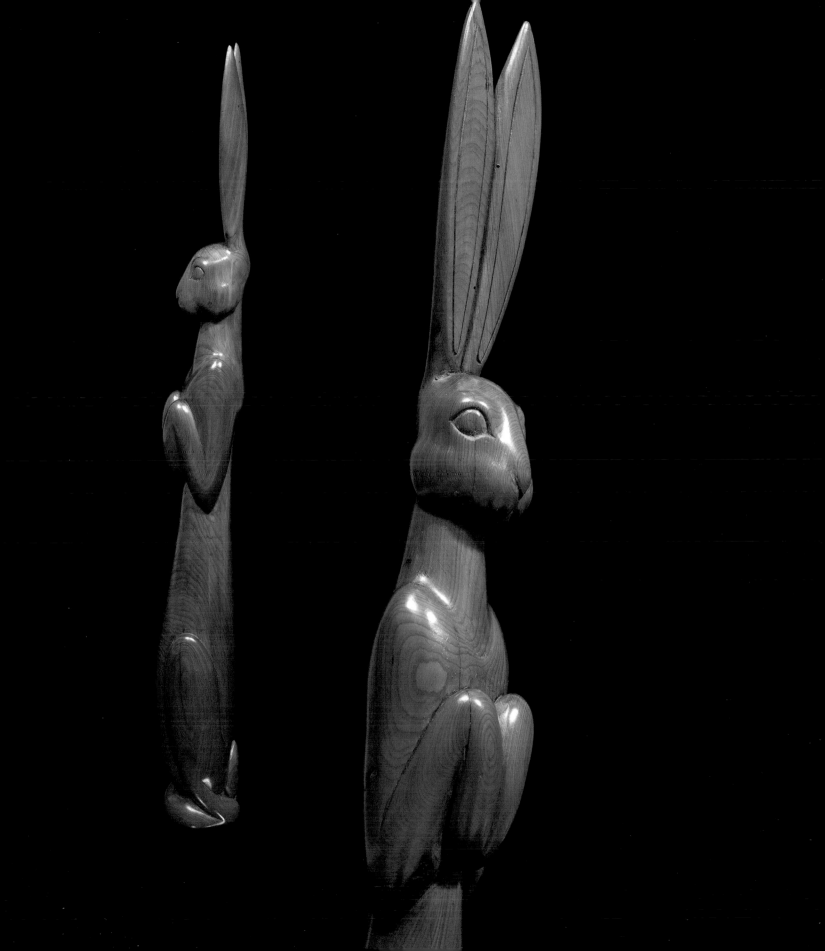

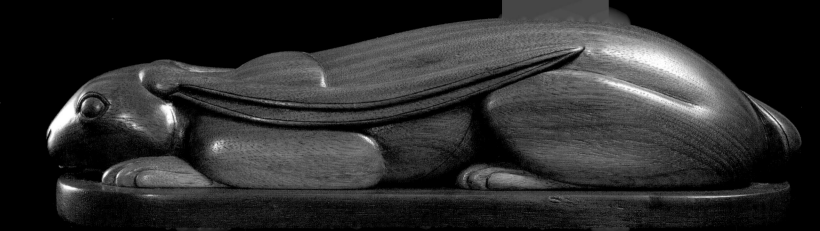

Stone sought to characterize the qualities he saw in the nature of each animal, perceiving them as personalities while subtly alluding to parallels in human behavior. Referring to *The Mighty Colt,* he speaks of pride: "I hope to catch the personality of the colt when he stands out from his mother and acts as if he owned the whole world and was lord of the universe."

The low-lying posture of *Tense Jackrabbit* personifies stealth, as the rabbit tries not to be seen. His readiness to spring into action if he is discovered is seen in the smooth, powerful haunches and the close position of the head and front feet: "That jack rabbit is lying in the grass hiding. He won't move a muscle until his eye meets yours. Then he knows he's been seen, and he takes off in a great leap." *The Mustang* represents "a rather wild natured mustang who has run down a sloping hill and has paused in the act of jumping a gully at the end of the shape. It is this pause that I have tried to catch."

WILLARD STONE WITH
TENSE JACKRABBIT. COURTESY
OF WILLARD STONE MUSEUM.

THE MIGHTY COLT.
MAPLE, 24.25 X 4 X 3.5.
GM 1127.68

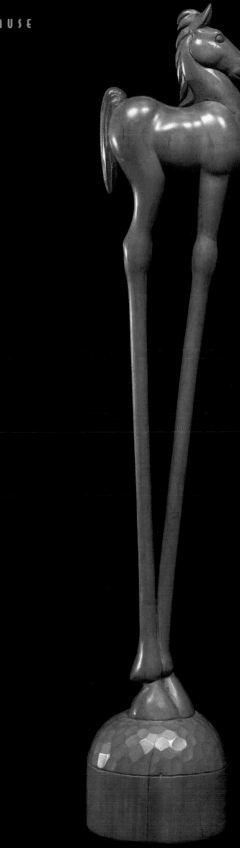

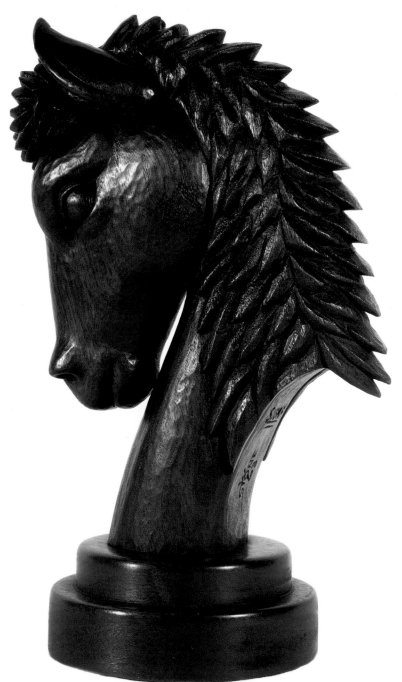

SUGAR, 1964.
WALNUT, 12 X 6 X 5.
WILLARD STONE MUSEUM,
LOCUST GROVE, OKLAHOMA

FACING: THE MUSTANG, 1946.
WOOD, 8.5 X 4 X 11.25.
GM 1127.25

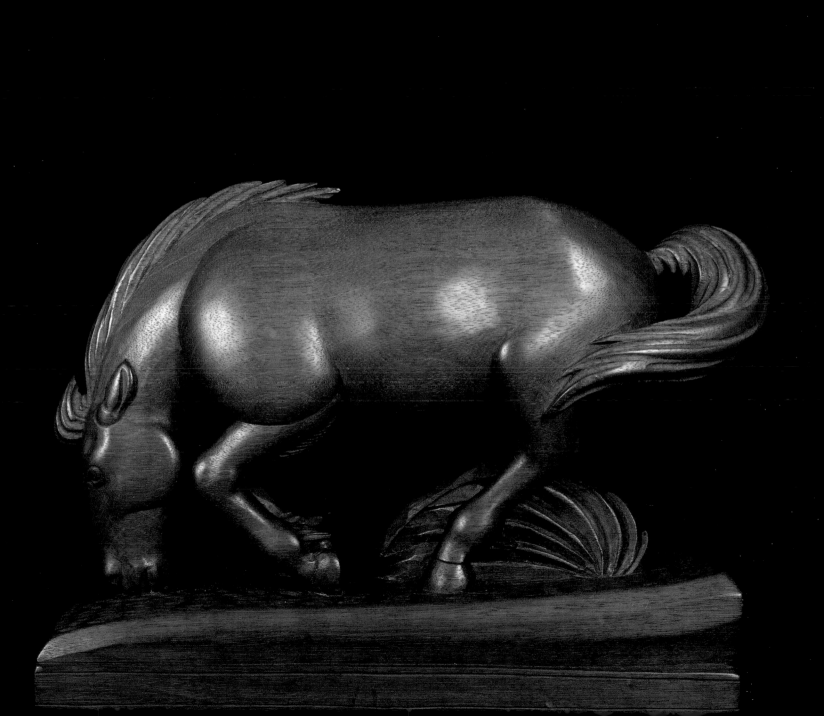

A group of fish moves upstream to spawn in *The Road Back.* Their energy ripples forward in a unified upward movement, the repeated forms of the fish creating a flowing continuity.

Stone's distillation of form from the dynamics of animal motion demonstrates close study of the natural world. His knowledge of animal anatomy is evident, though he stylizes and stretches forms. It is, however, his ability to characterize and symbolize that reveals how closely he observed the subtlest animal action. A family member recalls that he spent hours one day watching beetles roll a ball of dung. The resulting *World Cooperation* (page 72) depicts the two dung beetles rolling a ball that represents Earth itself. Stone took the opportunity to put a political spin on a subject which certainly grew out of nature. Whether grounded or airborne, Stone's animals, both in character and stance, are authentically personified in the shape and arrangement of his forms. Whereas the dung beetles and the mustang are anchored to earth, *Follow the Wind* (page 74) is delicate, horizontal, and airy, simulating flight. *Rhythm in Action* (overleaf) evokes the joy of speed with the sinuous horizontal lines of racing greyhounds. *Prairie Song* and *Howling Coyote,* tall and elongated forms with heads thrown back, practically make audible distant howls.

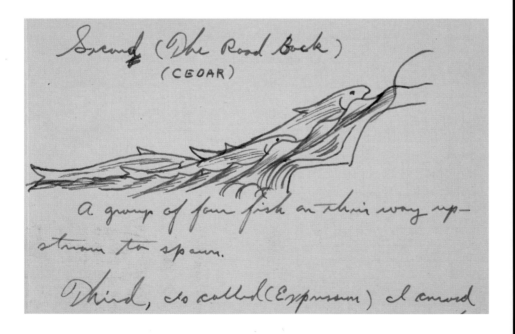

THE ROAD BACK (TOP VIEW AT
TOP, SIDE VIEW TO RIGHT).
OKLAHOMA CEDAR,
7.5 X 2 X 18. GM 1127.66

LETTER CONTAINING A
DRAWING OF THE ROAD BACK.
GM 3827.7831

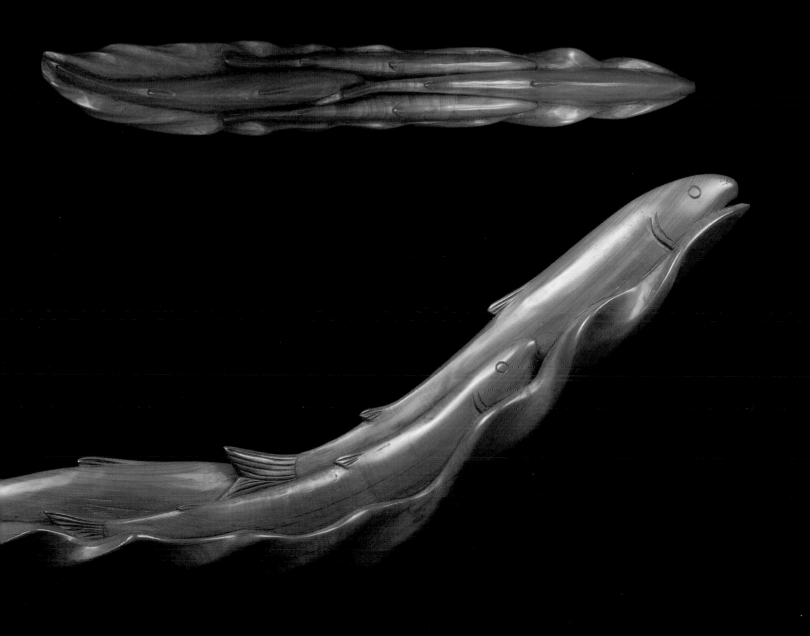

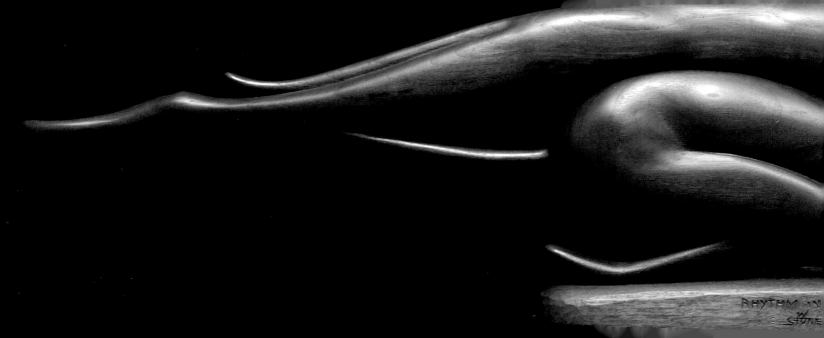

RHYTHM AN
w
STONE

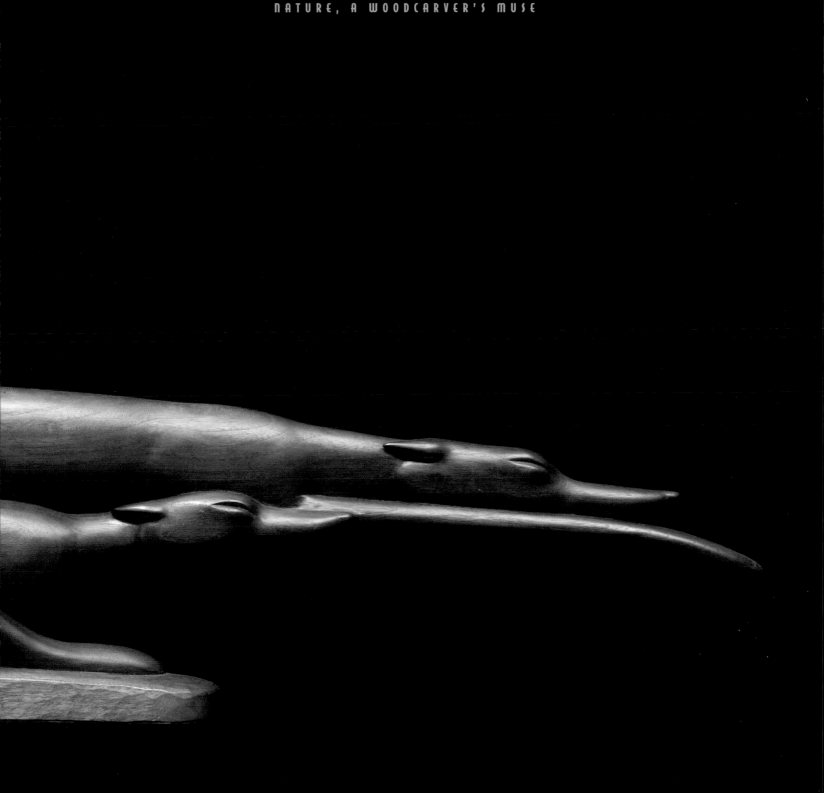

Stone's compositions suggest the inherent balance of nature with symmetry as a powerful element. The large plaque *Buffalo Hunt* has a central focal point and mirrored halves. *The Good Earth* exhibits symmetry with a central focal point, the halves not mirrored but equally balanced. This work expresses Stone's message to his children to "take care of the Good Earth," with its larger animals looking down upon smaller ones in peaceful harmony. All Stone's carvings reveal a pleasing distribution of weight that reflects the stability and harmony he saw in nature "Nature balances itself," said Stone, "everything plays its part." In *Part of Creation* the pumpkin vine, its male and female blossoms, and the pollinating bees are as intricately woven in the composition as they are significantly connected in nature itself, one depending upon the other.

PART OF CREATION, 1962.
SASSAFRAS, 10.5 X 4 X 20.5.
NATIONAL COWBOY AND
WESTERN HERITAGE MUSEUM,
OKLAHOMA CITY

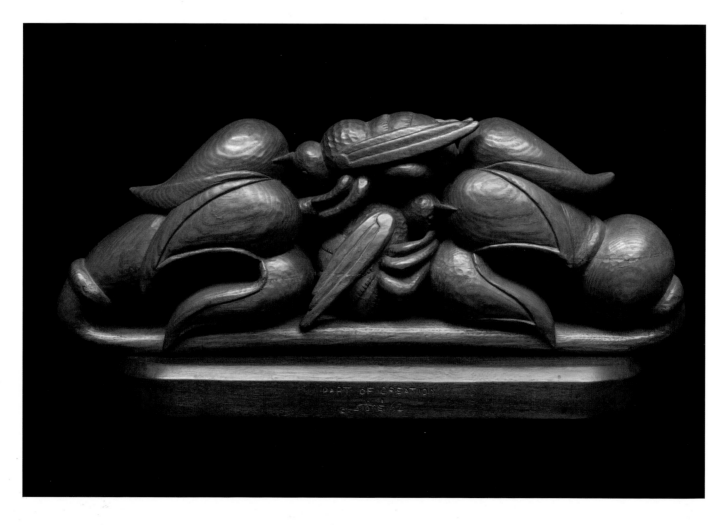

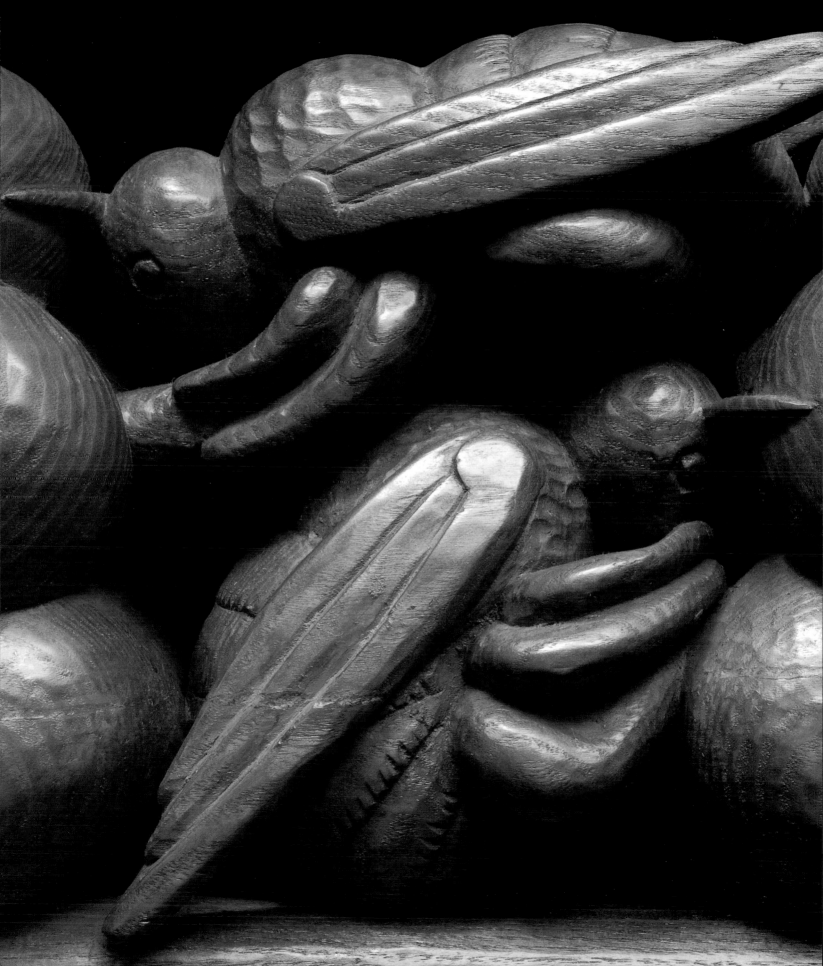

THE GOOD EARTH, 1972.

CHERRY AND WALNUT, 27 X 80 X 2.5.

COLLECTION OF GEORGE

AND GINNY KREITMEYER

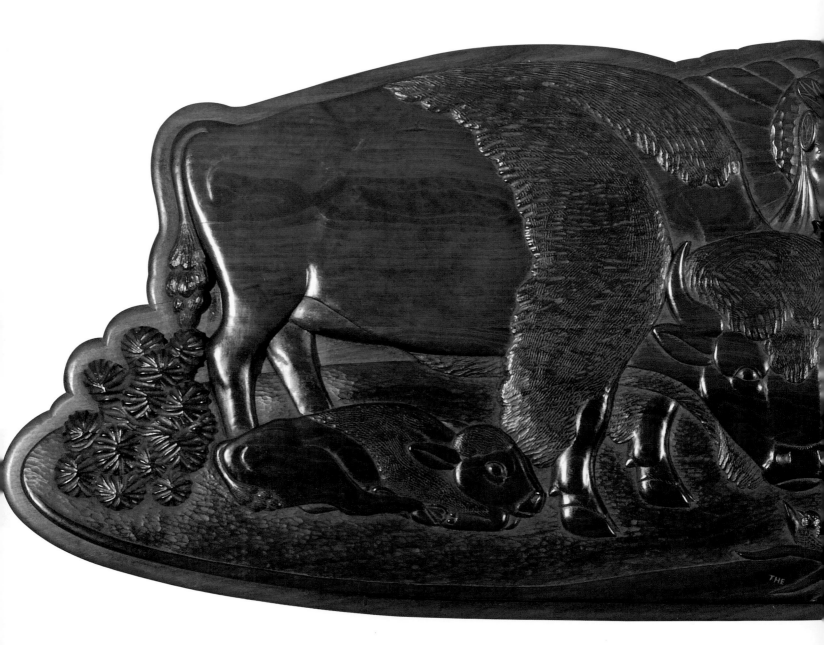

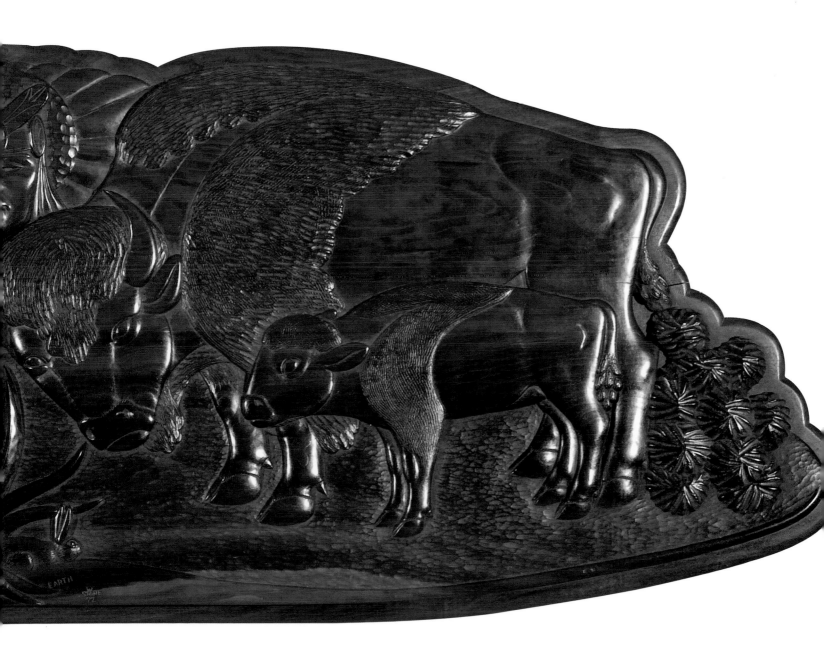

THE GUARDIAN.

WOOD, 15 X 1 X 47.

COLLECTION OF MAXINE AND JACK ZARROW

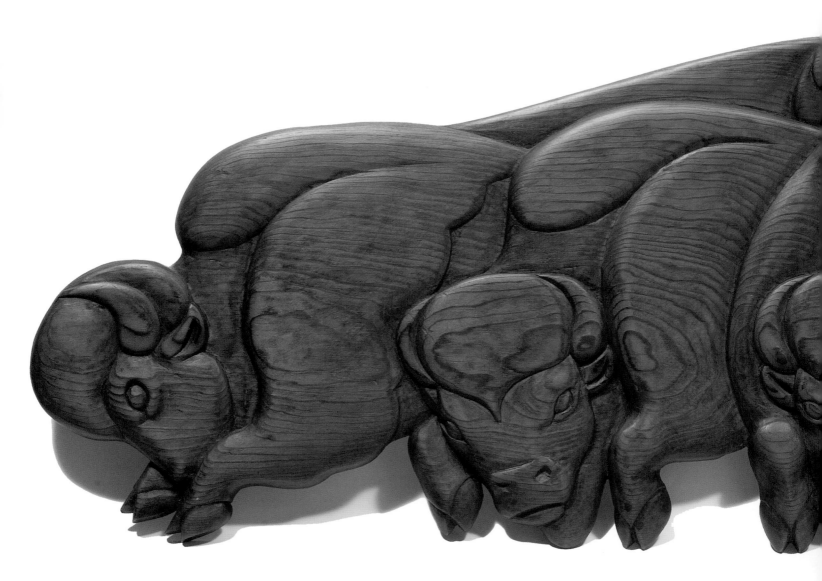

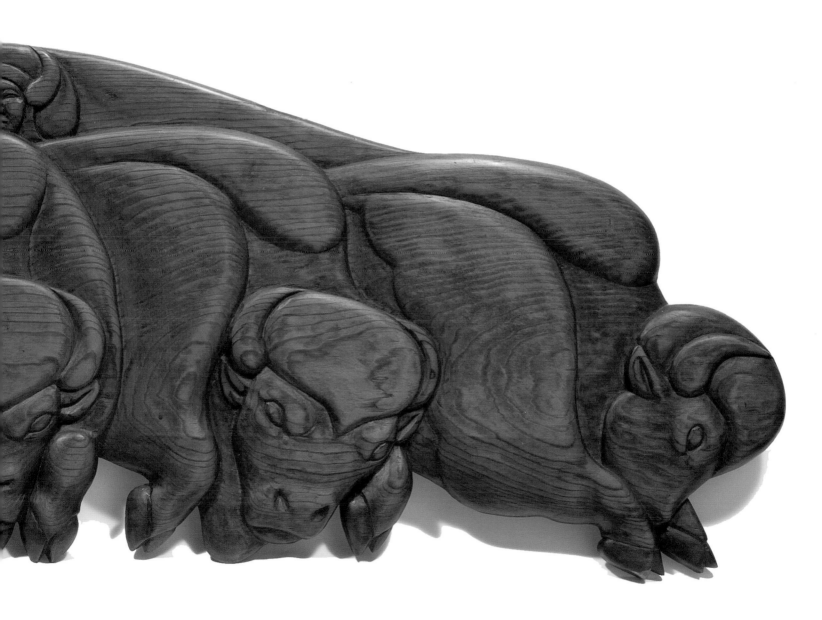

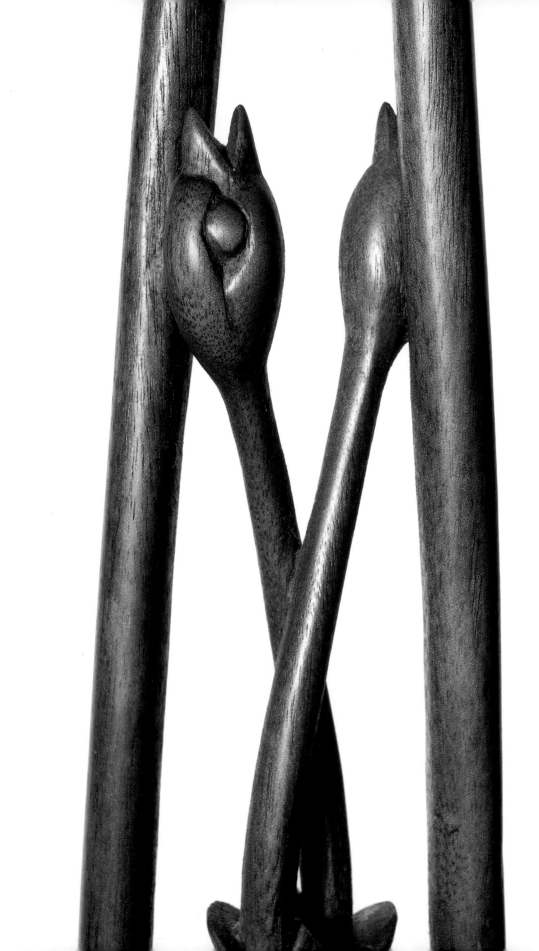

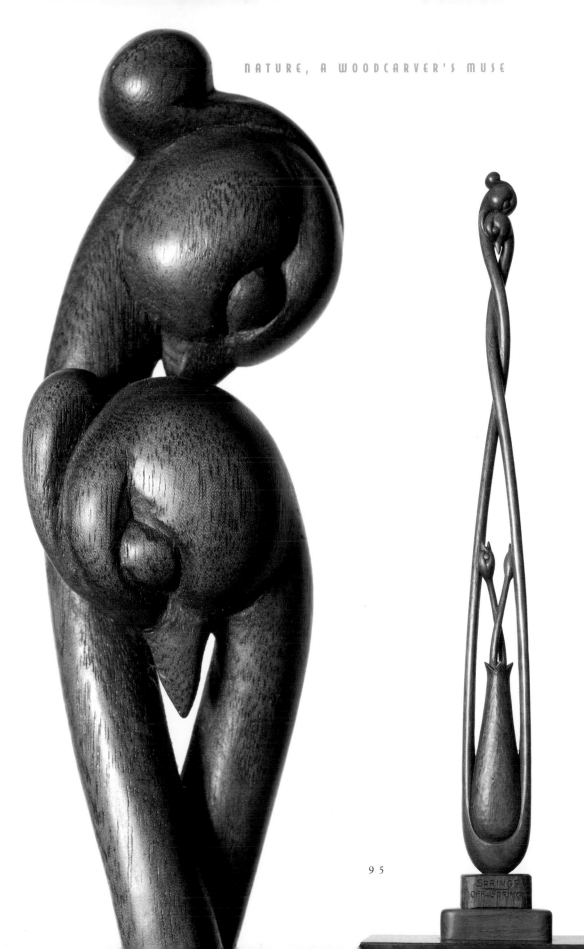

SPRING'S OFFSPRING, 1966.
WOOD, 28 X 6 X 4. FIVE
CIVILIZED TRIBES MUSEUM,
MUSKOGEE, OKLAHOMA

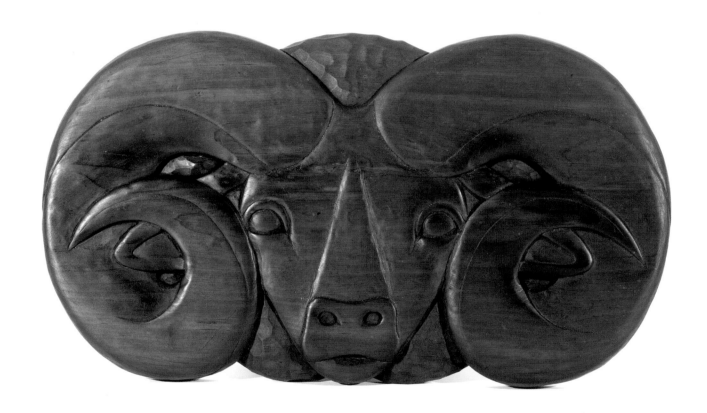

A RAM HEAD.
WOOD, 8 X 1 X 14.
WILLARD STONE MUSEUM,
LOCUST GROVE, OKLAHOMA

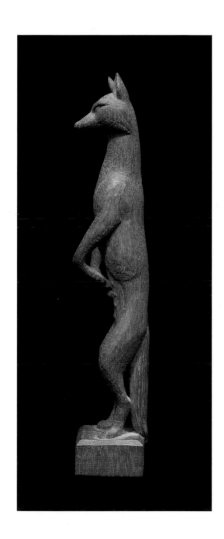
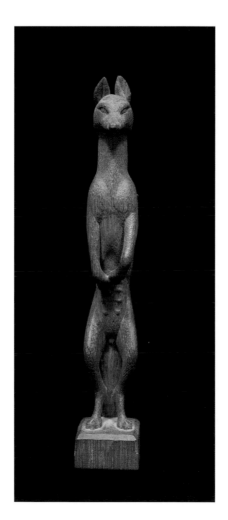
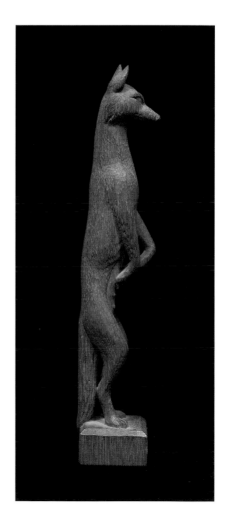

FOX, CA. 1940.

WOOD, 10.5 X 2.25 X 1.75.

COLLECTION OF GUY

AND PHYLLIS LOGSDON

The concepts of regeneration and rebirth appear repeatedly in Stone's works, emphasizing that the balance of nature insures its continuity. "In the spring, all the species live again. They get together and they reproduce themselves and there is life again after being asleep, or dead, through the winter."

With a love for symbolism, Stone expressed universal themes that transcend the regional origin of his work. He said in wood what he wanted people to know about his love of God, family, creation. He saw animals enriching the world with their presence and he in turn enriched the world by telling their stories, exposing people to the mystery that is nature. Using animals to speak about human nature, he presented his precepts in a way that allowed people to see themselves, including the occasional error of their ways, and the humor in the absurd dichotomies of life. Whether his theme was love, war, or springtime, his work is infused with a sense that nature is sacred and life is to be treasured. *Lady of Spring,* according to Stone, "is dedicated to all the flowers of nature, who in the springtime, blossom out to show their appreciation to God for the right given them to live." In fact, *Lady of Spring* stands as a pinnacle of Stone's awe for the natural world and the powerful inspiration it gave him. The figure of the woman bursting forth from the bud of life can be seen as symbolic for the whole of nature as he portrayed it—a vital, cyclical force. His understanding is carved into the very forms—organic, smooth forms growing out one from the other, representing life's beginning, growth, and harmony— themes that run through his collective body of work.

In a world of ever-expanding technology, at a time when people are increasingly removed from nature, Willard Stone's carvings provide a connection to the elemental, eternal rhythms that form the foundation of life. He reminds people of roots, of time past, of the living present, and of the future. For a farm boy from a small Oklahoma town, he understood well the course of things and saw in the natural world an order that he made manifest in the fluid, rhythmic, lyrical forms of his carvings.

LETTER CONTAINING A
DRAWING OF LADY OF SPRING.
GM 3827.7827.1

FACING: LADY OF SPRING.
WALNUT, 27.75 X 4.5 X 4.75.
GM 1127.76

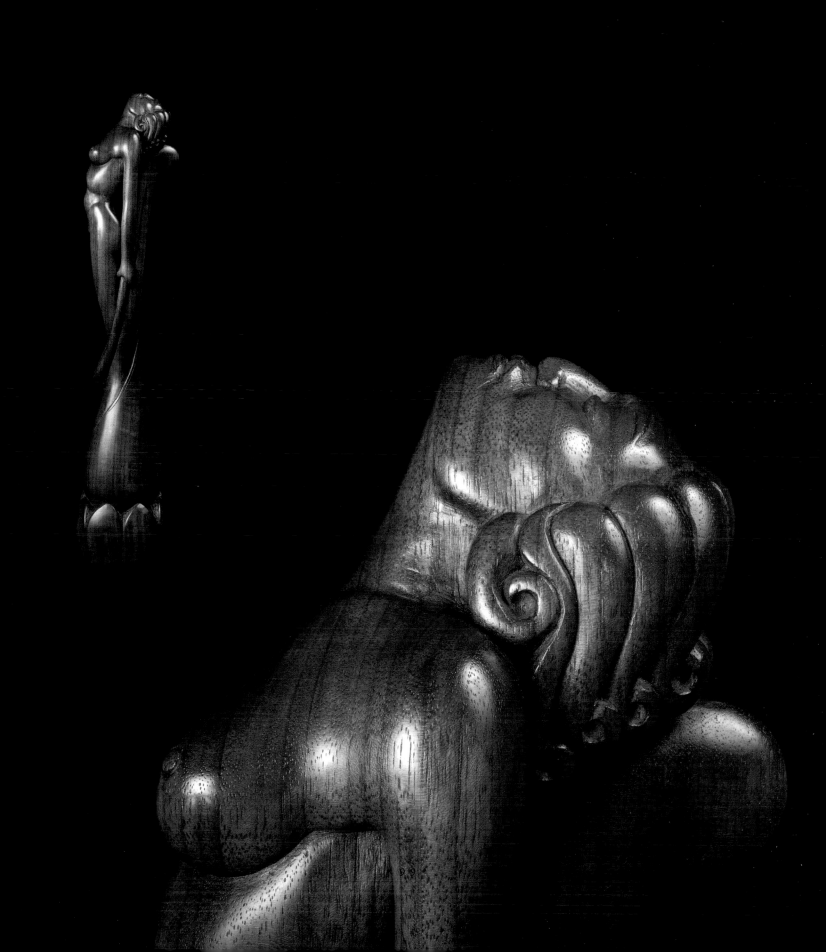

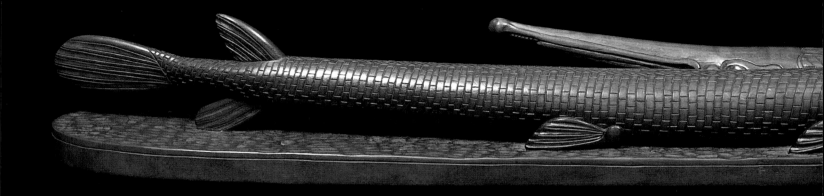

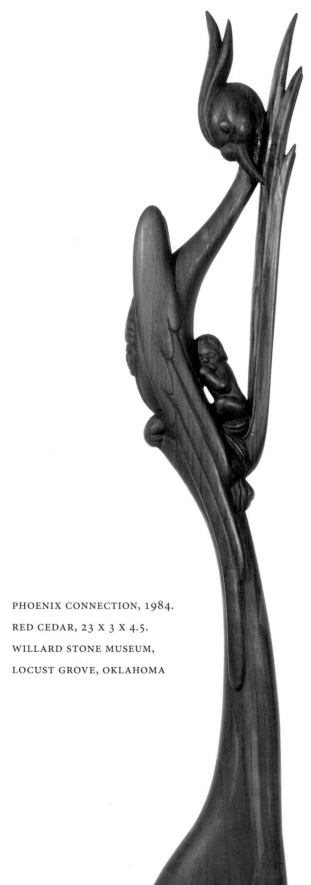

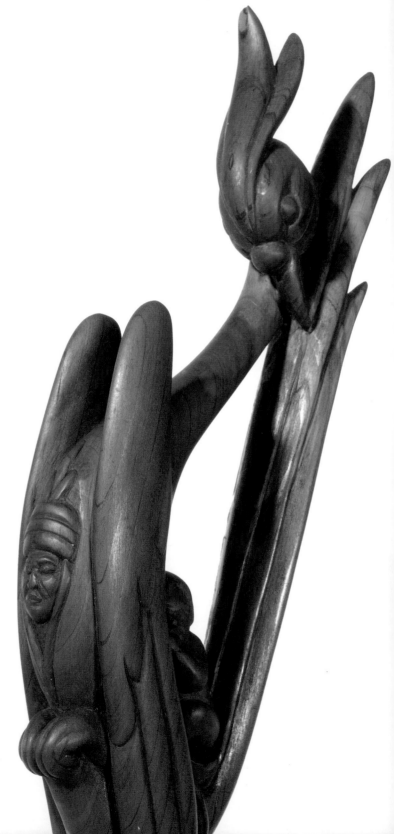

PHOENIX CONNECTION, 1984.
RED CEDAR, 23 X 3 X 4.5.
WILLARD STONE MUSEUM,
LOCUST GROVE, OKLAHOMA

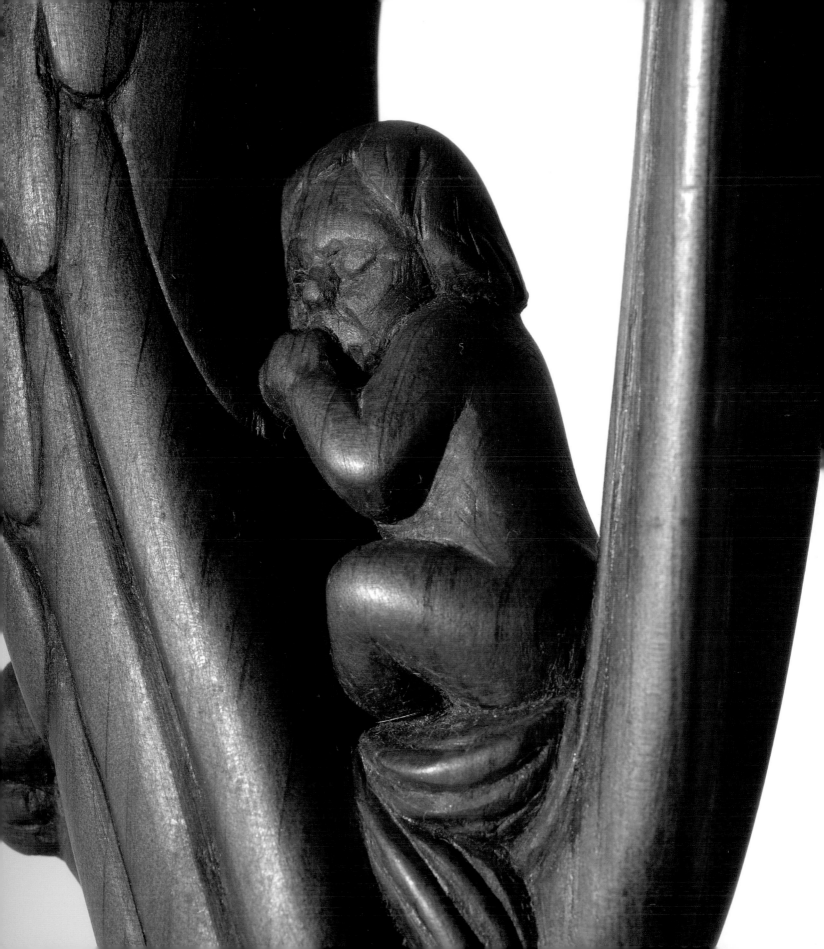

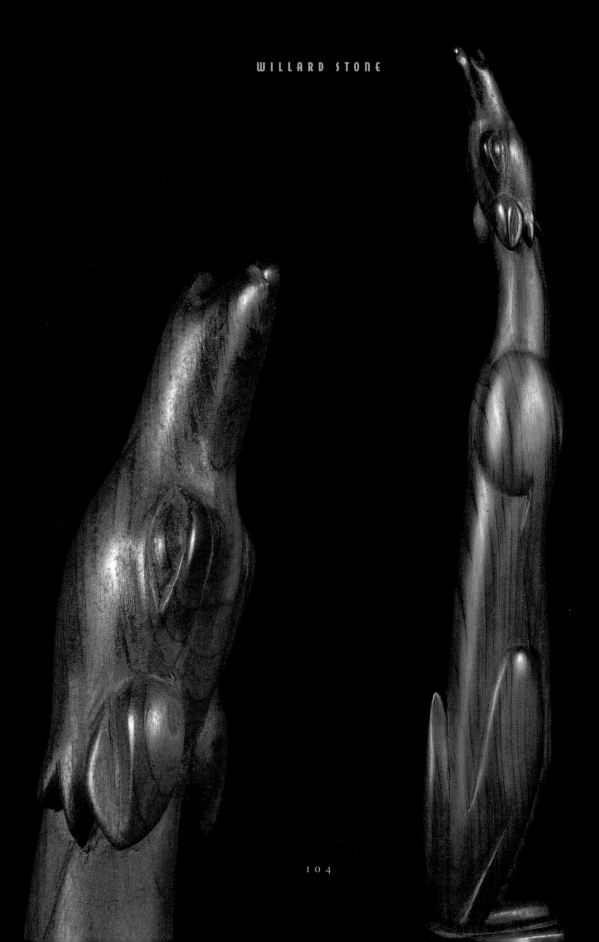

BALANCE OF NATURE, 1964.
WOOD, 24.5 X 2 X 2.25.
NATIONAL COWBOY AND
WESTERN HERITAGE MUSEUM,
OKLAHOMA CITY

FACING: HOWLING COYOTE.
RED CEDAR, 15.5 X 2.25 X 3.
COLLECTION OF
EVELYN STONE HOLLAND

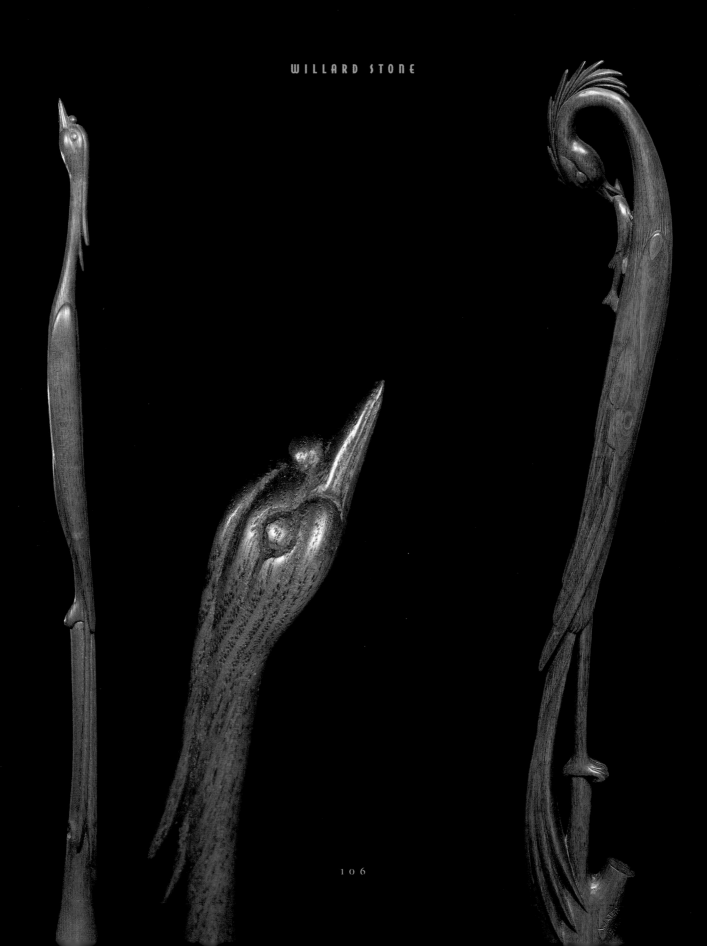

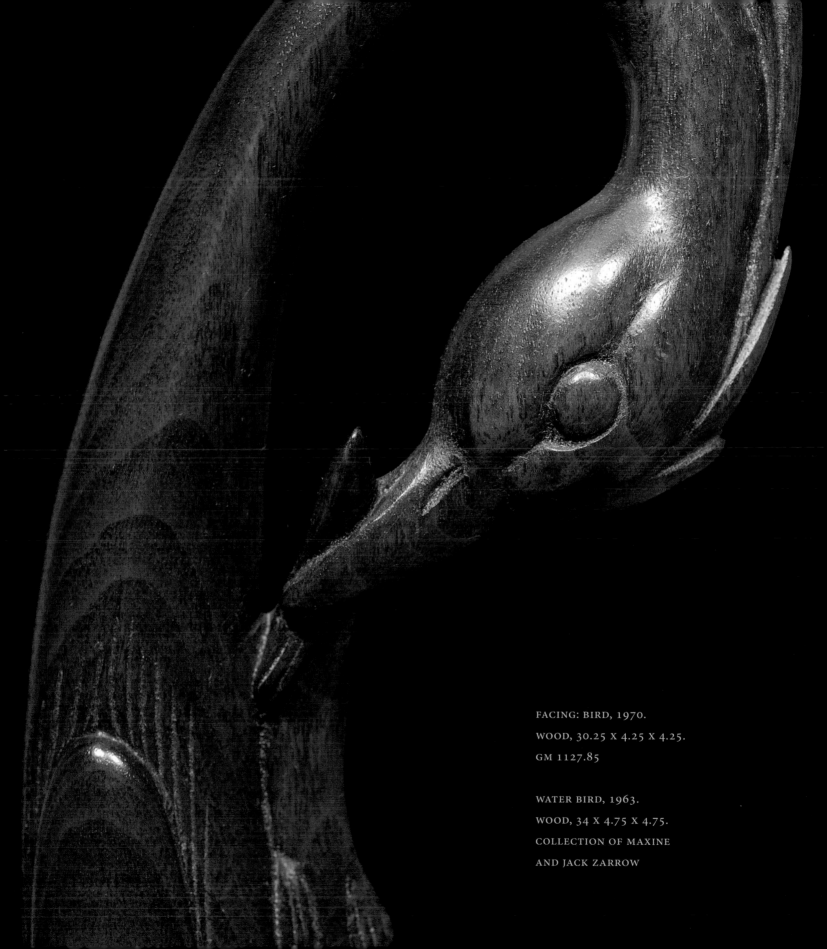

FACING: BIRD, 1970.
WOOD, 30.25 X 4.25 X 4.25.
GM 1127.85

WATER BIRD, 1963.
WOOD, 34 X 4.75 X 4.75.
COLLECTION OF MAXINE
AND JACK ZARROW

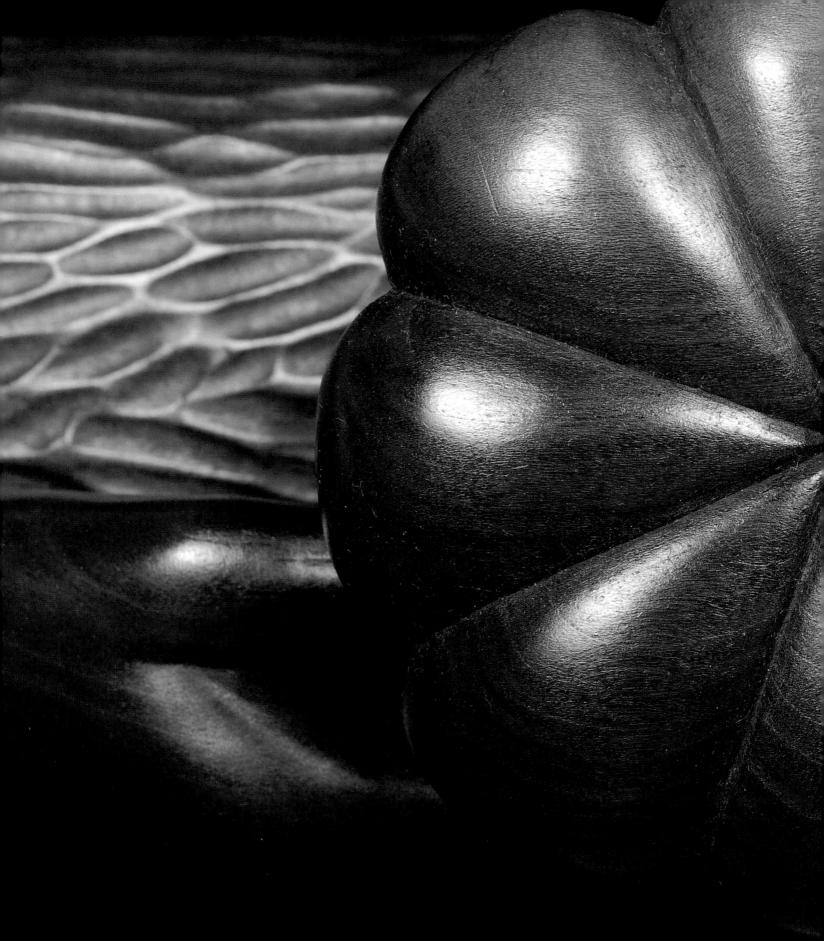

Of War and Peace

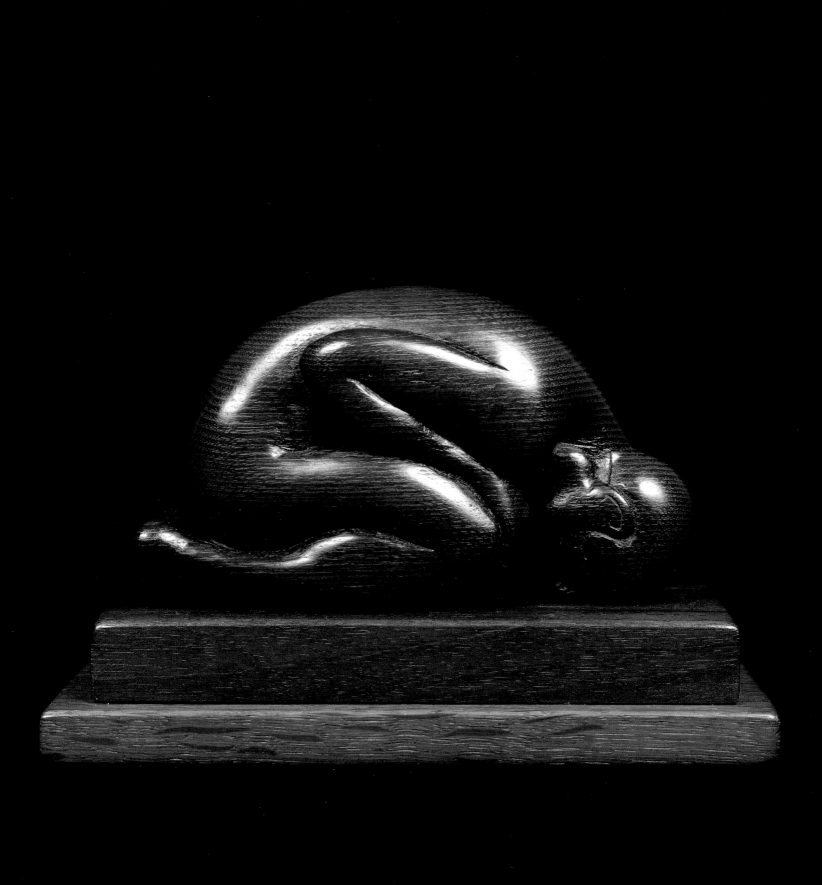

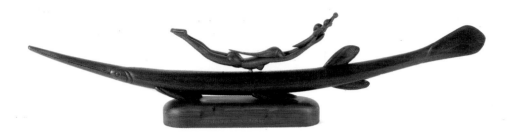

"I am going to carve what I think whether it destroys me or not, for slanted truth becomes an untruth."

SURVIVAL OF THE FITTEST.
WALNUT AND SASSAFRAS
ON CEDAR, 9 X 35.5.
WILLARD STONE MUSEUM,
OCUST GROVE, OKLAHOMA

THE JAP PRISONER.
BOIS D'ARC, 4.25 X 2.75 X
6.125. GM 1127.9

With its powerful lines and evocative Art Deco–like grace, the sculpture of Willard Stone is a striking study in delicate strength. Its appeal, however, rests not only on elegant aesthetics but also the social commentary it often provides. Stone used sculpture to literally shape the world as he saw it, illustrating his conviction that "an artist should present the period he lives in, the things that he learns during his lifetime." Stone had much to recount and interpret—his youth in Oktaha, enduring the Great Depression, witnessing global conflicts—but it was primarily two "bothersome" topics that received attention from the sculptor: politics and religion.

These socially contentious subjects can be volatile, quick to anger and divide. Sculpture, however, allowed Stone to address them without the confrontation and insinuation of words. To the public, his work was beautiful first and narrative second. They could take from it what they chose. Politics, specifically the politics of war, became a focus for him after the onset of the Second World War. He watched

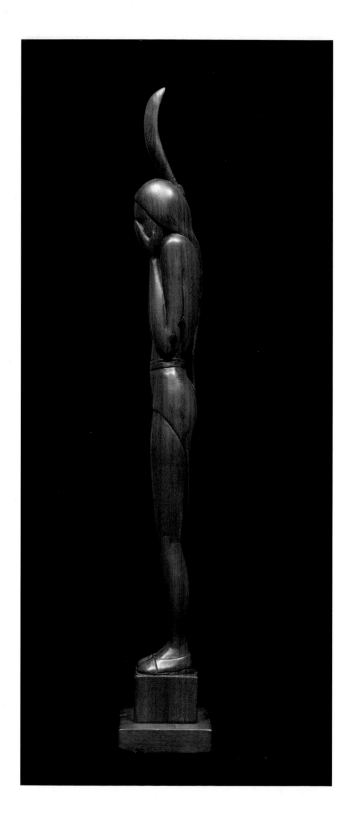

SHAME, 1946.

WALNUT, 21.5 X 3 X 3.

GM 1127.67

as the effects of war reverberated across the country, reaching even his rural community of Locust Grove, Oklahoma. Across the nation, telegrams from Western Union shattered families indiscriminately with their tragic messages. In two of his pieces Stone emphasized the emotions felt by individuals during war, particularly the sorrow of families and the humility of the defeated. *War Widows* is a lesson in loss, the widows forced to their knees by the weight of their grief. As Stone explained, "At the end of World War II, a lot of women had lost their husbands, this represents the grief they felt from the loss. The multi-figures represent the great number of grieving widows at the end of the war. The small figures are not children, but are just more wives." In *The Jap Prisoner*, Stone chose to illustrate the humility of defeat by representing the Japanese prisoners of war, saying "the subject is a man humbling himself."

WAR WIDOWS, 1946.

WILD CHERRY,

7.25 X 4.5 X 20.5.

GM 1127.56

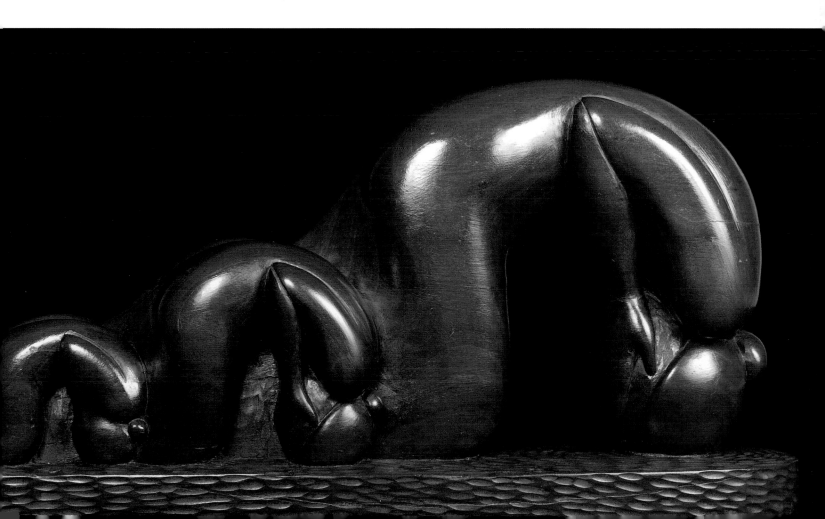

Apart from showing how war impacted individuals, Stone also concentrated on the broader themes of war. Characterized by technological advancements and scientific progress, the 1940s saw the creation of one of mankind's most advanced and most destructive inventions—the atomic bomb. Like most, Stone shared a combination of fascination and apprehension of the new weapon. In 194 he completed *Birth of Atomic Energy,* the first of three sculptures on the subject. A depiction of "science working on cracking the atom," it had two arms, symbolic of Russia and the United States, reaching towards the infamous mushroom cloud. Underneath the cloud was the figure of a nude woman, representing the seductive and alluring nature of science. Men were sometimes so preoccupied with whether or not something could be done, they did not always consider if it should be done. The same year he also finished *International Peace Effort,* an illustration of deteriorating Russian-American relations and the role atomic weaponry played in the conflict.

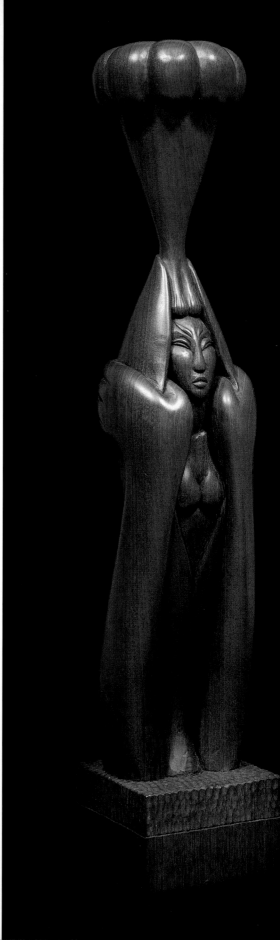

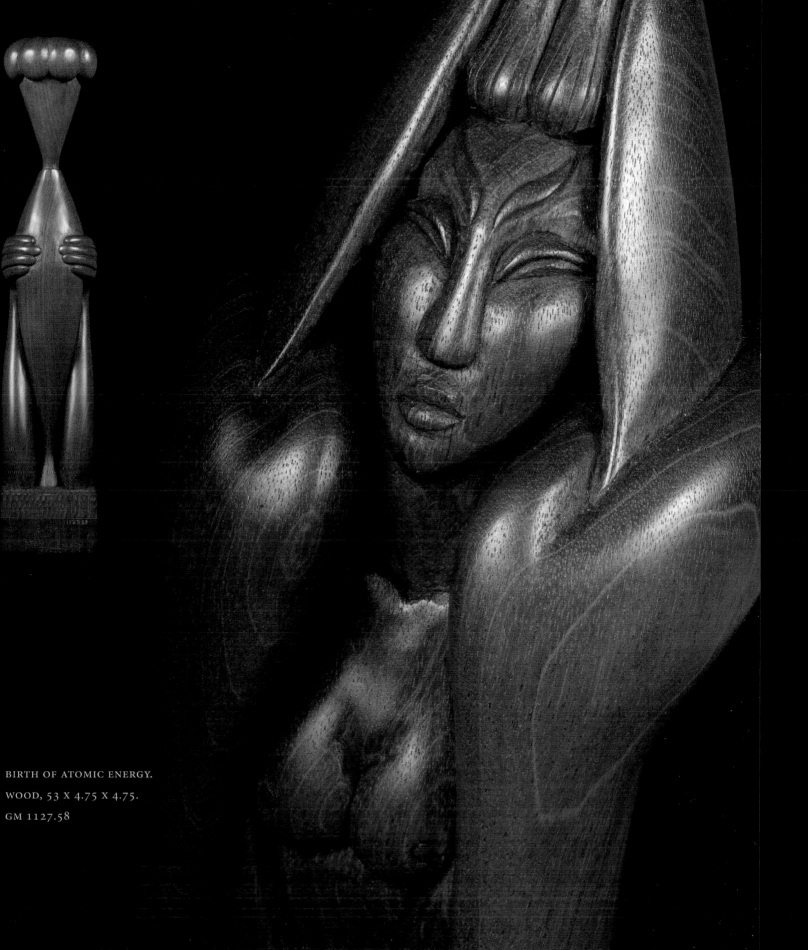

BIRTH OF ATOMIC ENERGY.

WOOD, 53 X 4.75 X 4.75.

GM 1127.58

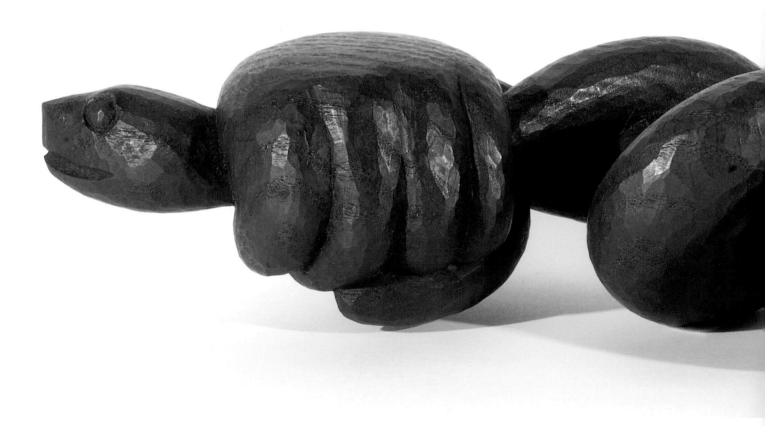

BALANCE OF POWER, 1977.
SASSAFRAS, 3 X 5 X 15.5.
WILLARD STONE MUSEUM,
LOCUST GROVE, OKLAHOMA

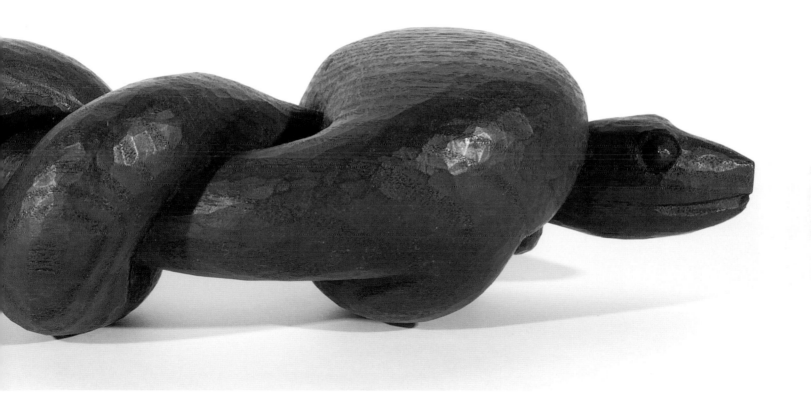

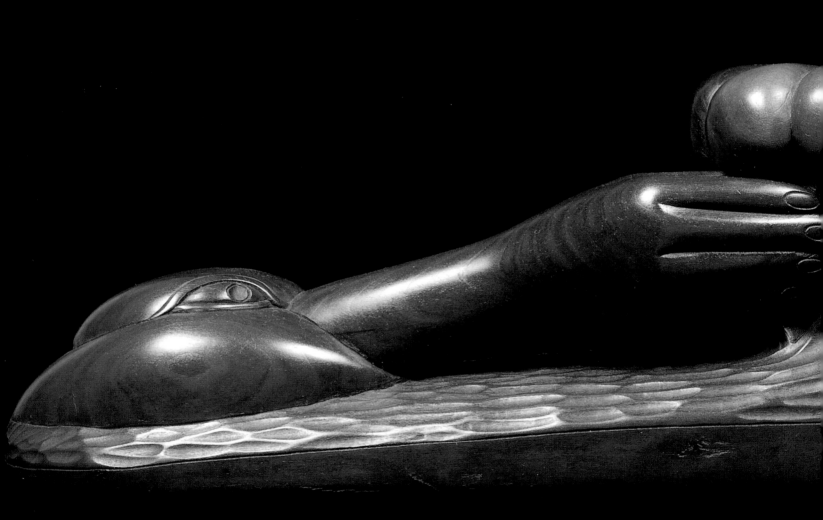

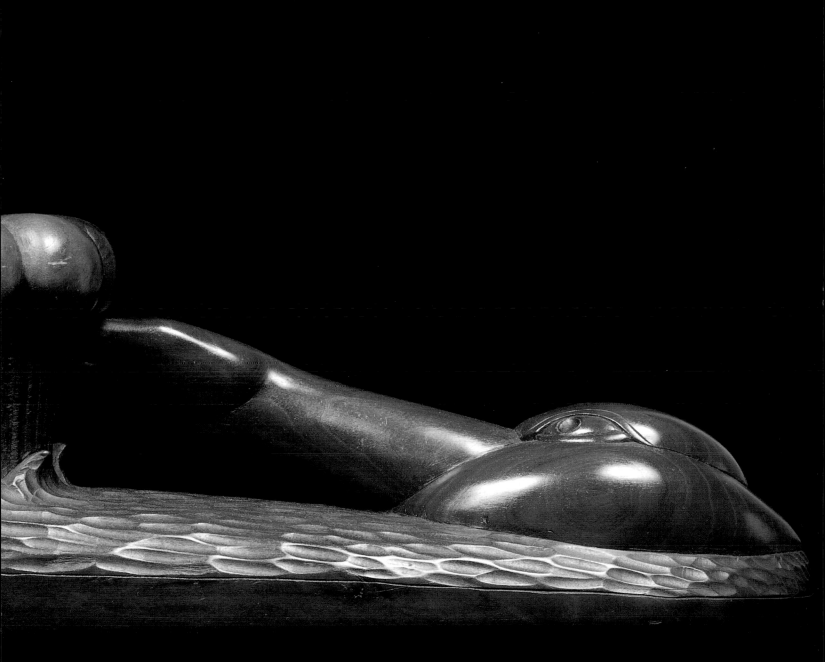

INTERNATIONAL PEACE EFFORT, 1946.

CHERRY, 5 .75 X 4.5 X 24. GM 1127.55

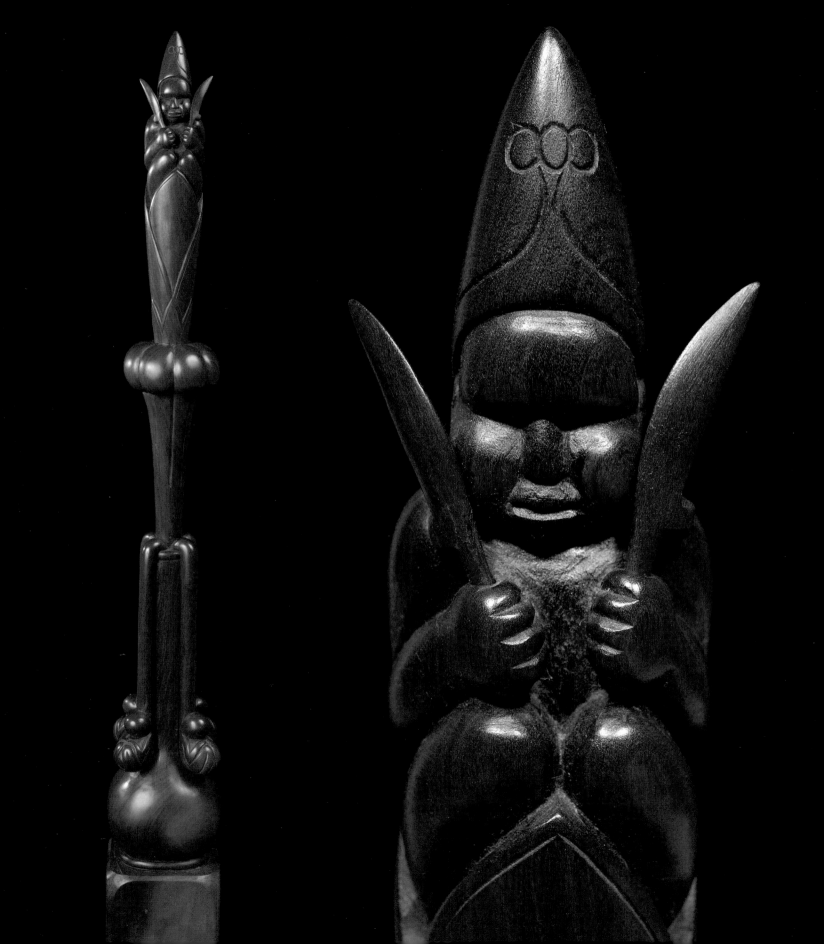

Shortly after *Birth of Atomic Energy,* Stone completed *Our Atomic Baby.* In a letter dated July 13, 1946, the artist explained to Thomas Gilcrease, "I have tried to picture, using the baby as a representative figure, the Atomic infant and how he was born." In the same letter he included a drawing with explanations of the sculpture's components, tracing the genesis of the atomic bomb from the laboratory to its completion. Tellingly, the end result is an infant holding knives. The subject's infancy corresponded to the relative youth of atomic science; the knives represented both the dangerous precedent set by the new creation and the inherent violence of its purpose. As Stone noted, "We didn't know how dangerous those atomic babies could be."

After the close of World War II men and women returned home, and within ten years the country was experiencing an economic and population boom. Unfortunately, another conflict was approaching, and in the 1960s the generation of World War II watched as fighting emerged in the jungles of Vietnam. One of the most debated and controversial engagements in United States history, the Vietnam conflict sparked division from the beginning. In 1966, Stone displayed considerable foresight when he illustrated the complexity and intricacy of United States involvement in Vietnam with *Our Viet Nam Problem.*

Roadrunners eat snakes, and this roadrunner represents the United States. No one ever caught a snake like this one. The two heads represent the Viet Nam problem. The roadrunner never should have caught a snake like that to start with.

OUR ATOMIC BABY. CHERRY,
30 X 3.75 X 3.75. GM 1127.74

LETTER CONTAINING A
DRAWING OF ATOMIC BABY.
GM 3827.7836

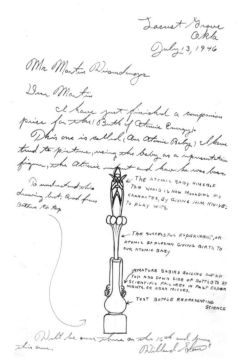

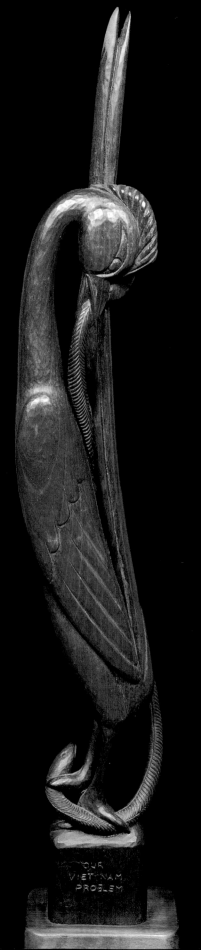

OUR VIETNAM PROBLEM, 1966.

WOOD, 26 X 3 X 4.5.

COLLECTION OF PAT AND PATTI LESTER

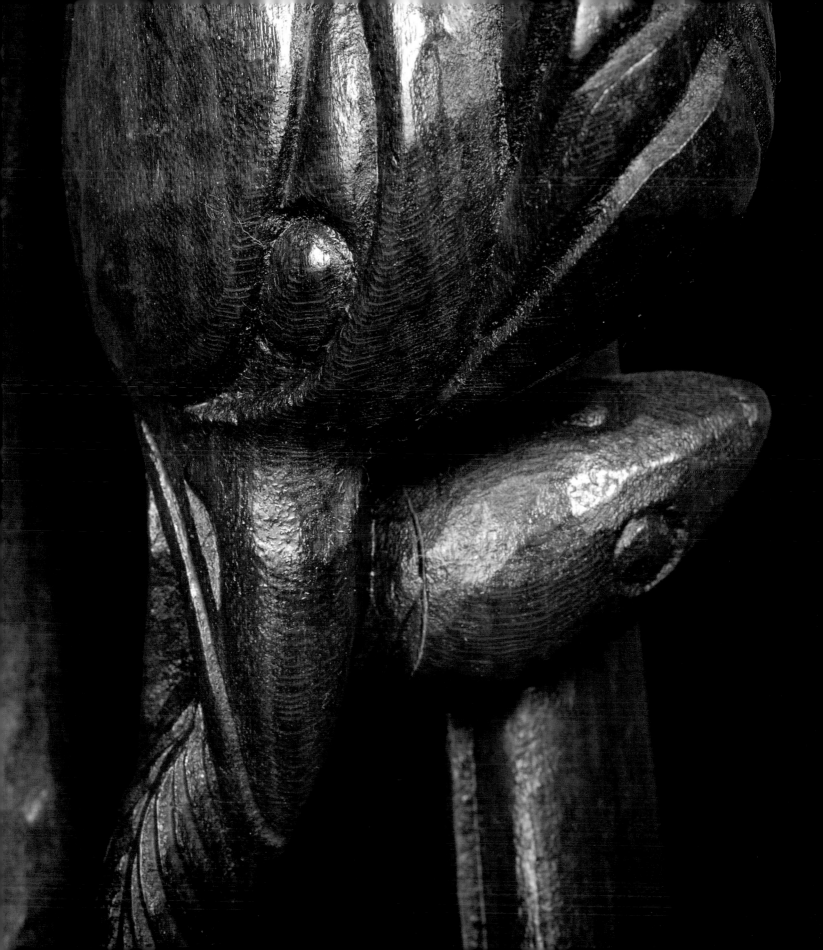

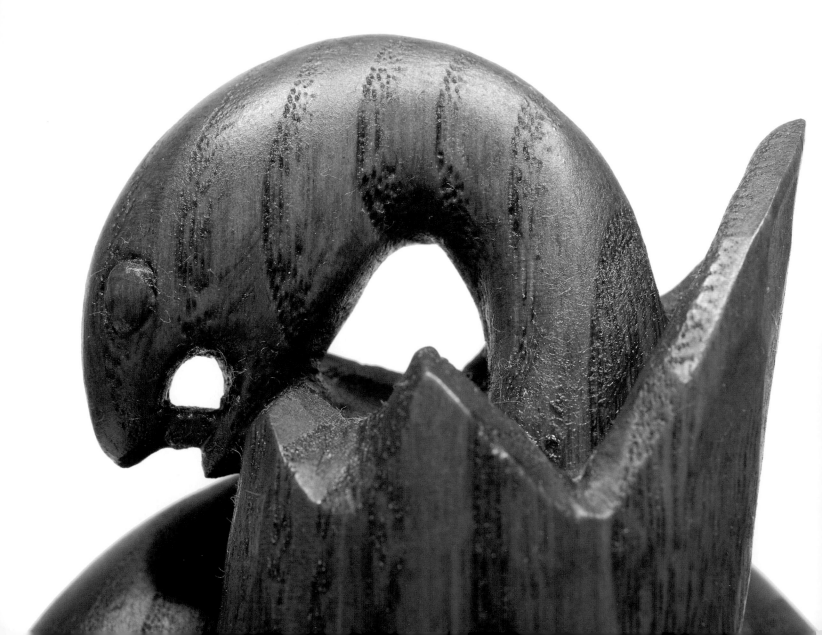

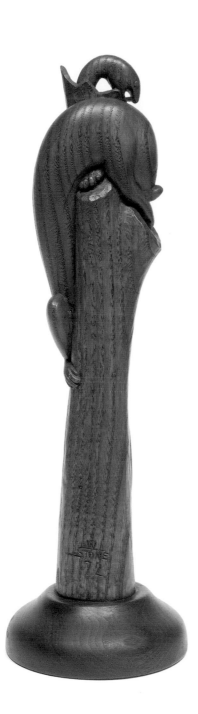

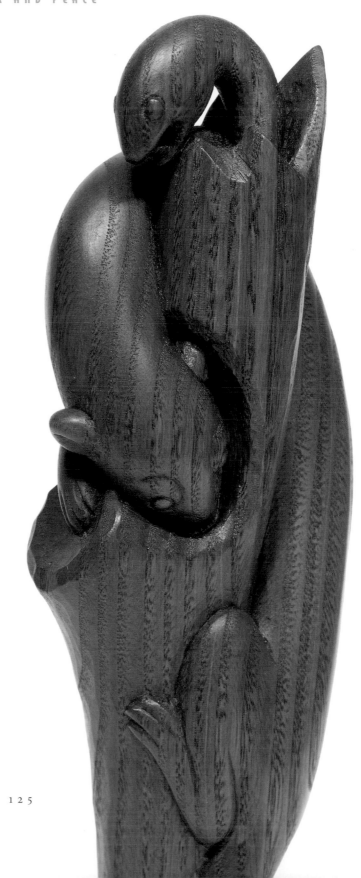

OUR NOSE IN FOREIGN AFFAIRS, 1972.

OAK AND WALNUT, 17.5 X 5 X 5.

COLLECTION OF GEORGE AND MARTHA KAMP

Caution and cooperation were underlying themes of Stone's political works, as he perceived war as a product of chaos and conflict, the ultimate exercise in disunity and distrust. In *Spoils of War,* he reiterated this sentiment. There were no spoils reaped, only death and destruction, depicted by Stone as a hooded skeleton. "I wanted to make it as horrible as possible," he said of the sculpture. "No one wins a war."

Stone's work, however, did not focus on the horrific. He concentrated on celebrating "the highest degree of perfection"—the unity and faith he found in religion. Faith was the foundation of Willard's life and work. "No matter what field of work man chooses for himself, he must have faith in himself and the Creator before he can excel in any chosen." For Stone, faith should unify, not divide people:

> First of all I want no one to get the impression that I do not believe in the Bible; But all my life I have been confused as to how so many different denominations all originating from the same book yet believing different doctrines can all arrive at the same place in the end. And too I wonder how many people who have led Christian lives. And who have belonged to some Church in life, who on their death bed didn't wonder whether they had been in the right church or not.

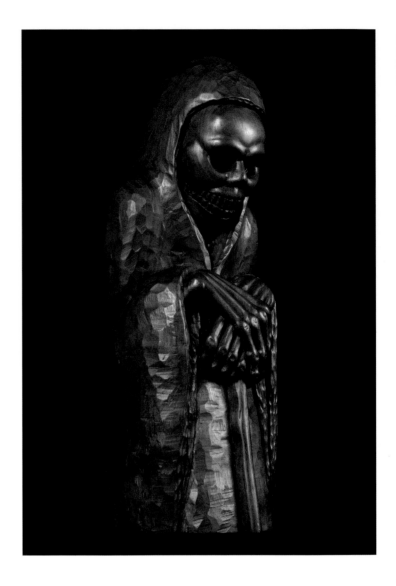

SPOILS OF WAR. PHILIPPINE
MAHOGANY, 19.5 X 7 X 7.125.
GM 1127.59

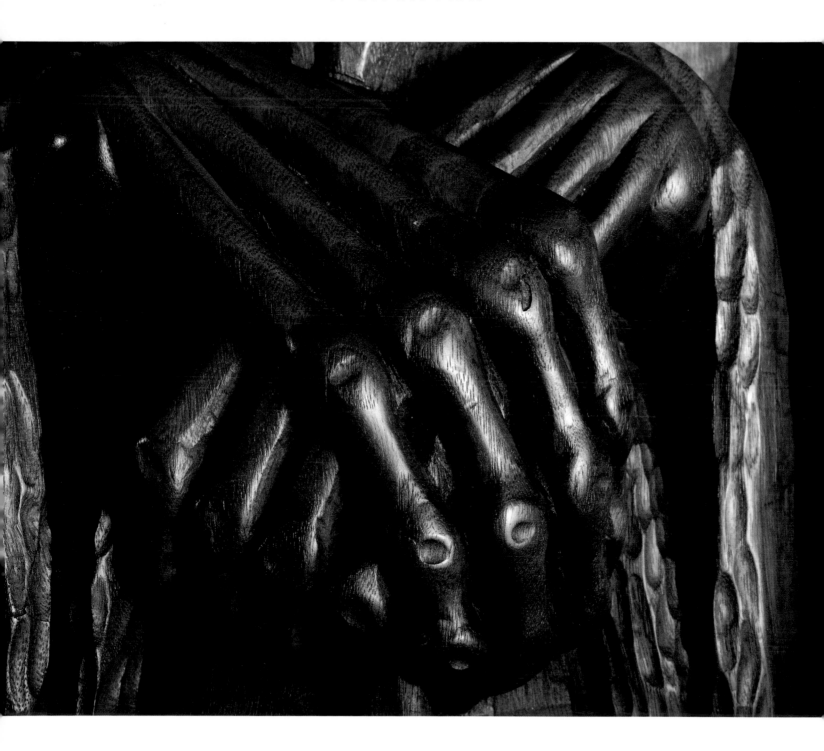

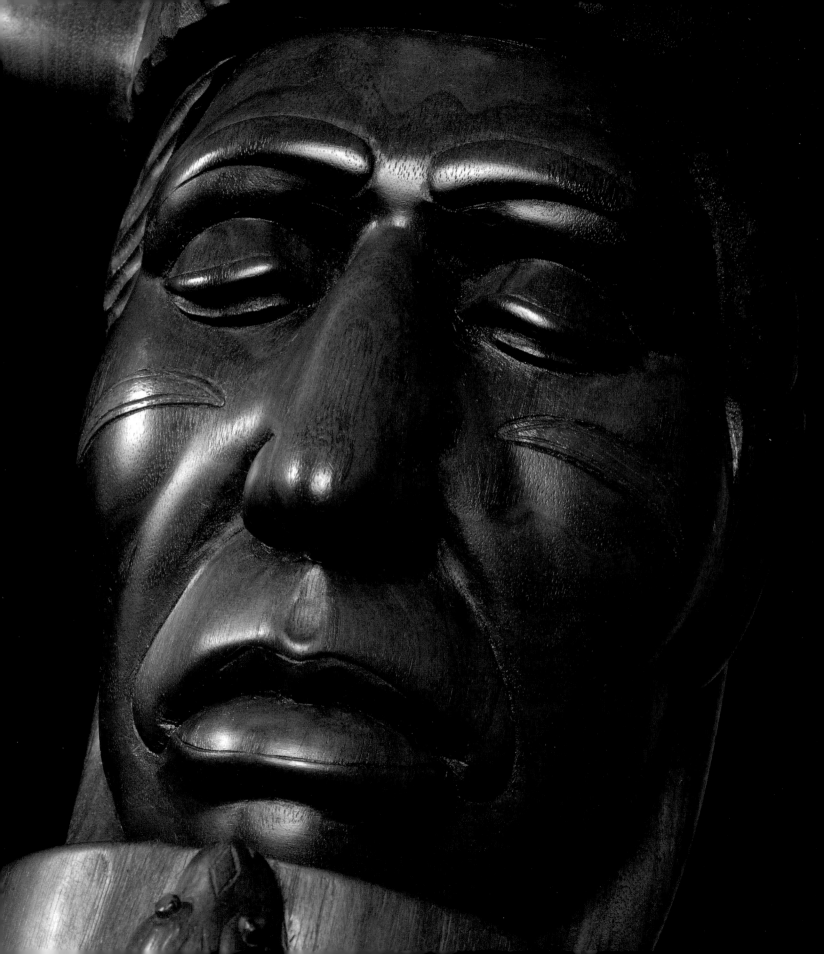

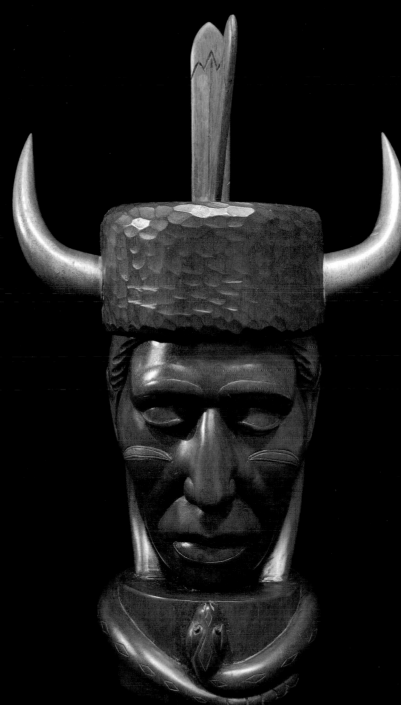

THE DOCTOR, 1946.
PHILIPPINE MAHOGANY
AND WALNUT, 16 X 6 X 10.
GM 1127.13

YESTERDAY'S
FIRES. COLOR
PENCIL ON PAPER,
30 X 22. GM
1327.344

BUFFALOES'
DEPARTURE, 1946.
COLOR PENCIL ON
PAPER, 24 X 19.
GM 1327.338

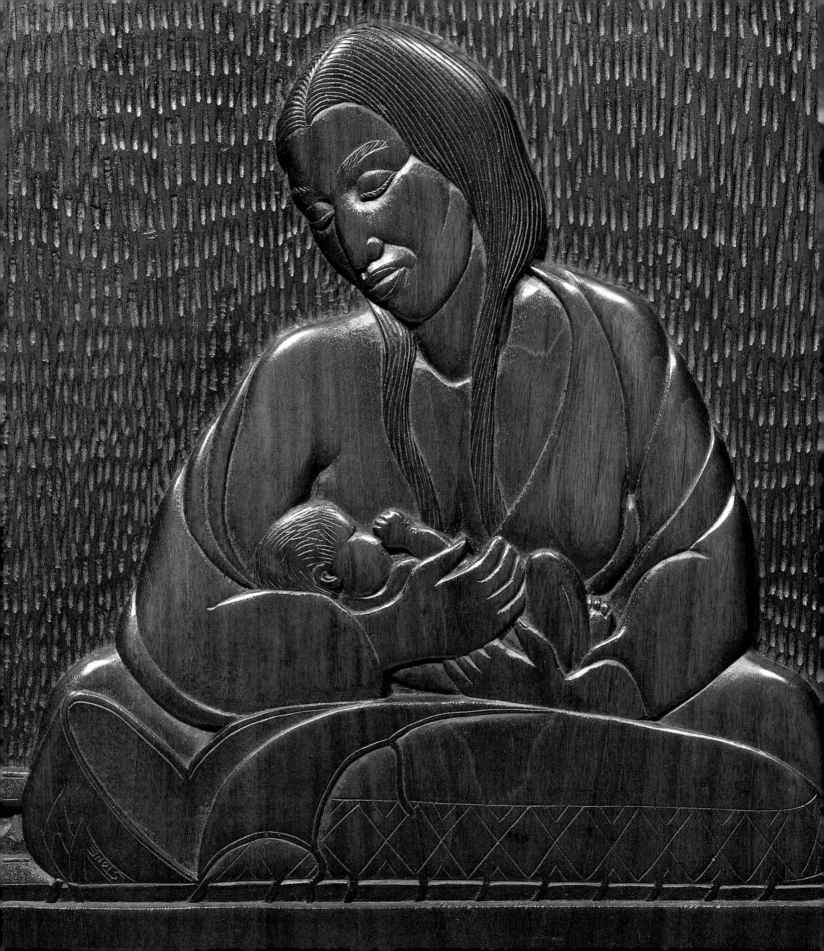

Through sculpture Willard Stone illustrated what he believed was possible if people set aside their differences and focused instead on their similarities. This inclusive approach perhaps stemmed from his childhood among families of Native American ancestry like his own, exposing him to older Cherokees and Creeks who maintained "their old customs and traditions." The influence on his work was apparent as it blended Christian elements such as crosses, the Holy Trinity, and the Virgin Mary with Native American elements such as peyote birds found in Native American Church imagery. This concept of duality and cohesion emerged time and again in his work. *Squaw of Three Feathers,* one of his earlier works, is an example:

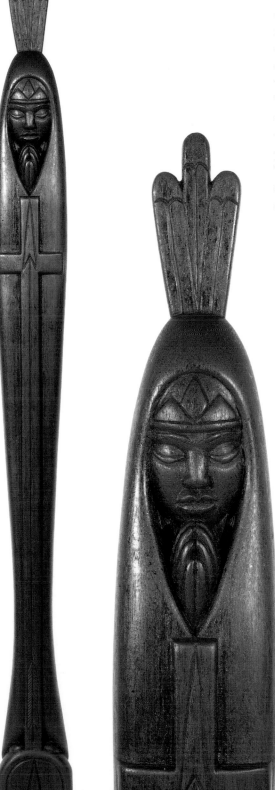

THE HIGHEST MOUNTAIN, 1980.
HONDURAS MAHOGANY,
35 X 5 X 3.75. WILLARD STONE MUSEUM,
LOCUST GROVE, OKLAHOMA

INDIAN MADONNA,
1945. WALNUT,
17.5 X .5 X 28.
GM 1127.14

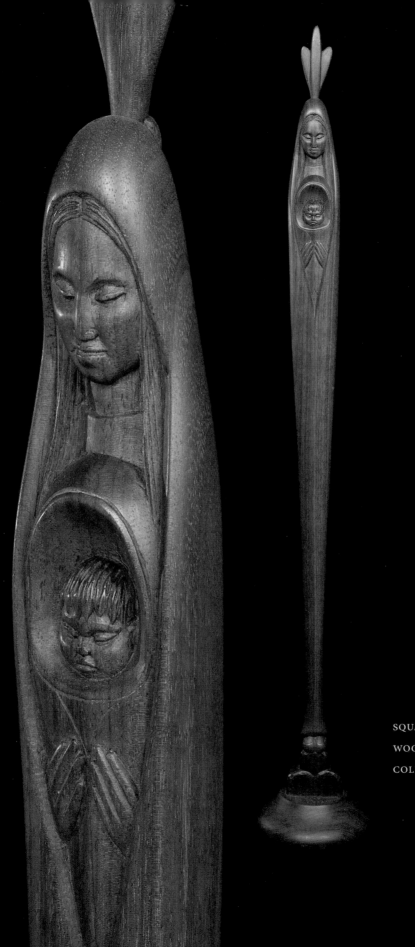

SQUAW OF THREE FEATHERS, 1966.

WOOD, 33.5 X 5 X 5.

COLLECTION OF PAT AND PATTI LESTER

A serene Madonna who wears three feathers, signifying the Holy Trinity. Her small feet rest upon a base of mountain design, representing man at the peak of human understanding. As the design flows upward, it widens to enfold the Christ-child, presenting the artist's conviction that there exists a higher plane of understanding.

FAITH, 1973. GRAPHITE
ON PAPER, 14 X 11.
WILLARD STONE MUSEUM,
LOCUST GROVE, OKLAHOMA

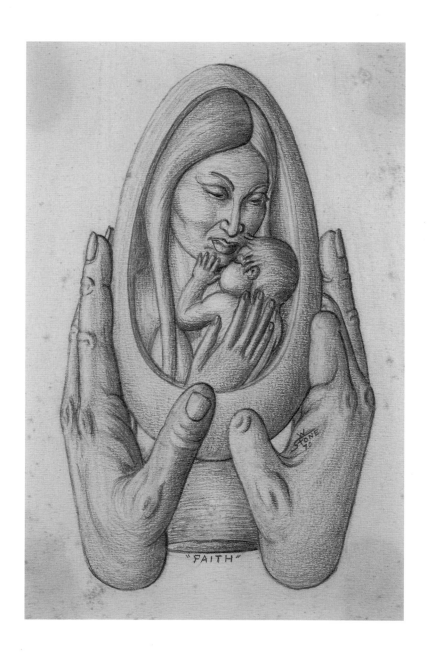

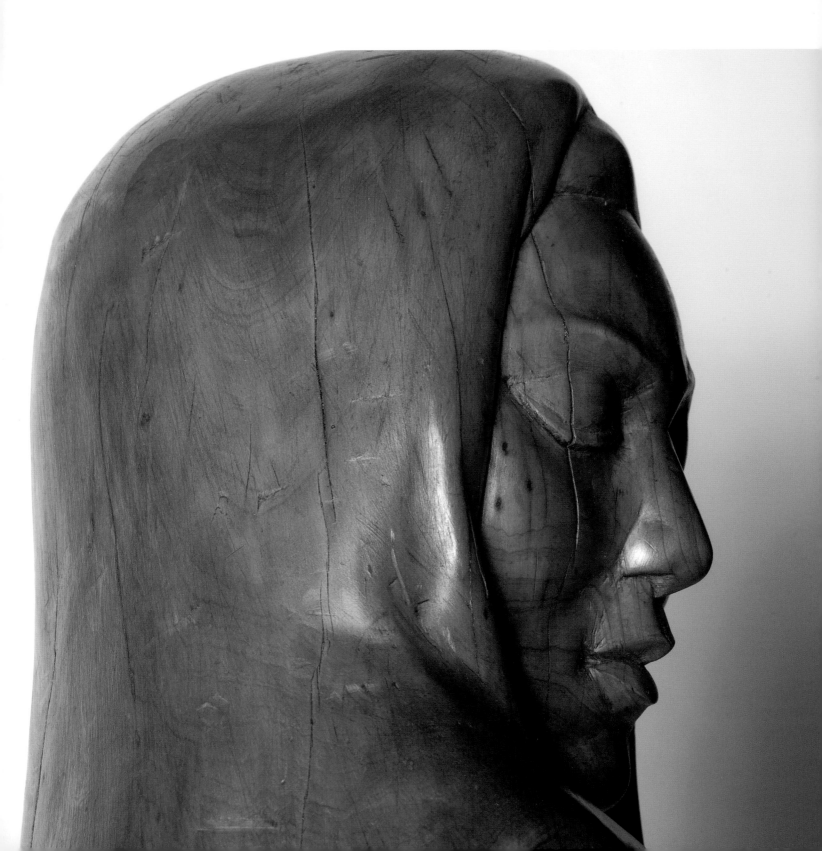

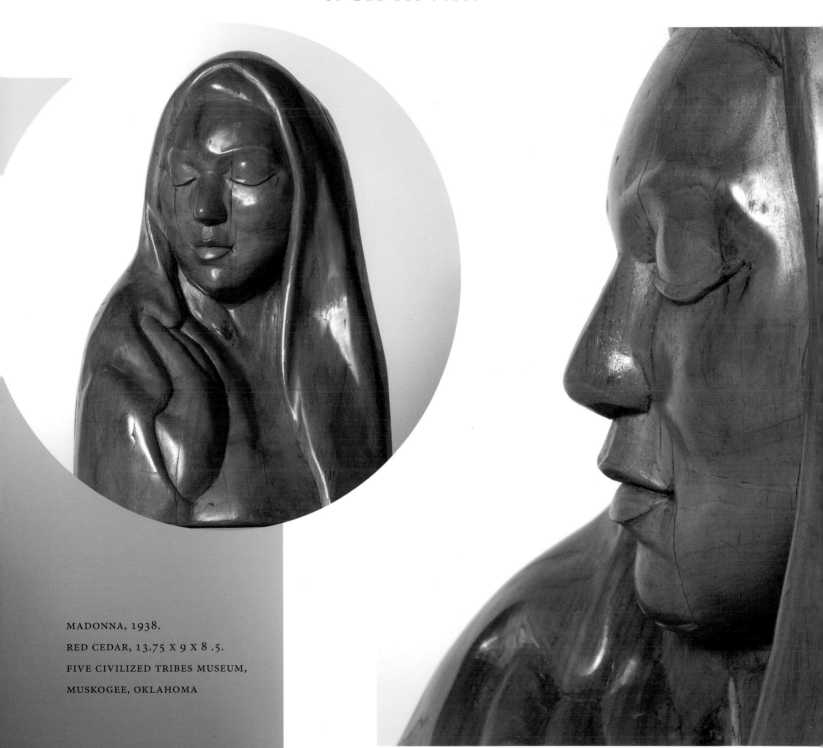

MADONNA, 1938.
RED CEDAR, 13.75 X 9 X 8 .5.
FIVE CIVILIZED TRIBES MUSEUM,
MUSKOGEE, OKLAHOMA

In reference to *Cherokee Follower*, another early work combining Christian and Native American elements, Stone said that he had "tried to show the sincerity of the Cherokee once he is converted to religion." Missionaries, he continued, "tell me that the Cherokee are hard to get converted to religion but when once they are, they are then strictly Christians. What I mean is they don't believe Christianity as a half way thing. And I think all the other Indians are about the same way. . . "

Other works by Stone varied in the blending, such as *The Appeal, Unity of Purpose I,* and *Unity of Purpose II. Unity of Purpose I,* carved between 1946 and 1948, represented Christian harmony. Three sets of praying hands, symbolic of the Holy Trinity, reached towards a cross. Ten years later Stone completed another piece named *Unity of Purpose,* this one also representative of unity:

> Four Madonnas, facing inward, symbolize the Christian Denominations from the four corners of the earth, and they have agreed on "one earth, one heaven, and one God." Their heads support a four-pronged cross, the strength of that union. From the center of the cross four flames spring upward representing the light of the world, surrounding a newborn infant and joining above him into four hands representing fervent common prayer. The infant is the symbol of world-wide belief for the sake of God and humanity.

Prayer was another common theme of Stone's work because he felt it was universal. "Man, regardless of his race, creed or color or nationality surely has one prayer in common, a prayer for life, either here or in the hereafter." In *The Appeal,* the man lifts his head to the "Great Spirit" as though in prayer. Throughout his career, Stone used his sculpture to profess his faith and conviction, not just in a higher power, but also in mankind:

> God comes from the inside out. Man takes from the outside in. We are surrounded by the Great Spirit and our life and its meaning depends upon faith...I'm a simple man. What I want to show in my work is life itself. I want my carving to tell a story. If I can't do that, I won't work.

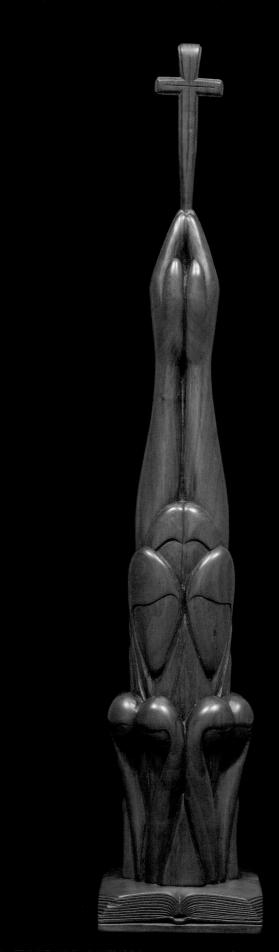

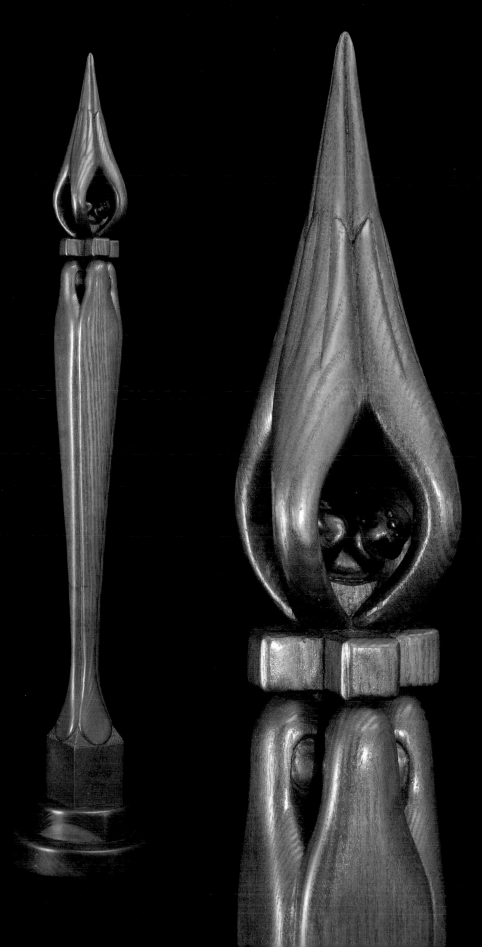

FACING: UNITY OF PURPOSE.
WALNUT, 28 X 5 X 5.25.
GM 1127.78

LEFT; UNITY OF PURPOSE II,
1961. SASSAFRAS, 43.5 X 3.25 X
3.25. NATIONAL COWBOY
AND WESTERN HERITAGE
MUSEUM, OKLAHOMA CITY

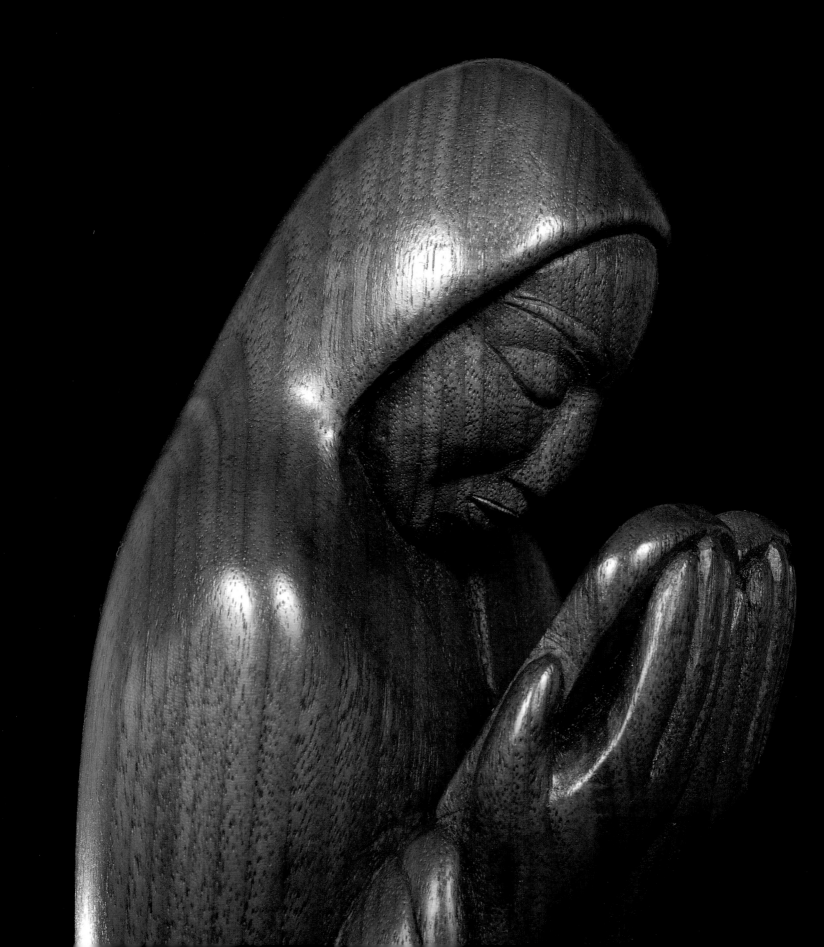

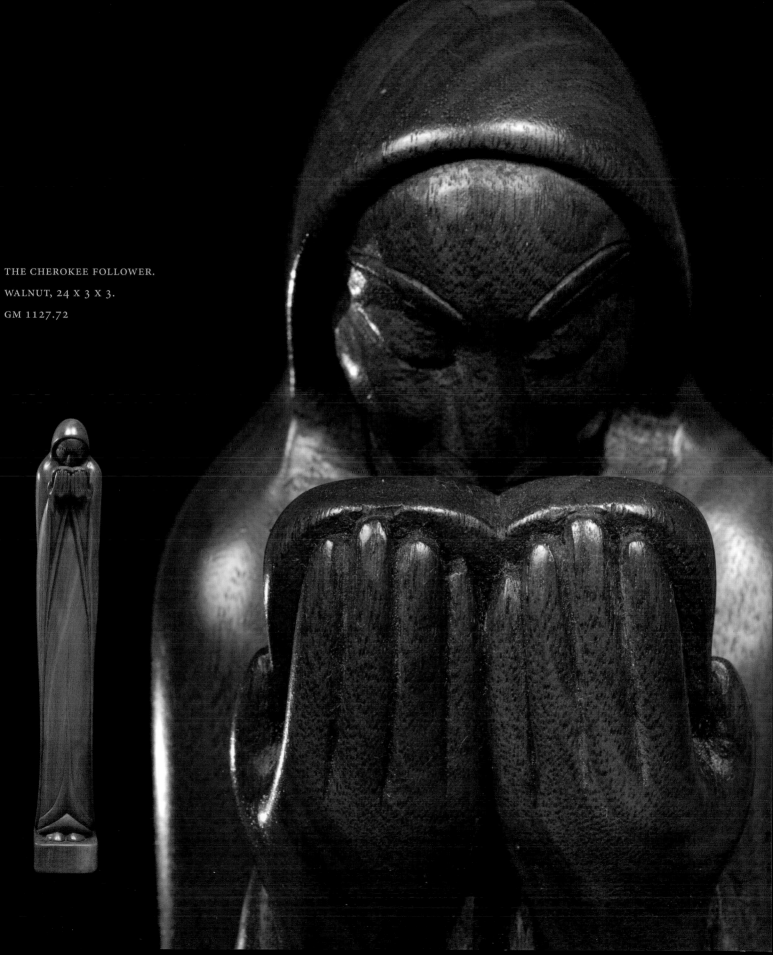

THE CHEROKEE FOLLOWER.
WALNUT, 24 X 3 X 3.
GM 1127.72

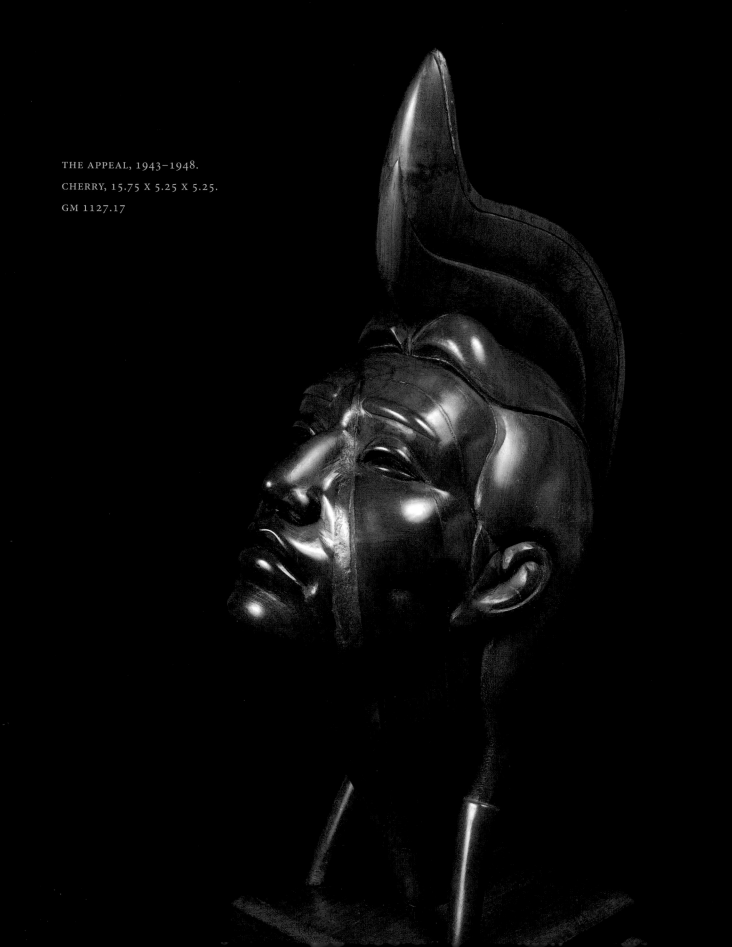

THE APPEAL, 1943–1948.
CHERRY, 15.75 X 5.25 X 5.25.
GM 1127.17

COMMUNION WITH THE
GREAT SPIRIT.
OKLAHOMA RED CEDAR,
12 X 3.75 X 3.75.
GM 1127.8

With pieces like *World Cooperation* (page 72),
Today's Fullblood (page 23), and others, Willard Stone
told stories for more than forty years from his home
in Locust Grove, illustrating the complexity of human
nature while emphasizing the similarities of all people.
At times, his work was a study in extremes—the
divisiveness and negativity of war contrasted with the
unity and optimism possible with religion. Although
he professed to be a simple man, Stone was inherently
a philosopher, observing the world around him and
approaching his work with honesty and humility. His
talent for stripping away wood to reveal the sculpture
within was matched only by his talent for stripping away
social rhetoric to reveal his truths on war and peace. In
his words, "Life is a great mystery. And so is my work."

143

Famous for a Reason

"The famous man had the ability to make everyone else feel famous. If Willard Stone had never picked up a pocket-knife and a piece of wood, I don't think we would remember him much differently."

— Regan Hansen

In the old days, before reality TV and the internet, people became famous for a reason. And fame set them apart. The interesting thing about fame is that it becomes a barrier, a transparent wall separating those looking in from the folks on the other side. In the old days, the people who lived behind those invisible walls resided there because of something special they had achieved or been a part of, and those of us looking in believed that we were looking at unique individuals, somehow better than the rest of us. The truth is, and this is from someone who has known true greatness—even genius, that the only thing separating the famous folks from the rest of us is our assumption about what it means to be famous.

In the years since my grandfather's death, my memories of him have traveled along two parallel paths, one path which has, sadly, dimmed somewhat over time, and one that has gained focus. As I have gotten older I have developed a greater

appreciation of Willard Stone the artist, a man of tremendous wit and vision, and as I search for those fading memories of the man I knew, simply Grandpa Stone, I find it more and more difficult to reconcile the two. Surely my grandfather could not have been this great man, no matter how great a man I thought he was. He was just that: Grandpa Stone. And that's the point. Those of us who knew the man, the ridiculously large family that he left behind, didn't realize that he was truly famous, even those of us who did realize it, as strange as that may sound.

We each have our own favorite memory of the man. For many of his children, it is waiting for him to return home from work, racing to the end of the driveway where he had been dropped off from the car pool. He always saved something from his lunch bucket, and the speediest child was rewarded the prize. For others it is the quiet days spent fishing at the pond of one of many family friends, listening to him make up complex personal histories for the fish he caught. Perhaps it is one of the many art shows he attended to show and sell his work. They often would become happy outings, with the family enjoying a picnic in the middle of the day in the old station wagon. Maybe it is simply a quiet night at home watching *Gunsmoke* after dinner and listening to Willard's humorous commentary on the goings-on in Dodge City.

For my mother, who as a young girl thought of horses the way other young girls thought of Prince Charming, it is the time he bought her a Shetland pony, Sugar, when she was nine. Later, he would immortalize the ornery pony in wood, in a sculpture that has become a prized family heirloom. My brother's favorite memory of our grandfather is the time Willard gave Sugar a drink of his beer, causing him to pull his head back and extend his upper lip like he was reaching for the highest apple on the tree, and causing those of us watching to roll laughing in the pasture. Some of our favorite memories have become intermingled with our dreams. My grandmother has dreamt of Willard descending the steps from an upstairs addition to their home that was added years after his death. He has only come to talk, to catch up on things, and to her the dream is as reassuring of his still constant presence as any memory of their life together. Not long after his death, his youngest son dreamed of seeing him and hugging him and telling him how much he loved him, and as the dream faded, so did much of the pain of his loss.

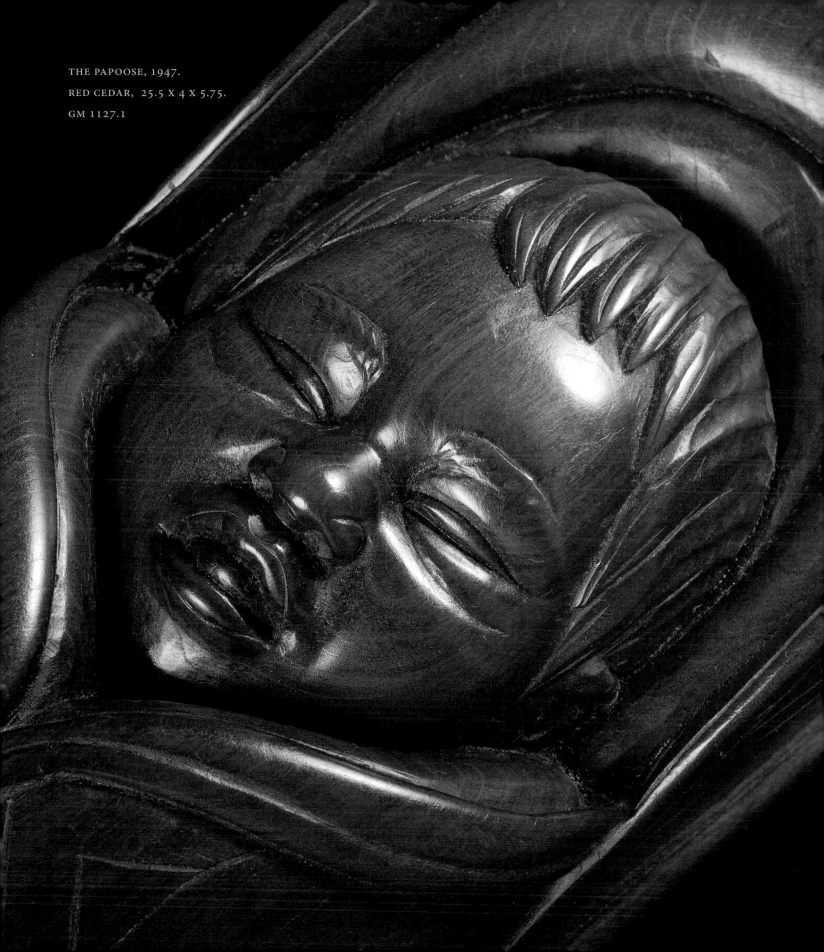

THE PAPOOSE, 1947.
RED CEDAR, 25.5 X 4 X 5.75.
GM 1127.1

My personal memories are of a man who loved the simplest things in life. I recall walking with him around the family farm on a rocky and densely wooded hillside east of Locust Grove. He was always closely followed by his constant companion, a tired-looking dog named Coyote (pronounced Kee-ote), who moved a few slow steps behind with a rolling action that resembled that of a gently swaying ship. Coyote had an incredible talent, as far as dogs go: he could speak in plain English. The fact that only Willard could understand him didn't diminish the talent. The truth is, all the animals that resided on the farm could speak to Willard, and he to them. The busy-body hens would inform him of their affairs, and he would relate them back to us. The pigs never failed to assert that it was meal time, and he never failed to remind them that they had just eaten, and always with a mischievous twinkle in his eye.

It is the twinkle that I remember most clearly, always combined with an equally mischievous grin. The man liked to tease, never mean-spiritedly, anyone and everyone who happened to be at ear's length. My mother used to tell me stories of when she and two of her sisters, all very close in age, were young girls, and their baby teeth were ready to come out. Willard liked to extract teeth the old-fashioned

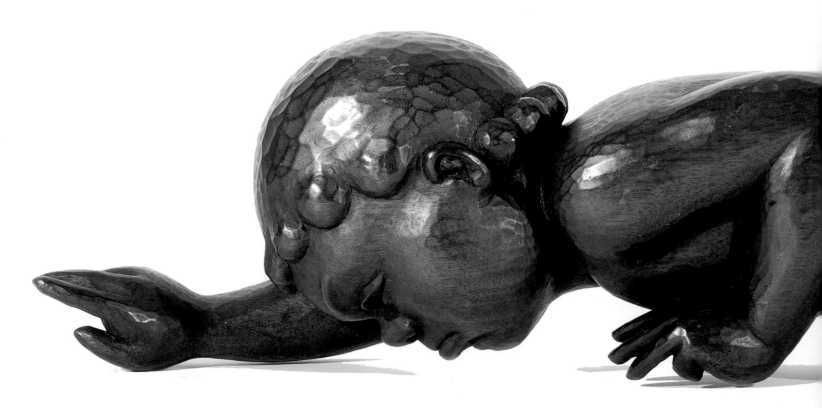

way, with a piece of string, one end tied to a doorknob and the other to the offending tooth. Very quick and painless, he always assured his frightened little girls. And it always was quick and painless, aside from the horror the girl, whichever one happened to be losing the tooth, felt upon hearing the door slam loudly and watching as a half-dozen teeth fell to the floor. Of course, she had failed to notice Willard hiding a handful of white corn kernels in his fist and dropping them just as he swung the door shut. Imagine a mortified young girl screaming, Willard laughing, and Sophie, his often exasperated and constantly loyal wife and the mother of his eleven children, scolding him for his teasing, and you will be imagining a common scene in the Stone household.

OUR CHILDREN'S CHILDREN, 1962.
PHILIPPINE MAHOGANY, 6.5 X 5 X 28.
WILLARD STONE MUSEUM,
LOCUST GROVE, OKLAHOMA

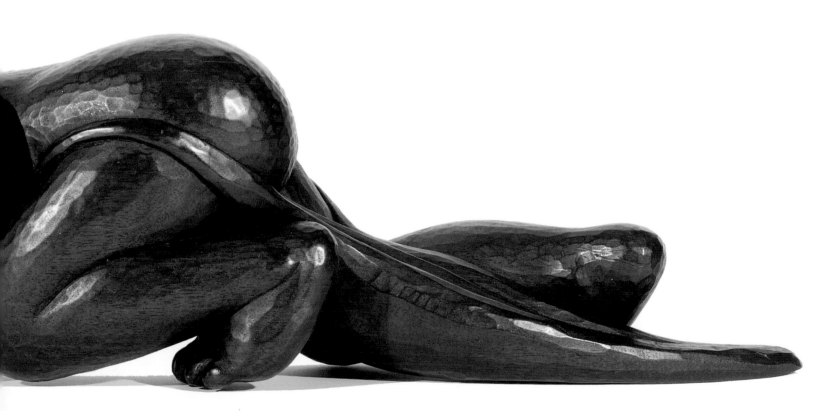

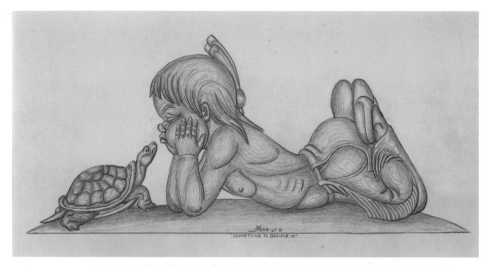

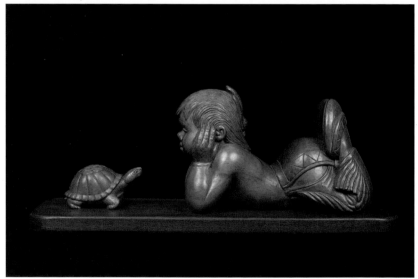

SOMETHING TO BELIEVE IN.
GRAPHITE ON PAPER, 14 X 20.
WILLARD STONE MUSEUM,
LOCUST GROVE, OKLAHOMA

SOMETHING TO BELIEVE IN. WOOD,
7.5 X 6 X 19. PRIVATE COLLECTION

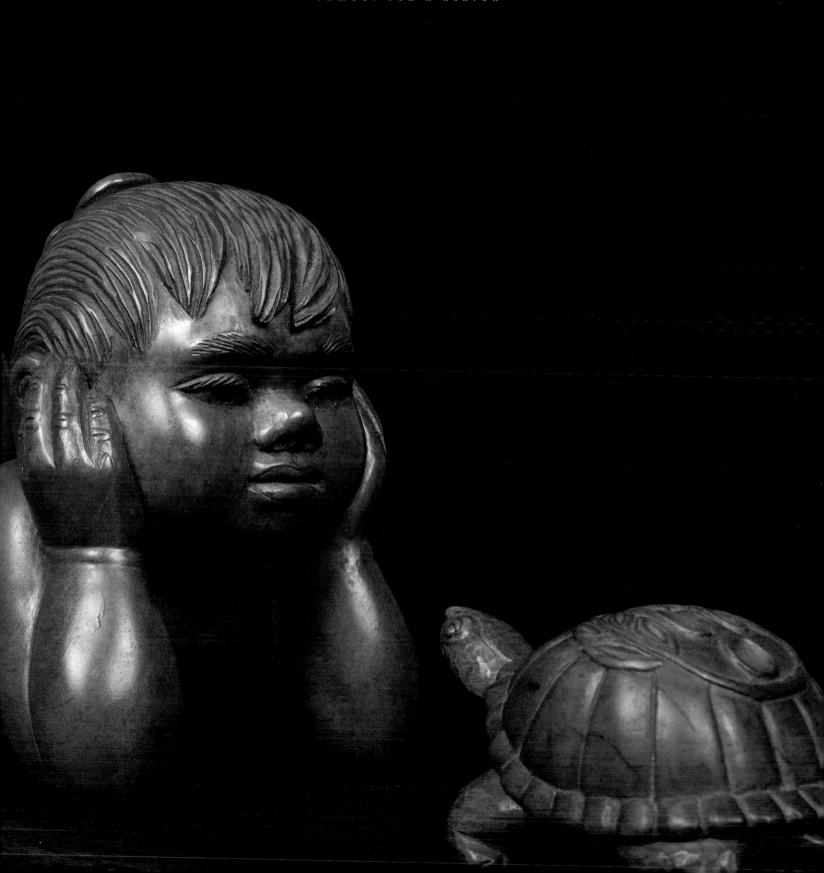

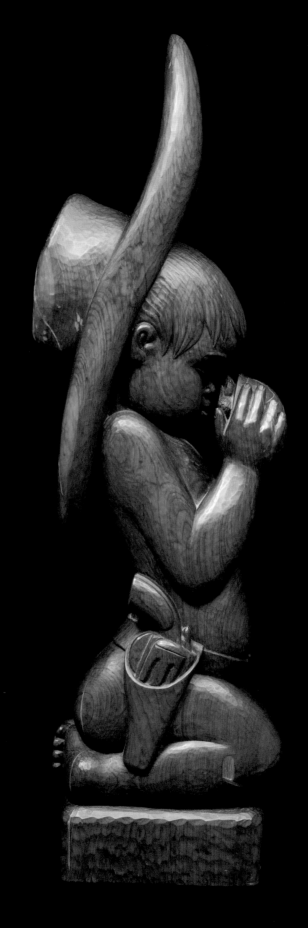

HELP US CROSS TOMORROW'S
ROADS (MOST IMPORTANT
THINGS), 1965. CEDAR,
29 X 9 X 6. NATIONAL COWBOY
AND WESTERN HERITAGE
MUSEUM, OKLAHOMA CITY

LINNIE'S DUCK. SASSAFRAS,
1.25 X 3 X 4.5.
LINDA STONE GALLERY

UP A STUMP.
WOOD, 6.5 X 4 X 2.
WILLARD STONE MUSEUM,
LOCUST GROVE, OKLAHOMA

Whether it was his own kids or the dozens of grandkids, children were a constant presence at the farm. For the grandchildren, visits to the farm often included one of the many chores or odd jobs Willard assigned them to keep them busy. Most of us remember picking up the white plastic tips from the sweet-smelling cigars Grandpa discarded in the backyard beside the patio. The ground was always littered with the things, and he would give us a penny apiece for each one we brought to him. The funny thing is, there was no way he could have smoked enough cigars to keep the yard so littered. We only found out much later that as soon as we left the farm Grandpa would throw the same tips back into the grass to be picked up by the next unsuspecting grandchild who came to visit.

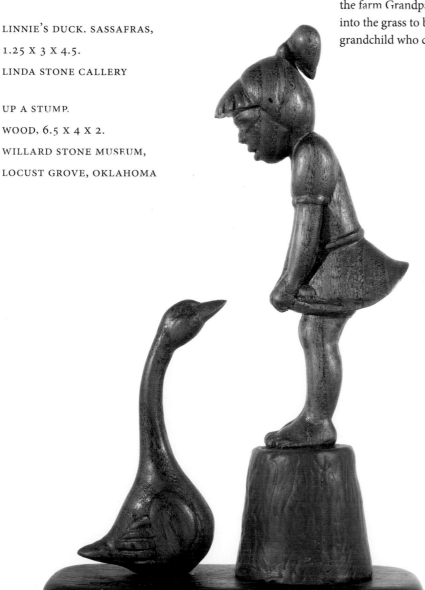

There were times spent sweeping his studio, The Shop, of curling wood shavings, the boys always trying to sneak furtive glances at the girly calendars that adorned the walls. We never realized or stopped to consider the magic that he created there. This was just time spent with Grandpa, each of us secretly hoping for a handful of loose change or simply to hear his good-natured teasing as we giggled. There were hot summer afternoons picking weeds in the garden for what seemed hours, but in reality were likely minutes, so we could go swimming in the pool. For each simple task there was always a reward. Looking back, the greatest reward for all of us was spending time with Grandpa within the closeness of a loving family.

WILLARD STONE'S STUDIO,
LOCUST GROVE, OKLAHOMA

LINNIE'S BASHFUL
FEET. RED CEDAR,
9.375 X 5 X 6. LINDA
STONE CALLERY

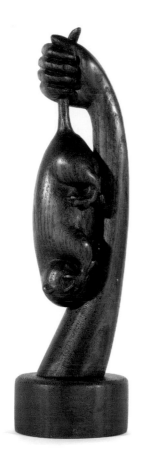

For all the fun, there was plenty of work to be done. Willard worked the boys, Jason, Danny, Dwight, Rocky, and Michel (another, Grant, died as an infant), and Sophie worked the girls, Irene, Nettie, Evelyn, Lyda, and Linda. The work was nothing extraordinary for an Oklahoma farm family. Livestock was fed, the garden was tended, eggs were gathered, butter was churned, wood was cut, livestock was butchered, the harvest was sowed, and the circle continued, all the while building a strength throughout the family that has continued as one generation has given way to another, and as some memories fade and others gain focus. Jason, the eldest son, has taken the lessons learned from his father and become an artist of national prominence himself. Many of the other children and grandchildren have demonstrated artistic talents of their own, be it in woodworking, painting, gardening, sculpture, jewelry-making, or any of a number of things. It all can be traced back to Willard.

I always felt I was Willard's favorite grandchild. I knew it. But I would wager that every one of Willard's grandchildren knew the same thing. I would go a step farther and say it is likely that most of the people Willard encountered felt they were his favorite people. That was his most special talent. Each time you were in his company he was overjoyed to see you. Anything you had to say was the most interesting thing he'd ever heard. The famous man had the ability to make everyone else feel famous. If Willard Stone had never picked up a pocket knife and a piece of wood, I don't think we would remember him much differently.

THE THIEF (HEN HOUSE
THIEF). RED CEDAR,
12 X 2.5 X 3.
WILLARD STONE MUSEUM,
LOCUST GROVE, OKLAHOMA

WARHEAD FRUIT BOWL. WOOD,
3.75 X 5.5 X 18.5. GM 1127.54

KANUTCHEE BOWL. WOOD,
1.5 X 14.75 X 3.5. GM 1127.12

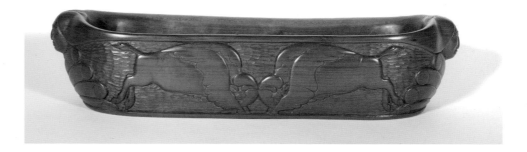

EXPRESSION.

WOOD, 12.75 X 2.75 X 5.5.

GM 1127.4

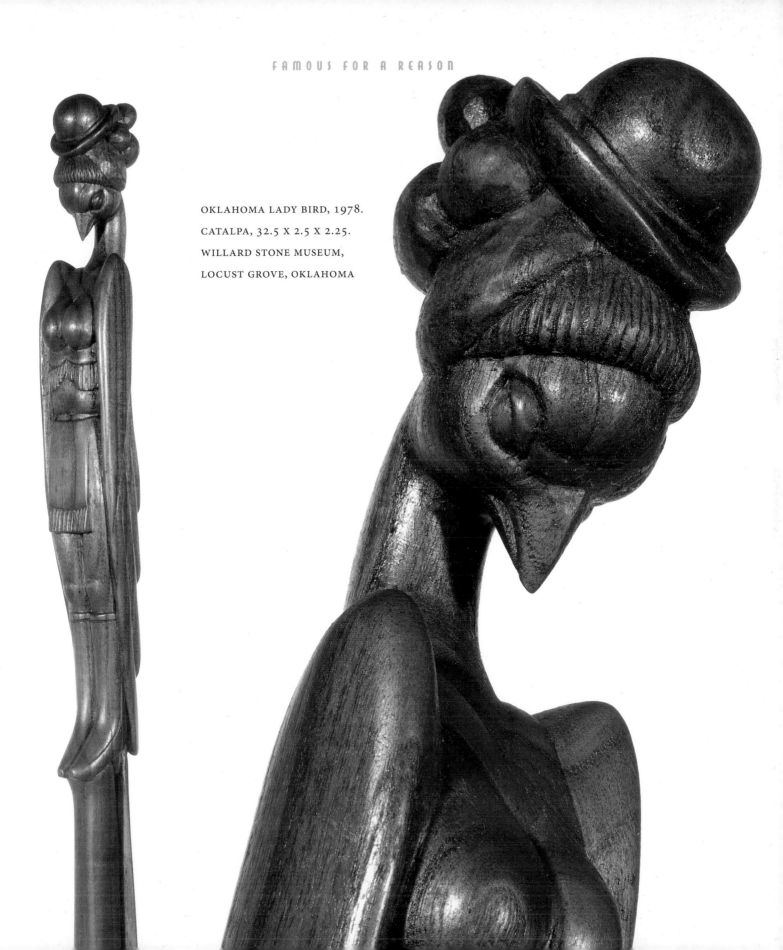

OKLAHOMA LADY BIRD, 1978.
CATALPA, 32.5 X 2.5 X 2.25.
WILLARD STONE MUSEUM,
LOCUST GROVE, OKLAHOMA

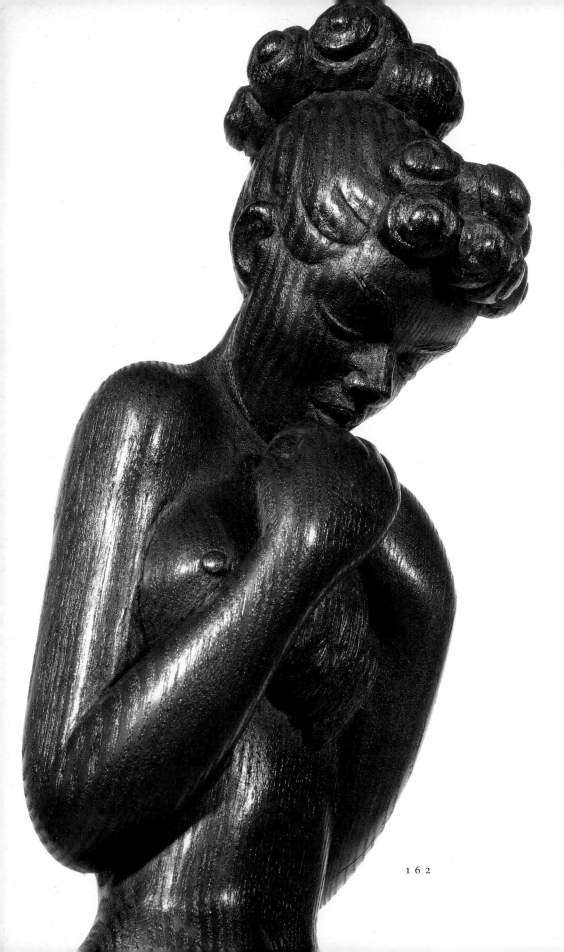

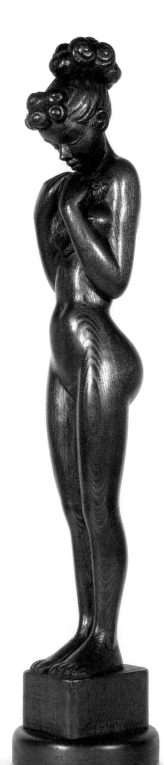

PET, CA. 1960.
SASSAFRAS, 28 X 3.5 X 3.
WILLARD STONE MUSEUM,
LOCUST GROVE, OKLAHOMA

162

CHIEFS ARE MADE
NOT BORN, 1978.
WOOD, 37 X 4 X 6.
COLLECTION OF PAT
AND PATTI LESTER

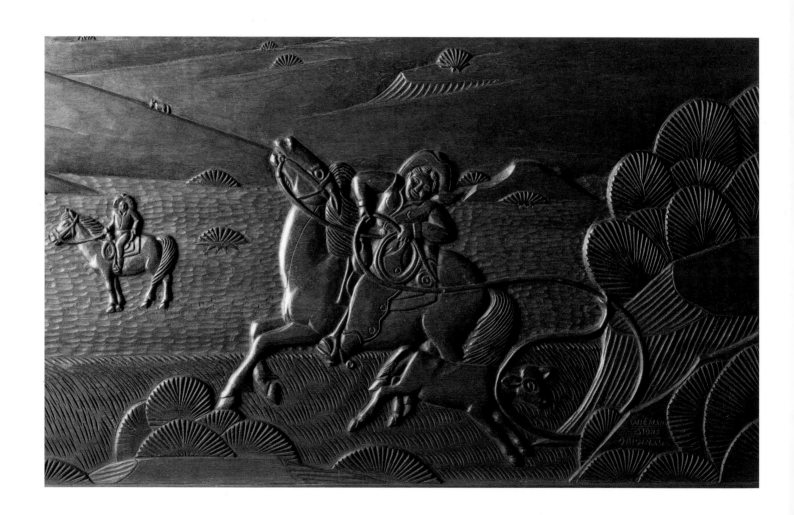

UNTITLED (COWBOY SCENE).
WOOD, 18.5 X 35.5 X 1.
WILLARD STONE MUSEUM,
LOCUST GROVE, OKLAHOMA

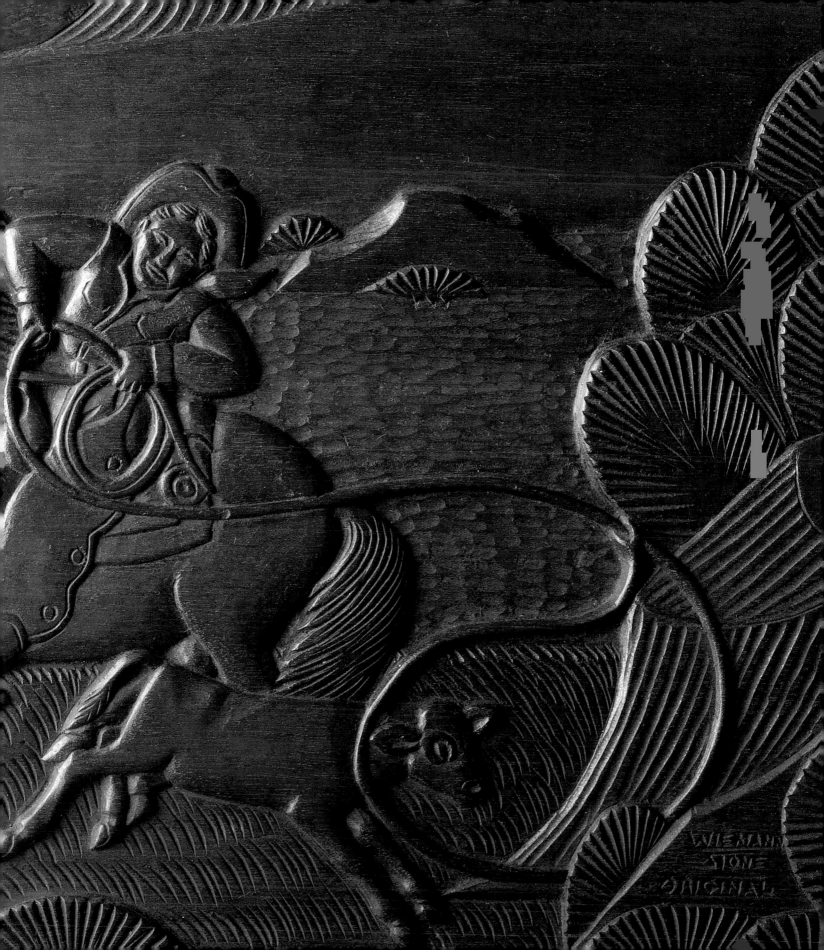

WAITING HIS TURN. WOOD,
15.5 X 3 X 3.5. GM 1127.83

DOWN THE DRAIN, 1965. SASSAFRAS,
34.5 X 6.5 X 3.25. NATIONAL COWBOY
AND WESTERN HERITAGE MUSEUM,
OKLAHOMA CITY

A Place Carved in Time

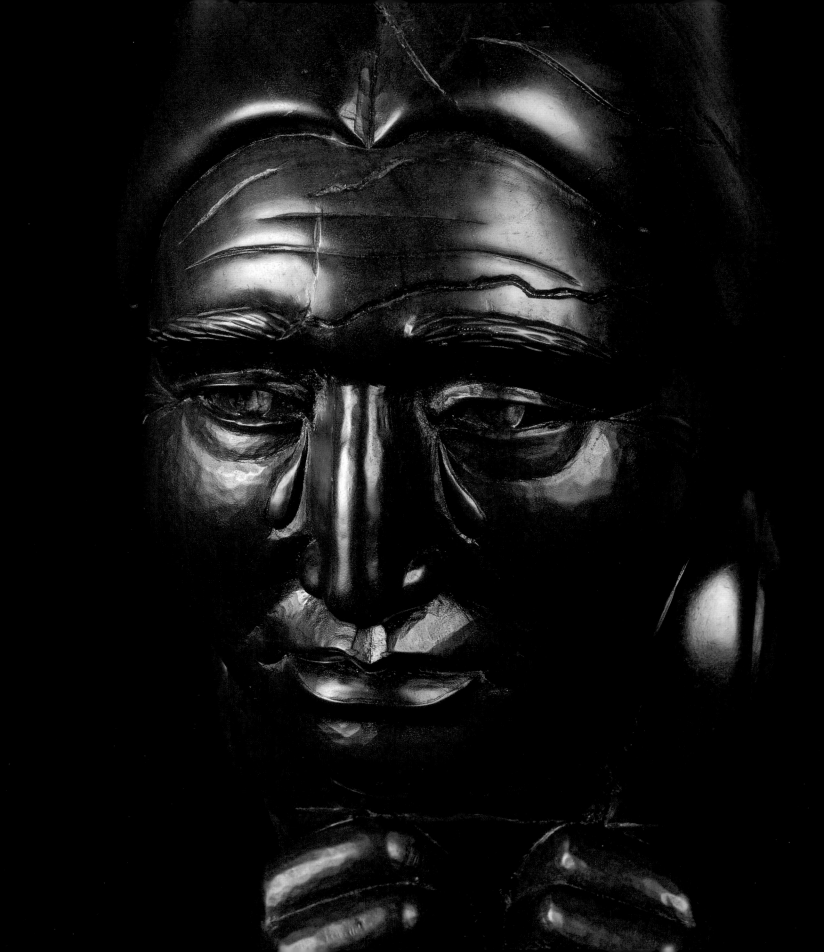

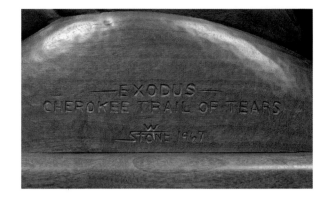

"What I want to show in my work is life itself."

In November 1962, Willard Stone had arrived at the Kennedy Galleries in New York as a regional artist with aspirations toward wider prominence. The forty-six-year-old Oklahoman was poised to become one of the nation's foremost wood sculptors. Over the past twenty years, he had grown significantly both personally and professionally. He had met the challenges of providing for a growing family and somehow still managed to pursue his art. The road from Oktaha to Manhattan had been both formidable and fortuitous. His work would soon become known to a larger audience—to collectors and admirers around the globe.

While the exhibition in New York inspired him, it also left Stone with a great sense of dread. Always a private person, he was self consciously uncomfortable with formal occasions. He preferred the quiet and solitude of the woods to crowded galleries and casual conversation with strangers. He felt desperately out of place and viewed his surroundings with a skeptical eye. From his Madison Avenue hotel, Stone wrote to good friend Jess Hightower back in Oklahoma, "The plane traveled around 700 miles per hour and the people here seem to think they should do so, too. And they are not far from doing it either . . ." As an artist, he knew that he was entering

FACING: DETAIL, EXODUS, 1967.
WALNUT, 34.5 X 6.5 X 3.5.
COURTESY OF THE
CHEROKEE NATION

a new realm of prominence, one that would take him far from his home in Locust Grove. The passing of Thomas Gilcrease months before had left him without one of his most enthusiastic supporters. He was alone and could not seem to connect with the pace and nuance of New York life. He wrote, "The general mass of people rush here and there with a dead pan expression on their face and seem to have no soul…"

After his return, Stone wrote about the exhibition opening to David R. Milsten, Tulsa attorney and former counsel to Thomas Gilcrease. "It was encouraging to learn that Indians were considered Americans," he wrote about a conversation he had overheard among viewers of his artworks. "This fellow, talking to a lady said, 'All my life, I have sympathized with the Indians. I think we should, because in a way, they are Americans, too'. " Stone went on to sum up his weeks away from Locust Grove. "It was a wonderful experience But I wouldn't trade one acre of eastern Oklahoma for all of Manhattan for my own use."

Stone returned to Oklahoma, relieved to be back to his family, the farm animals, and to the tools of his woodshop. Over the next several years, he continued to pursue subjects that challenged him. As the demand for his work increased, he sought subjects and themes that would expand his range in terms of both design and execution. Above all, Stone wanted his art to say something. He wanted it to tell a story—to reveal insight into the depth and complexity of the human condition. In his Oklahoma woodshop studio, Willard Stone continued to present the world with subtle yet eloquent renderings of everyday life.

WILLARD STONE WITH ENTERTAINER BOB HOPE. COURTESY OF WILLARD STONE MUSEUM.

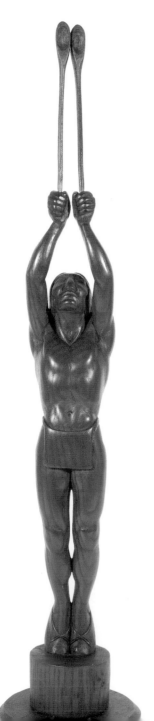

CHEROKEE STICKBALL PLAYER,
1942. KENTUCKY COFFEE
BEAN, 28 X 3 X 4.
WILLARD STONE MUSEUM,
LOCUST GROVE, OKLAHOMA

Throughout the 1960s, Stone's work remained in high demand. The decade also saw the births of Willard and Sophie's last two children: Rocky Maloy in 1963 and Michel Da Vinci in 1968. As the family continued to grow, his sculptures continued to be increasingly shown in exclusive exhibitions and invitational art shows across the Southwest and beyond, including Gilcrease Museum, the National Cowboy and Western Heritage Museum, the Five Civilized Tribes Museum, Philbrook Museum of Art, and the Smithsonian Institution. Stone's work was becoming more and more collectable as well to both individuals and art institutions. In the latter part of the decade, he received a number of commissions that would not only challenge his abilities but also establish his place as "America's foremost wood sculptor."

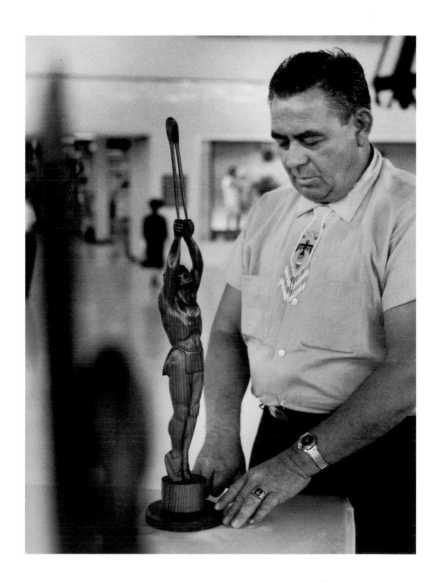

173

In 1967, Stone's masterpiece *Exodus* was commissioned by the Cherokee Historical Society. "It is one of the most memorable and most poignant of Stone's works," said Anne Morand, art historian and for many years curator of art at Gilcrease Museum. The large walnut sculpture was a triumph of both execution and design which Stone described as being "composed of two large teardrops, one balancing the other, on a base representing the contour of the earth." *Exodus* was the first of his noted trilogy honoring the Cherokee experience during the tribe's forced removal by the United States government in the early nineteenth century from traditional homelands in the East. Stone's ultimate theme was profound. "I have tried to capture the tragedy and heavy load of sorrow and heartache being overcome by the Cherokee's courage and determination," he said. "I have tried to boil down and bring into focus the heavy load of life the whole of mankind carries and put it into an individual mother and child."

WILLARD STONE WITH A BUST
OF THOMAS GILCREASE

Stone excelled in depicting the experiences of an individual person or culture to be interpreted as an allegory that spoke to the larger human experience. Soon after *Exodus,* the second part of the trilogy was completed. Also commissioned by the Cherokee Heritage Society, Stone's two-dimensional sculpture *Transplant* depicts a Cherokee mother and child "after the ordeal" of removal. In Stone's words, the large walnut wall relief shows that "By faith, enough survived the Trail of Tears to seed the new land. By faith, they will sprout and make it better. For this they give thanks."

In the next decade, Willard Stone would achieve levels of prominence well beyond his imaginings growing up as a boy in rural Muskogee County. In 1970, he was honored with the induction into the Oklahoma Hall of Fame, an acknowledgment exclusive to individuals who have excelled in areas of public service or brought significant acclaim to the state. Stone was both thrilled and humbled by the award. He was never moved by accolades except to express an appreciation for the opportunities he had received. "I look at my wife, my children, and my grandchildren and realize how lucky I've been. . . . For some reason the Great Spirit gave me a gift to use and kept me using it."

As he continued his artistic efforts, Willard Stone continued to be recognized as one of Oklahoma's most acclaimed and admired individuals. While his artistic output was greatly diminished after a stroke in the summer of 1976, he received only weeks later an honorary Doctorate of Humanities from Oklahoma Christian College for his "outstanding ability . . . as one of the most foremost wood sculptors in the United States." The accompanying citation also recognized his "deep understanding and love of the universe [and] unparalleled gift to transform wood into an expression of the rhythm, movement, and poetry of nature."

The following year, an article in the *Christian Science Monitor* noted that "if the heart of Oklahoma were carved in wood, Willard Stone would have done it…Mr. Stone can sculpture what a rabbit is thinking the moment before it springs out of the grass, the exact point at which a coyote howls his longest note, and the intertwined tenderness of goslings and greenery in spring."

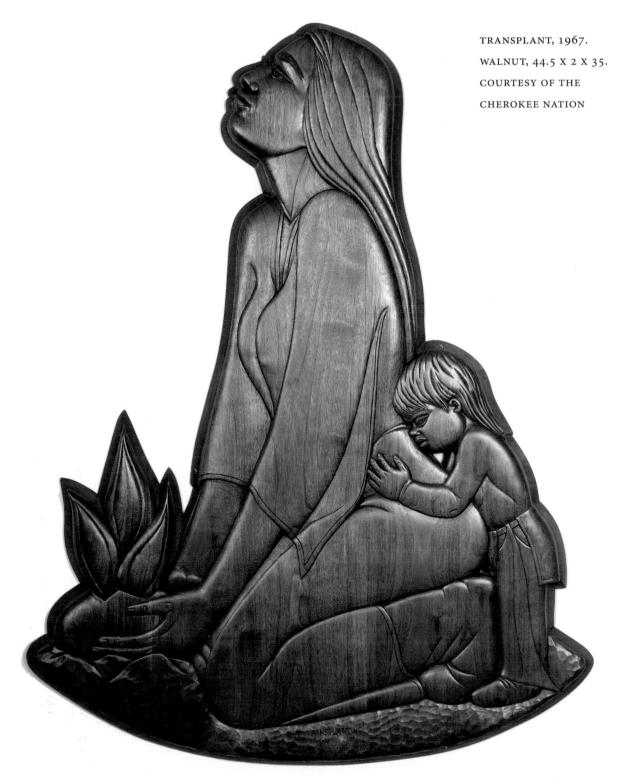

TRANSPLANT, 1967.
WALNUT, 44.5 X 2 X 35.
COURTESY OF THE
CHEROKEE NATION

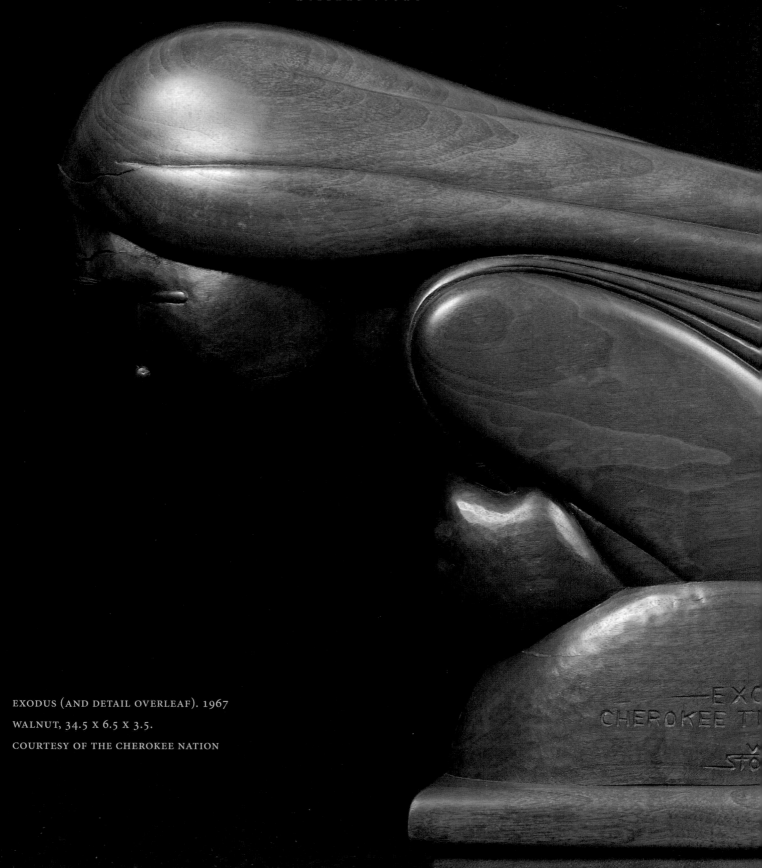

WILLARD STONE

EXODUS (AND DETAIL OVERLEAF). 1967
WALNUT, 34.5 X 6.5 X 3.5.
COURTESY OF THE CHEROKEE NATION

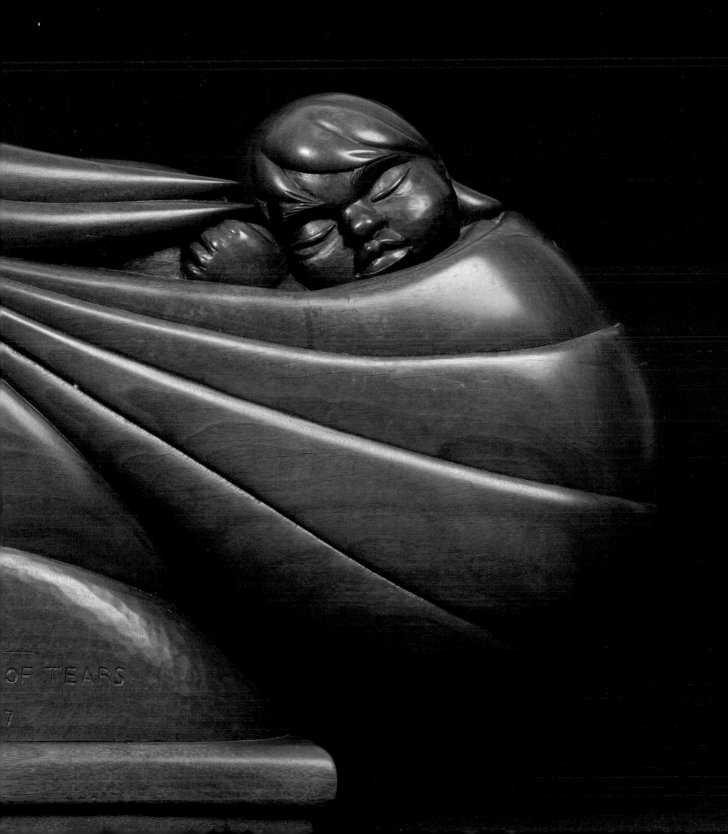

OF TEARS

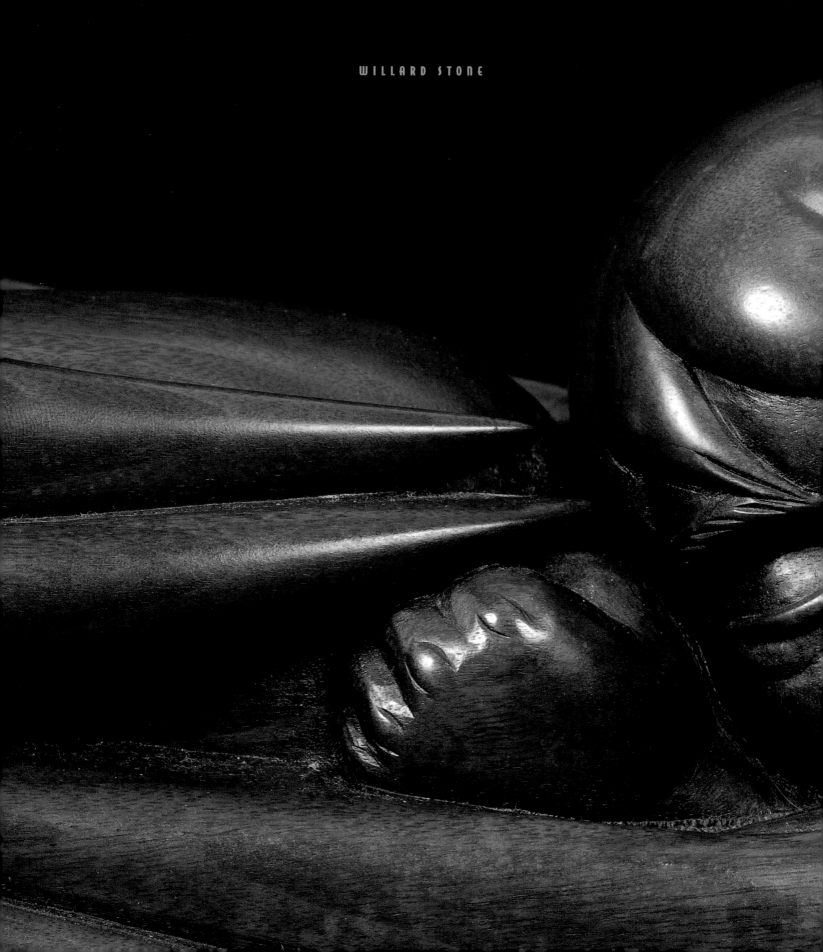

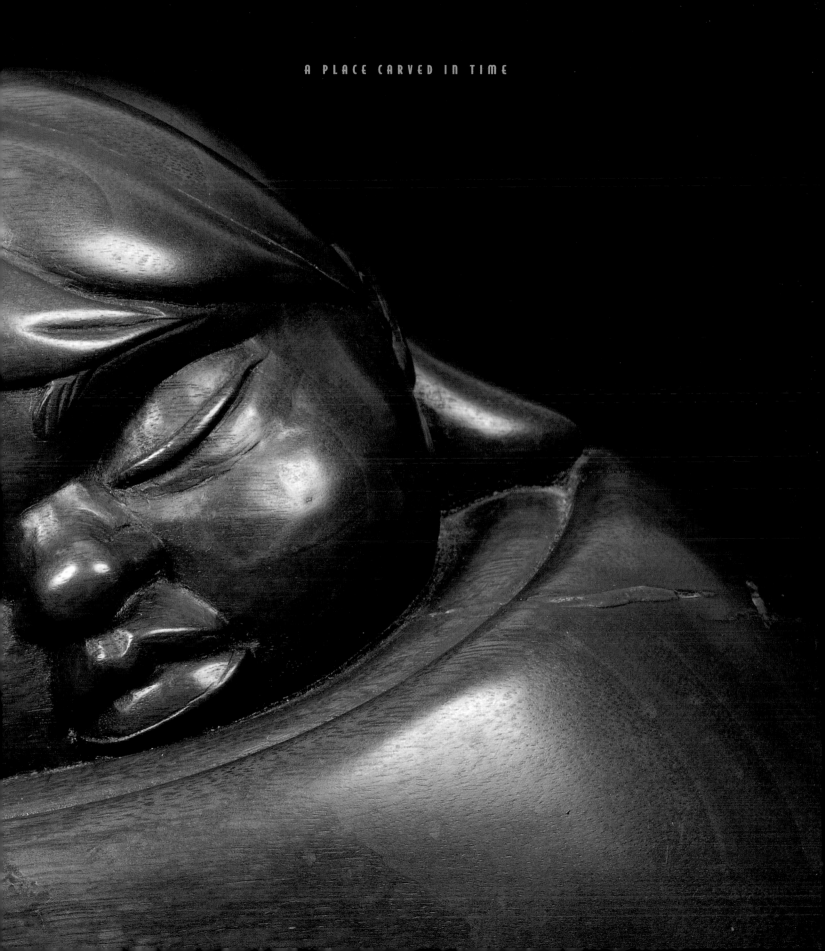

Although health issues continued to plague him, Stone continued working with the help of sons Jason and Danny. Gradually, he accepted his limitations. He also accepted his role as an accomplished artist. During the last years of his life his output was limited, but the depth and quality of his work continued to approach new heights. In 1980, the last of his trilogy honoring the Cherokees and the Trail of Tears was completed. Stone's *Uprooted* would become one the artist's signature works. The sculpture represents the Cherokees "pulling away from the ground they had been living on from the time they were born," Stone said. "It also represents the Creeks, the Seminoles, the Choctaws, and the Chickasaws, along with the Jews, the Cubans—any people who were forced from their land because of the greed or lust of some more powerful race." Carved from the stump of an Oklahoma red cedar, the sculpture is widely considered to be perhaps the most important artwork of his long career. Masterfully executed, the sculpture demonstrates Stone's ability to let the natural flow and form of the wood speak through him as an essential element of a given composition.

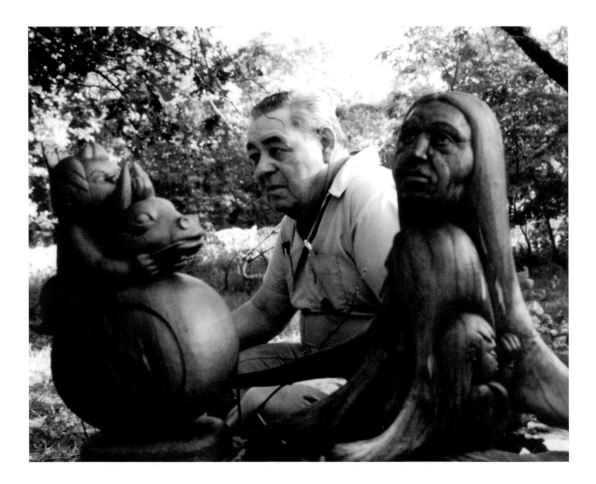

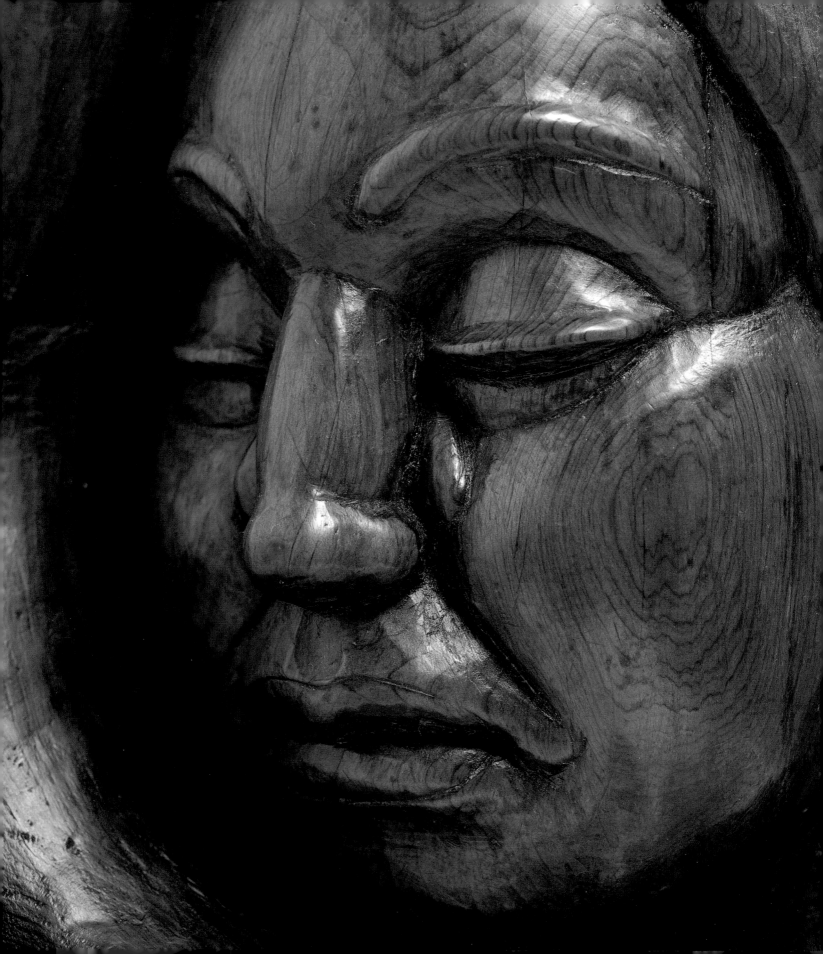

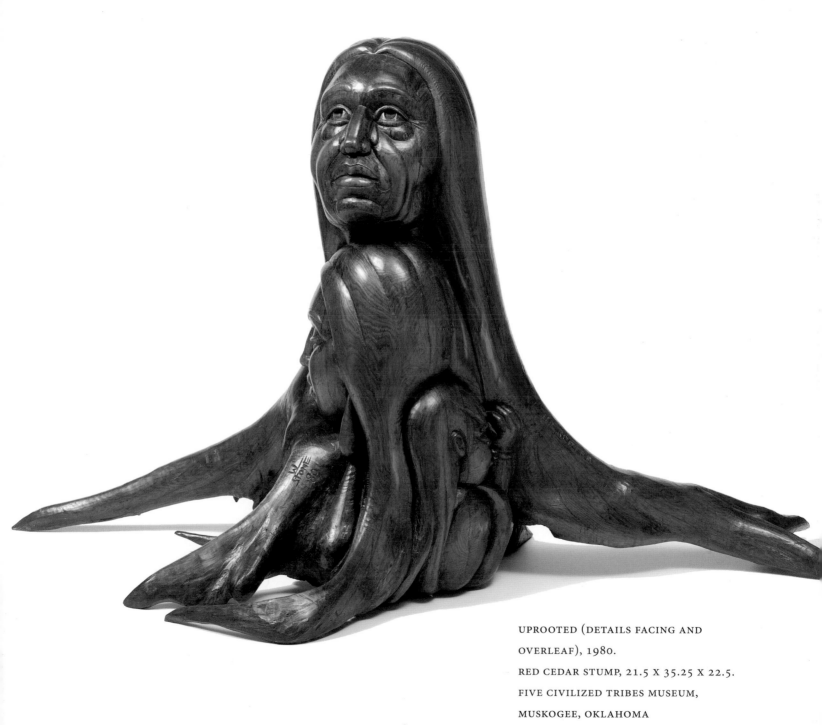

UPROOTED (DETAILS FACING AND
OVERLEAF), 1980.
RED CEDAR STUMP, 21.5 X 35.25 X 22.5.
FIVE CIVILIZED TRIBES MUSEUM,
MUSKOGEE, OKLAHOMA

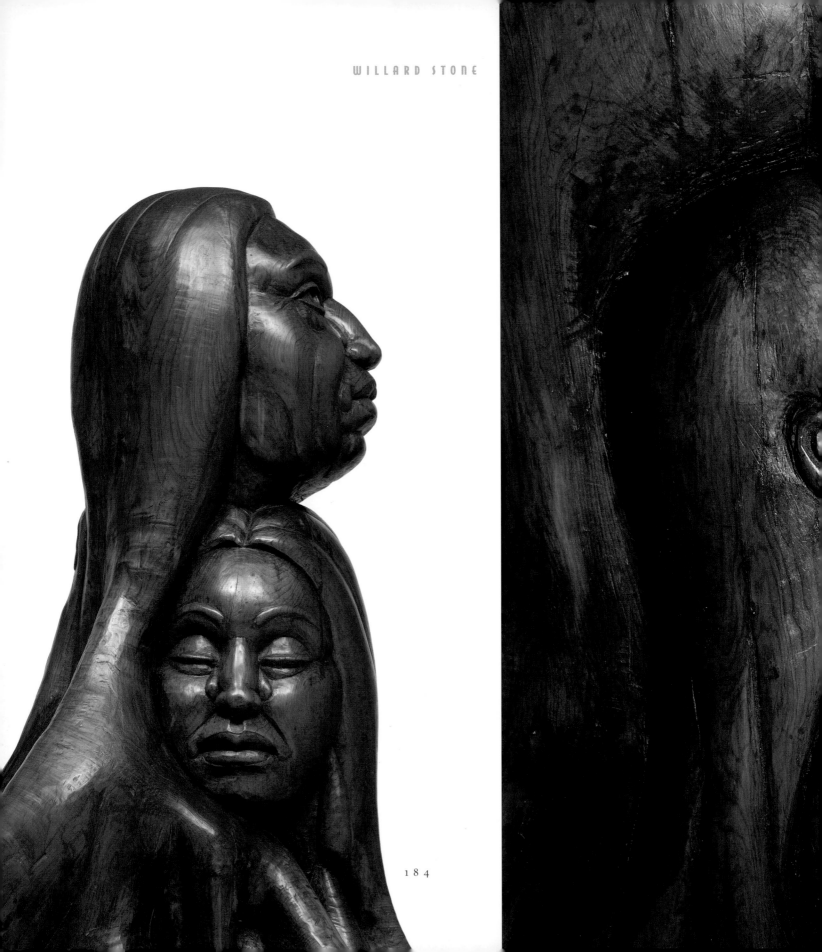

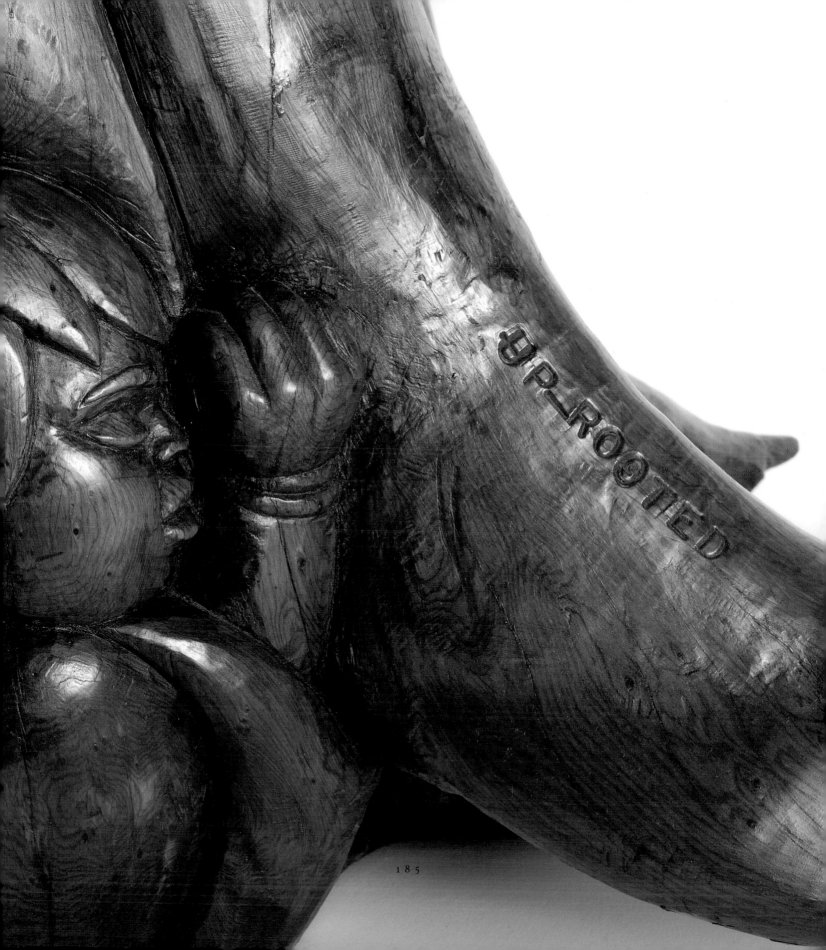

Willard Stone died peacefully in his sleep at the family home he had built in Locust Grove, Oklahoma, on March 6, 1985. His funeral was attended by well over a thousand friends, family members, and admirers. The sixty-nine-year-old artist was buried on the grounds of the family homestead. Throughout his life, Stone had been an intensely private man. He had shunned the limelight and its dubious honors. Praise seemed anathema to his view of the world. Stone's work had originated from a lifetime of experience that originated in the fields and creekbeds of rural America. It had been impacted by extreme poverty and an accident that, for a time, had cost him his dreams. While he has often been described as a man of few words, Willard Stone was ultimately bound by circumstances that forged within him a fundamental need to reveal things words could not tell.

In his biography of Thomas Gilcrease, David R. Milsten commented eloquently on Stone's work: "He loved wood with the same fervor that his idol Michelangelo loved marble. He was aware of the grains, colors, textures, and warmth of wood. A block of wood to Willard Stone was something that had once been alive and he wanted to make it live again."

Stone's passing marked the end of an era in Oklahoma and Native American art. As an artist, he had forged new forms of expression. His work in wood, with all its natural tones, hues, grains, and textures, remains unique for the style of storytelling he perfected and for his contribution to an ongoing dialogue about the world condition. Throughout his life, Stone was a man centered on faith, family, and an abiding love for nature and the world around him. His art speaks softly yet reveals subtle thought through his genius for execution and design. Times have changed, but Stone's sculptures retain their power as intuitive renderings of a shared human experience. Their social, political, and spiritual themes telegraph the wry wit, quiet humor, and understated commentary that were central to his view of the world. He had a way of telling a story that was truly his own.

FACING: SCULPTURE OF A HAWK THAT WILLARD STONE WAS CARVING AT THE TIME OF HIS DEATH. WILLARD STONE MUSEUM, LOCUST GROVE, OKLAHOMA.

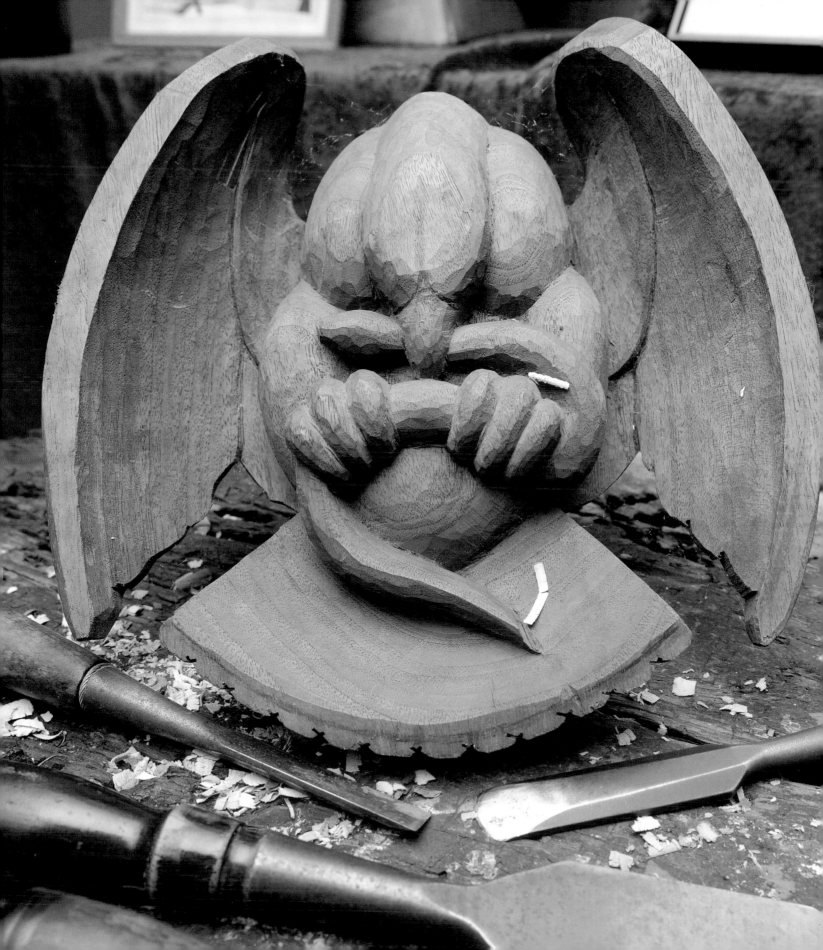

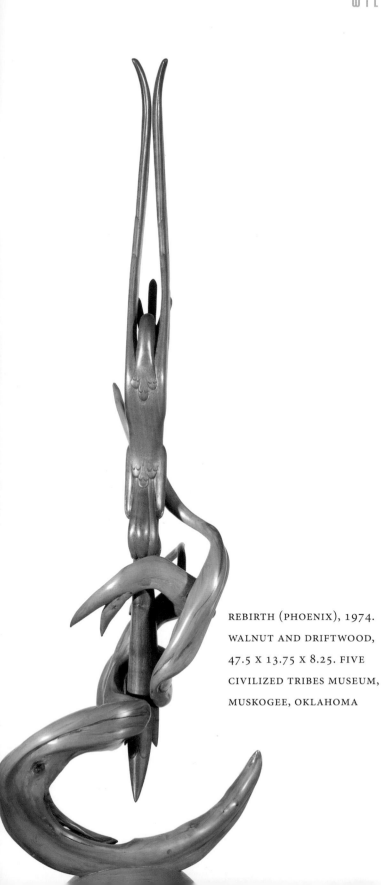

REBIRTH (PHOENIX), 1974.
WALNUT AND DRIFTWOOD,
47.5 X 13.75 X 8.25. FIVE
CIVILIZED TRIBES MUSEUM,
MUSKOGEE, OKLAHOMA

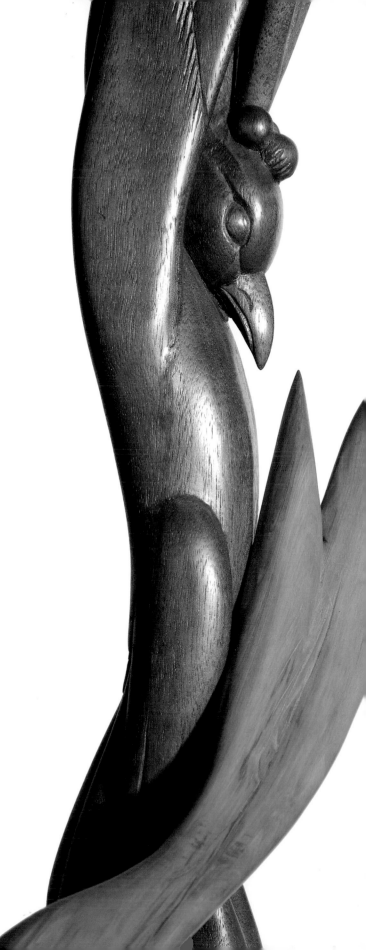

FACING: DETAIL, THE RIVER.
CHERRY, 27.75 X 4.5 X 4.75.
GM 1127.77

OVERLEAF: DETAIL, SOMETHING
TO BELIEVE IN. WOOD, 7.5 X 6 X 19.
PRIVATE COLLECTION

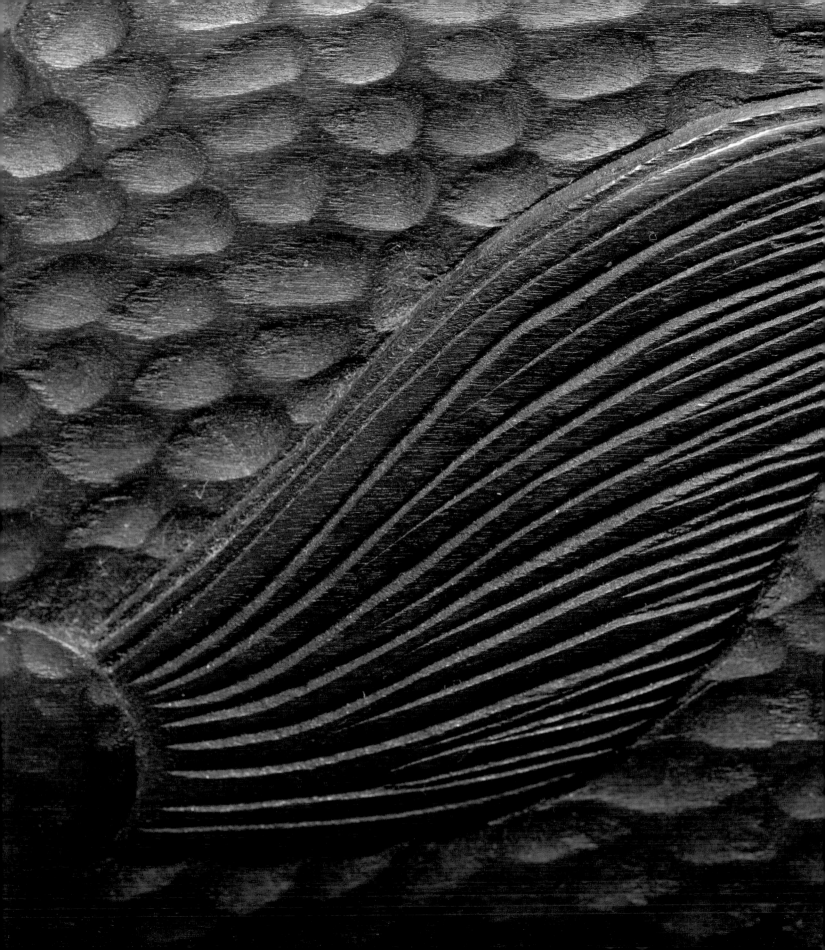

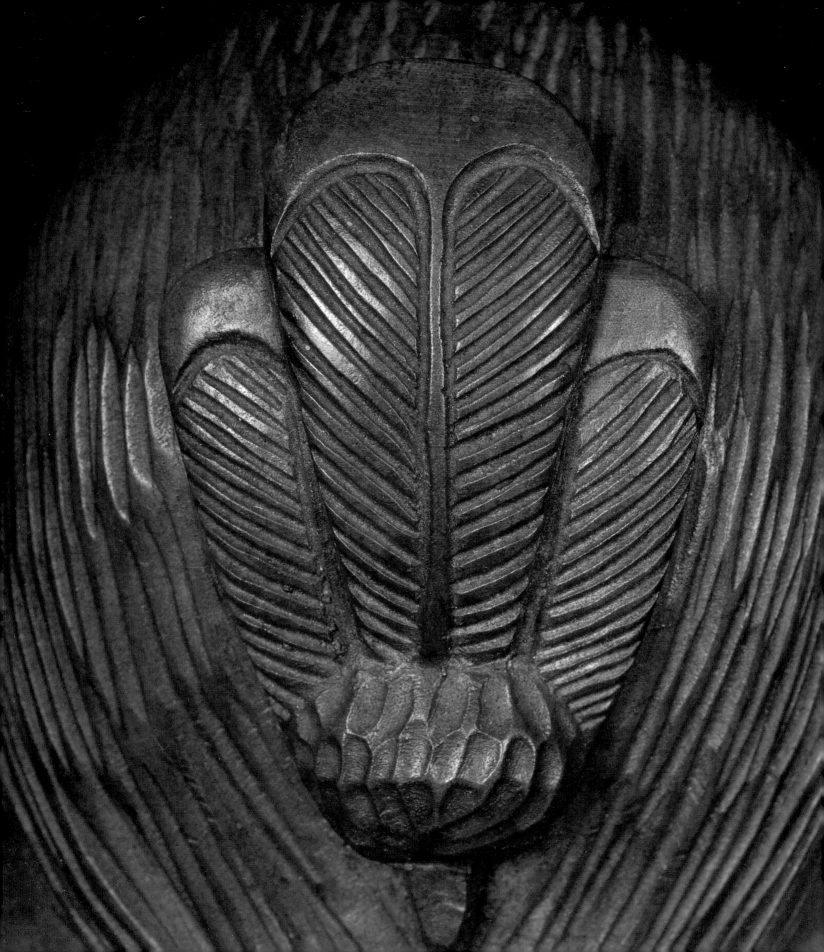